Let Me DIE

Do Not Resuscitate

Rubby Nwonye

Copyright © 2017 Rubby Nwonye

All rights reserved. No part of this publication may be reproduced, stored in a retrieval system, or transmitted, in any form or in any means – by electronic, mechanical, photocopying, recording or otherwise – without prior written permission.

ISBN-13: 978-1542703352
ISBN-10: 1542703352

Contents

Synopsis ... v
Chapter One ... 1
Chapter Two ... 14
Chapter Three .. 29
Chapter Four .. 47
Chapter Five ... 53
Chapter Six ... 61
Chapter Seven .. 69
Chapter Eight ... 78
Chapter Nine .. 89
Chapter Ten .. 104
Chapter Eleven ... 115
Chapter Twelve ... 124
Chapter Thirteen .. 127
Chapter Fourteen .. 137
Chapter Fifteen ... 141
Chapter Sixteen .. 151
Chapter Seventeen .. 157
Chapter Eighteen .. 164
Chapter Nineteen .. 172
Chapter Twenty .. 175

Synopsis

Elsie hated the awful care her mom received from a nursing home and the associated back and forth visit to the hospital. It hurt anytime she remembered the pain and agony her mom suffered from endless needle sticks for intravenous, pick line, blood draw, finger sticks, tube feeding, and tracheotomy while in a coma, yet she didn't survive. In her will, Elsie directed her children and lawyers in advance, "Do not resuscitate or put me on life support if I'm in a similar situation as my mom. Please let me die."

Two of her three children came to terms with her. Rodney, her oldest, wasn't just the outlier, but also a criminal mastermind bent on favoring himself in Elsie's will. His long process to steal, rob and burgle in an attempt to forge Elsie's will, was thwarted by the cops. That landed him and his buddy in prison. This novel combines little aspect of healthcare, more of crime and romance

Chapter One

Elsie had just slumped to the floor. She was in a closed door meeting with Janet, the nurse supervisor of Goodwill Home Health Care owned by Elsie.

"Elsie, are you alright?" Janet yelled. She jumped to her feet, rushed over and shook Elsie. "Are you alright?" she repeated. Elsie didn't respond.

"Oh my God. Please help me," Janet screamed louder. Frightened and nervous, Janet thought nobody heard her. She rushed into the adjoining office. "Call the Emergency Medical Service (EMS) now," she yelled to Kester.

"What's going on Janet?" the bespectacled Kester inquired. His focus now shifted from the desktop computer to Janet.

"Elsie slumped to the floor," Janet reported and turned back immediately to assist Elsie.

"You must be kidding," Kester responded with surprise. He jumped to his feet behind Janet and dashed into Elsie's office. "You must be joking. It's a lie," he said interchangeably as he went.

Janet knew that time was of the essence now to save Elsie. Rather

than wait for Kester, she grabbed the phone and activated the emergency code for help.

Kester made it straight to Elsie on the floor and knelt beside her. With head tilted to one side, Kester lowered his right ear above Elsie's nose. He listened to her breathing quickly and swept his eyes over her chest to check for the same. He also placed two middle fingers on Elsie's neck to feel for a pulse at the carotid artery. There wasn't either of them. He started a cardiopulmonary resuscitation, CPR, process. "One, two, three, four, five," he counted out loud in that sequence, up to thirty, compressing her chest hard and fast up to two inches in depth.

Ivory, the patient care coordinator, joined them in Elsie's office. "Janet," she called out of confusion. Janet couldn't answer. Janet was on the phone with a 911 operator.

"Oh never mind," Ivory said, turning to Kester. "Oh my Gosh," she screamed with her palm covering her mouth. "Is she alive?" she asked curiously.

Kester ignored the distraction. He concentrated totally on the CPR. With a measured rhythm, he continued to yell out the number of compressions he'd performed.

Ivory was a certified first responder trained by an American Heart Organization. She knew her role in an emergency, especially during two person's CPR process. She grabbed the oxygen bag and a mask hanging by Elsie's door. Ivory knelt over Elsie's head. The mask was firmly positioned air-tightly over Elsie's nose and mouth with Ivory's left hand. Two sets of breaths were administered to Elsie after each set of thirty compressions by Kester. As Ivory squeezed the oxygen bag, she meticulously watched to see Elsie's chest rise.

Janet hung up the phone. "The paramedics are on the way," she said quietly. She joined the duo on the floor and very ready to relieve Kester, now in the middle of the fourth cycle of the CPR. The three worked so hard on the CPR, switched roles as necessary as they waited for the ambulance to arrive.

An ambulance pulled up within twelve minutes. A police car followed suit after a couple of minutes. Two paramedics walked into the office with a stretcher and first aid kits. A cop followed behind them.

"Guys we'll take it from here," said Randy, one of the paramedical staff. He and Rachel, his colleague, lay the stretcher down at one corner of the spacious office. Rachel took over chest compression from Janet, who also had just relieved Kester. Randy powered the AED, placed two adult pads on Elsie. The AED ordered a shock to be delivered after an analysis.

"Everybody clear now. Do not touch the patient," yelled Randy suddenly. Rachel stopped CPR and drifted backward like every other person. Randy pushed the shock button. This created a sudden jolt on Elsie. Her pulse returned. CPR was discontinued at that point. Rachel now switched her role. She delivered a set of oxygen breath to Elsie every six to eight seconds.

Randy reached for Elsie's left wrist and checked her pulse. Curiously, he placed his stethoscope on her chest and listened to her breathing. "Very good; she's breathing," Randy declared.

"Oh is she?" Ivory asked rhetorically with excitement. "Thank God."

"I'm so glad; although she's still unconscious," Janet added worriedly.

"Yeah," Randy chipped in. "We have to rush her to the Emergency Department quickly."

Rachel readied the Intravenous - IV - set as Randy extracted every detail of the incident from the staff. She scanned Elsie's left arm for a suitable vein to start the IV. Luckily, she found a nice hassle-free one.

"Thank goodness. She has good and visible veins," Rachel said. She reached for a tourniquet in the first aid bag and tied it around Elsie's bicep. In a split second, the IV was up and running on Elsie's left wrist.

Randy pulled out a notepad. "What happened?" He inquired.

"She slumped in the middle of our meeting," Janet said.

"Wow," Ivory exclaimed surprisingly. Her eyes almost popped out of the sockets.

"That was it," Janet followed up.

"Any sign of sickness or discomfort prior to the meeting?" Randy asked as he continued to take notes.

"Not that I knew of," Janet responded.

Randy hooked up oxygen tubes to the cylinder. He inserted nasal

cannula on Elsie and secured the tubes around her ears to keep the cannula in place.

"Are you through with the IV start?" Randy asked.

"Yup, we're good," answered Rachel. She'd done IV start quite some time and had been very good at it. Rachel had been an IV nurse specialist with Hollywood Hospital over fifteen years. She switched over to emergency response service to get a break from the hospital floor.

Randy, on his part, had been a registered nurse at the same hospital for eighteen years. Like Rachel, a colleague and close friend, he needed a break from passing meds on the floor. These two were suited for one another. They always worked together whenever they were on the same shift. Funnily, they had what they termed an innocent crush on each other. They hung out frequently and did a lot together because none of them was married. Randy had pushed a little further to get Rachel come home with him one evening after dinner. She didn't mind. But she rebuffed him for a simple reason that sex might damage their very cordial work relationship. In any case, they played it by the ear.

The cop, Officer Benet took notes at the same time on his pocket size notebook. He'd remained calm and observant while all the medical process went on. He was dispatched from Hollywood Police Department.

Randy scanned Elsie to ensure no stone was left unturned. He and Rachel unfolded the stretcher and pulled out the stands upright. Kester, the database administrator of Goodwill Home Health Services and Officer Benet assisted the duo to lift Elsie onto the stretcher. Elsie was now awake and confused. The paramedics fastened the belts around her and were ready to take her to the emergency unit. Rachel pulled out a notebook and requested a witness signature from Kester.

Kester politely declined. Instead, he pointed at Janet and said simultaneously, "Janet will sign that for you."

Janet signed the consent notebook on the spots indicated by Rachel.

"We're all set and good to go now," Randy said. "We need one of you to go with us, the person who witnessed the fall preferably, in case the doctor requires more explanation," Randy requested.

"Where are we going to?" Janet inquired.

"Hollywood Hospital Emergency Department," replied Rachel.

"I'm going with you," Janet volunteered. She'd been emotionally involved all along. Janet was Elsie's right-hand employee who oversaw home visits and patient treatment, the core of the business. She was better positioned as the eye witness and a registered nurse to provide accurate details of what happened to the doctors. There wasn't a better time to show solidarity than now she thought.

"Janet, what's your last name again and position here?" asked Officer Benet.

"Snow is my last name, said Janet. I'm the nurse supervisor for Goodwill Home Healthcare," she continued. Jane flashed her identity card to the cop. Benet took note of that in his tiny pocket size notebook and returned it to his pocket.

"Good job guys," Randy congratulated the staff for the nice job done, as they pushed the stretcher away towards the door to the ambulance. Benet and Janet walked behind them. Ivory and Kester went close to the window to catch a final glimpse of the activities before the ambulance departed. Officer Benet did not leave with the ambulance or immediately. He took the time to observe the paramedics load Elsie into the ambulance and watched them leave amidst a loud siren. He stood outside a bit by the police car, made a call and walked back into the building to get more information.

"Did you guys witness exactly how it happened," he asked Ivory and Kester, who were still in shock and trying to process the incident.

"I do not know exactly. My colleagues were already doing CPR and talking to 911 respectively when I walked into the office this morning. I am still lost as to what happened," Ivory said. "Kester could tell better, he was doing the CPR when I walked in," she concluded

Kester went on to recount what he saw when Officer Benet switched his glance towards him, "I was not present in the room where the fall occurred. But I was around in a different office. I heard Janet yelling for help and saw her when she ran into my office for help. She told me that Elsie had suddenly slumped in the middle of their meeting. I went

over there and started CPR, while Janet called 911. That was what we were doing when Ivory arrived. Thank God, we got her breathing a few minutes before you guys made it into the office. That's what I know," he concluded.

"Ok. What's your name and position here, sir?" the cop asked. He'd continued to take notes as he spoke to the staff.

"I am Kester Smith. I am the database administrator and office manager." He showed his Identification card to the officer simultaneously.

Officer Benet noted that and turned to Ivory again. "How about you, Ms.?"

Ivory pulled her ID card, which attached to her blouse, towards the cop. "I'm Ivory Monty. I'm a social worker in charge of patient coordination for Goodwill Home Health Services."

"You guys did a nice job with CPR and coordination," Benet complimented.

"Thanks," responded the duo.

"Let me head out now. We shall refer to you for more information as we investigate this situation, if required. Thanks, guys," Benet said with a wave of the hand and left the office.

Kester was about to resume work on the computer when the office phone rang. He grabbed the phone while Ivory looked on.

"Hello," he said with eyes wide opened.

"It's Janet," Kester whispered to Ivory in a very low tone.

"Hi Kester," Jane responded from the other end.

"What's the situation; are you guys there now?" He paused to hear the latest situation on Elsie.

Ivory swiveled her office chair around to listen to the conversation. Kester pushed the speaker phone button to let Ivory hear.

"Yes. We just got here a few minutes ago."

Kester continued, "How's Elsie doing so far; still confused?"

"Yeah, kind of; but she slept all through the ride. They have checked her in, took her vital signs and are now waiting for the doctor to see her," Janet informed Kester. "This place is extremely busy. The ambulance is bringing people continuously every split of a second. People involved

in auto accident, some others in Elsie's situation, while others were brought in from the same hospital or different ones, just about various people with different life-threatening situations," Janet said. Her voice really smacked of concern from what was going on there. But, in a quick change of subject Janet said, "Hey listen, Kester, please call and inform Elsie's daughter, Nancy, about her mother's situation. I won't be able to do that from here. It's so busy. I need to know what's going on with Elsie first. Give her my cell phone number to call me."

"Ok. I'll do that once I get off this phone," said Kester.

"I trust you would handle that properly and in a manner not to panic her," Janet said with a chuckle. "We can't afford a mother and a child in the ER at the same time," she jokingly concluded. "Kester, I have to go. The doctor is here," Janet said hastily and ended the conversation. She was the only one present to explain the situation to the ER doctor. Janet was not a stranger to the emergency department. While a nurse at the hospital, Janet occasionally accompanied some of her patients to the ER anytime a doctor referred them. She used to hate the 'know-it-all' attitude of the ER nurses then. All the same, she got used to how they operated at the ER and had no choice but to put up with it.

25 MINUTES LATER.

Janet sauntered along the hallway of the ER. The doctor and nurses needed some privacy to examine Elsie. She waited to see Elsie whenever the nurses flipped the curtain open. She hung around part of her day to monitor her boss at the ER. Jane's intent was to go back to the office as soon as Nancy, Elsie's only daughter, showed up. On one hand, she thought it was nice someone close to or familiar with Elsie hung around to continue to monitor her. Jane wasn't sure if they would let her accompany Elsie to do the tests ordered by the doctor. "I'm not Elsie's next of kin," Janet thought within herself. "If I'm barred to accompany her to get her tests done, I'll have to wait until they bring her back," she guessed.

Janet's cell phone rang. As she grabbed it from her suit pocket, she muttered to herself, "I hope it's Nancy. Hello," she answered.

"Hello," echoed a voice from the other end. "This is Nancy. Is this Janet?"

"This is she. How're you doing Nancy?" Jane struggled to be calm and composed to stop Nancy from freaking out.

"Kester called and told me that my mother was rushed to the ER. How's she doing?" Nancy asked with an unsteady voice.

"She's feeling a bit better now. Nancy, there's no need to panic. Your mom is in good hands," Janet reassured her.

Which of the emergency departments are you at now?" Nancy asked anxiously.

"We're here at the Hollywood Hospital," replied Janet.

"I thought as much," said Nancy.

"How much longer before you get here?" Janet asked.

"I'm on the road now," responded Nancy. "As a matter of fact, I'm not too far away. Should I come in through the back or front entrance to the hospital; which one is closest?"

"The rear entrance is closer I guess," responded Janet.

"Ok. I'll see you shortly," said Nancy.

"That sounds good. I'll see you when you get here dear," said Janet. "Poor thing," she said as she hung up her phone. She empathized with Nancy considering how she would be feeling about her mother.

Nancy arrived at the hospital fifteen minutes later. Janet waited at the ER hallway to bring her to the right place. She feared that as a first time visitor, Nancy might be confused and get lost in the massive complex with many hallways. Nancy was visibly scared because she wasn't sure of her mother's condition that moment.

Kester didn't disclose the major details to Nancy for two reasons; the first was not to panic her. He made Nancy believe that her mother knew what was happening and voluntarily went to the ER. Second, Kester didn't want to violate Health Insurance Portability and Accountability Act – HIPAA, rules despite that Nancy was Elsie's daughter.

Janet tried to calm and reassure Nancy. "Come on let's see your mom. Don't panic at all. She's doing far better now than earlier. I wish you saw her then. She'd been calling your name minute after minute

since we got here," Janet continued as they made their way towards Elsie's cubicle in the ER.

"Has the doctor seen her?" Nancy asked curiously.

"Yes. He suspected cardiac arrest but hadn't confirmed that yet. He'd been cautious not to misdiagnose her or make the wrong assumption. But first, your mom would do some tests, which the doctor had ordered. We'll wait and see what happens when the results are out, and then go from there. Hopefully, no complications," Janet prayed.

"Whoa," Nancy exclaimed. "Ok," she said. "If it's that serious, Kester should've said so at first than leave me with a big surprise?" Nancy was a bit upset.

As a professional nurse with experience, Janet knew exactly why and how to deal with such situations. With a little hesitation, Janet said, "Let me apologize on his behalf. Actually, I told him to be careful speaking to you to avoid causing you any heartbreak. I'll take the blame. But it was out of consideration for you and your siblings. Also, HIPAA law forbade Kester from disclosing patient's personal information or medical condition to anybody, no matter who's involved. The patient has to give a written authorization for that to happen. It's worst to disclose such information over the phone because it could get into the wrong hands. HIPAA violation is a major infraction. Companies might lose their license, public confidence, and even sued for HIPAA violation," Janet concluded.

Nodding, "I understand the reason now. I didn't know that HIPAA laws applied equally to patient's immediate family," replied Nancy.

The duo finally got to Elsie's cubicle. The tiny cell-like cubicle consisted of tall and wide thick nylon cotton with rollers affixed at the top. The rollers helped the cotton to flow freely back and forth the metal rails attached to the ceiling. Elsie was now awake unlike when Janet left for the hallway. Elsie put up a wry smile immediately she saw Nancy. She's gone through a lot and had little to no strength to talk.

"Mom," Nancy called out. She leapt forward and kissed Elsie's forehead while Janet watched. "How're you feeling?" Nancy asked.

Elsie barely nodded her head in acknowledgment without speaking. She'd been weakened by all the IVs, tossing and moving since morning.

"I'm glad you're alive mother. My mind has been wondering since I heard about this. I wasn't sure where to begin," Nancy said tearfully. She turned to her right side and hugged Janet. "I can't thank you enough for all you've done. Thank you so much."

"You're welcome," Janet responded. Continuing, "The doctor ordered an ultrasound and a blood test. I was waiting for you to get here. Someone has to accompany your mom to do the tests whenever they come to get her. You've got to look out for yours in the hospital. Hope you know that?" Janet asked rhetorically.

"I get it," said Nancy.

"Alright, I'm glad you're here now. I've got to be back to the office to see what's going on." She turned to Elsie who was still laying on the stretcher. "I'll call later in the evening to check on you. I hope everything goes well. Please get well soon. We need you," Janet said. She stooped over and kissed Elsie's forehead.

Elsie nodded again. She'd not had the strength to talk after she fell.

Nancy responded on her behalf. "Please take care Janet. Thanks for everything."

"Goodbye for now," Janet said with a wave of her right hand and left.

James, one of the hospital transporters, showed up five minutes later with a stretcher, to get Elsie for the tests. He was clad in a navy blue shirt and pant. His name and the hospital logo were embroidered on the breast pocket of his shirt as an identity.

"Hello. My name is James. I'm one of the transporters. I've come to get you for the tests. Are you ready?"

Elsie had been ready and good to go. The nurses had already put a hospital gown on her since the time Janet was waiting in the hallway.

"Can I come along with her?" asked Nancy.

"Of course, if you like," said James.

James gently pushed the stretcher out of the wall. Elsie had been laying on the same stretcher since she arrived in the ambulance. He replaced the stretcher he brought with him in the exact position. It would involve lots of meandering through different departments, in

and out of the elevators and pushing along long hallways, to get to the ultrasound unit and to the hematology laboratory thereafter.

Nancy kept up with James in measured strides. As they walked, she made several attempts to call her brother, Josh, from her cell phone to inform him. She wasn't getting through.

James told her, "You may not get any service within here. I see you're trying to make a call."

Nancy exclaimed surprisingly, "Really. Why?"

James politely explained to Nancy, "I don't really know the reason behind it. We hardly ever get service on private cell phones in certain parts of this hospital, especially this area. It's the same issue in most hospitals according to friends and families who work there. I suspect nothing than security concerns." He paused and acknowledged greetings from fellow workers coming from the opposite direction.

"Hmm. It's strange. Isn't it?" Nancy chipped in.

"Funny enough, we could call anywhere in this hospital from the hospital-issued cell phone or call it intercom if you like, without interruption," said James. He pointed Nancy's searching eyes to the hospital phone holstered on his waist and continued to push the stretcher along with the remaining hand.

"I guess it's that way because it belongs to the hospital. It might be a preset arrangement to be used only for the hospital business within the premises. Anyway, I'll wait until I could get service somewhere to call my siblings. Thanks for informing me. At least you saved me the effort," Nancy said.

Elsie was almost dosing off from fatigue when they got to the ultrasound department. She was immediately taken inside the equipment room for the test by Viola, the technician. While the test went on, Nancy stepped outside quickly to call her brothers. She had to be quick and brief because she didn't know how long the test would last and the next point where the blood would be drawn. James was still waiting at the lobby to move Elsie. Nancy couldn't afford to miss him.

The ultrasound was almost done when Nancy got back to the unit. About a couple of minutes later, Viola called James to get Elsie. They

proceeded to the blood lab, the next department after radiology on the same side.

The Geriatrics unit on the 4th floor of Hollywood hospital had already reserved a private room very close to the nursing station for Elsie. James took her straight from the laboratory to the room. The emergency department had already sent her private clothing and shoe to this room numbered as 501. Elsie was closely monitored by the nurses.

A little after dinner, Dr. Mahesh, who was in-charge of the unit as well as Elsie's attending physician, came into her room to examine her. He was accompanied by Lynda, her primary care nurse.

"Ms. Snooker, are you able to roll on your left side towards Lynda," said Dr. Mahesh to Elsie.

"Please call me Elsie. I don't mind that," Elsie said to Dr. Mahesh. Annett was the name of her second husband, Nancy and Josh's dad, who died in an accident.

"Ok. I will," he responded. He observed Elsie roll over on both sides comfortably. Lynda checked her back and bottom for any skin tear. Dr. Mahesh asked Elsie to do two more things before he left.

"Elsie, please go back to your back," he requested. She did. "Raise your right arm." She did. "Raise the left one." She did as well. "Say, "Ah." She did that. Dr. Mahesh pinched Elsie under her left foot. "Tell me if you felt my pinch?"

"Yes I did," Elsie replied.

"Okay. Good so far," said Dr. Mahesh. "Do you have any questions for us?"

"Not right now," Elsie responded.

"Okay. Lynda, your nurse, will follow up with you on your medical history and plan of care," the doctor said. He washed his hands at the sink in the room. "Please excuse me for now. I'll see you shortly." He left the room with Lynda.

Dr. Mahesh was born in India. He immigrated to the USA after his medical school in Punjab. His accent is still heavy. He'd gone back to school in America and specialized in gynecology. His experience spanned over 23 years in medical practice. He was well liked and respected in the hospital. He returned to Elsie about forty minutes later as he was

about to leave for the day. "As I said before, your skin is intact and looks good. There are no bruises, tear or breakdown as a result of the fall. That's a good news. But I'm concerned about the pain you complained around your hip. Pray strongly that no bone was fracture when we receive the X-ray result." He paused for a few seconds and observed Elsie's reaction. "Anyway, I have put in an order for your medication in the computer. Lynda will see about that later when the pharmacy sends it. Any questions?" he asked Elsie.

"I'm wondering how long you'll keep me here. Just curious," Elsie inquired.

"I'm aware you want to go home soon. However, we have to observe you a couple more days and see the outcome of your tests. We shall make the determination from there to discharge you or not. Do you have more questions for me?" He paused for her response.

"I guess I'm good for now," Elsie responded.

"Good to know. I'll see you in the morning. Have a good night." Dr. Mahesh left.

Tired from the day's stress, Elsie was very ready for a nap.

Nancy decided to spend all the nights in the hospital with her mother. She considered that gesture an opportunity to make up with her mom and sink their differences. During the day, her brothers took turns to wait on their mother while she was at work. She took over from them after work much later in the day. No vacuum was created by the family throughout Elsie's hospitalization.

Elsie instructed the hospital not to let visitors, other than Janet and surprisingly, Frank, her 37-year-old gigolo, to see her.

Frank's visitor pass and privilege heightened and confirmed Elsie's children suspicion. That would eventually open up a cankerworm.

Elsie was discharged from Hollywood Hospital three days after.

Chapter Two

～

Four days after Elsie was discharged, Nancy called Josh from her office and invited him for dinner in her apartment.

Josh was surprised by that rare and sudden invitation with a short notice. But he still accepted her offer for that evening. The reason was simple; Josh and Nancy were the same parents and therefore, had more feeling for each other. They've been the closest among Elsie's three children.

Rodney, the oldest of the three, was their half-brother from the same mother but different dads. Elsie divorced Terry, Rodney's father, after Rodney turned two.

Rodney spent equitable time with his parents initially under joint custody. Eventually, he became more connected to his dad while growing up as a teenager.

Elsie remarried the same year she divorced Terry and had Nancy and Josh who were two years apart. Neither Nancy nor Josh knew their father that well because their dad died prematurely in an auto accident. That was six months after Josh was born. Elsie raised them alone until they turned eighteen respectively.

Josh was the most level-headed among Elsie's three children. He played more of a middleman between Rodney and Nancy. The two

neither agreed with nor hated each other. But they weren't close in any practical sense. It wasn't a surprise that Nancy didn't invite Rodney to the dinner.

As they dined that evening, Nancy disclosed to Josh the reason she invited him to her studio apartment.

"I figured out while with mom in the hospital that she was still upset with all of us. No exception. She was justified to be angry because we've been off the hook. She's seventy years now with poor health. Any successful and reasonable parents, who are also aging, ailing and frail, would be concerned about who'll be there for them when they're nearing their last days." She poured some coke into her glass and continued. "Part of mom's concerns was that her children weren't close to her and each other. She was right about that."

Nancy paused, stared into Josh's eyes vaguely and continued in a solemn, emotional and low tone. "Mom's illness had brought all of us together, under one roof for five straight days, after five years. It wasn't supposed to be that way. It occurred to me that we'd retrogressed as a family that couldn't unite and become more cohesive and responsible. It's time we eschewed individual pride, meet more often and be in each other's life. No one could certainly predict the future, not even what'll happen the next moment. We need to rethink our selfish ways and go closer to mom. We have more to benefit from her wisdom and wealth, which she'd built over the years, than to stay away and apart." She took a sip of her pop.

Josh had paid close attention all the while Nancy spoke. He'd occupied himself enjoying macaroni and cheese complimented with vegetables, potato wedges and grilled chicken in front of him. Some bottles of Budweiser beer, tequila, and 1.5-liter bottle of coke stared him in the face to wash down the food. Nancy was a good cook from time and very hospitable.

"Here's my suggestion," she continued, "Let's take her out for a dinner and have a chat with her in the process. The dinner forum would present the opportunity to resolve our differences with mom. She deserves to be happy these remaining years of her life."

"I'm glad you invited me for this conversation. It seems like you're a

mind reader," Josh joked. They both laughed. "I've thought about this myself. You were right about what you said. Actually, we've waited too long to resolve these infinitesimal differences among all of us, not just with her. She's the only mother we have for crying out loud. I feel so sad we've been very ungrateful to her for all her support." Josh suddenly switched the subject. "By the way, why isn't Rodney here; did you invite him?" He sipped his tequila and paused for Nancy's response.

Nancy struggled to produce an answer. Finally she stuttered, "I didn't."

"I didn't mean to sound rude or put you on the spot; but why, if I may ask you?" Josh followed up sarcastically. He knew the reason but wanted to hear it directly from his sister. Her response would become the pedestal to his next point.

"Josh," she called with a subdued tone. "You know Rodney and I don't agree most of the time. We've neither seen nor spoken to each other for two years until we met at the hospital. We don't have a solid relationship with each other, so there wasn't that zeal to invite him. I'm not proud of that. But unfortunately, it is what it is. You may be surprised that I don't have Rodney's phone number. I don't care either. Remember that it was you who informed him that mom was admitted in the hospital after I told you because I didn't have his number," she said in validation of her claim.

"Anyway, in my opinion, any reconciliation should begin with the three of us. That would be a moral ground to talk to mom, otherwise we would sound like hypocrites. We need to bury our grievances first. Mom would be happier to see us together and united. There's a popular saying that if you must come to equity, you must come with a clean hand. That said, it's a shame that you and Rodney have not spoken or seen for that long. Neither of you has each other's phone number in case of emergency. I'm so disappointed," Josh said with a straight look.

Nancy jumped in. "I agree. No hard feelings towards Rodney. But he needs to change his ways as well. At 45, he's no more a kid. Josh, you and I have had our little differences here and there. But they were mainly in principle than in practice. But we're always in touch regardless. Our sin is not coming together more often. We shall work on that from now

I promise sincerely. As for Rodney, I really don't care about him just as he doesn't care about anybody either.

"I'm glad you said that about you and me. But it's important we don't alienate Rodney. He needs to be part of this arrangement. Please call him to join us here. I'm sure he would like it. Sometimes, it's an ego thing with people even when they don't mean a thing about it. Why not call his bluff?" Josh suggested. He scrolled down the contact list on his phone to search for Rodney's number.

"Ok, I got it," Josh beamed a smile. "Here's his cellphone number," he said to her. He called the numbers to Nancy. But she looked morose at him and didn't utter a word. He noticed her hesitation and decided to unbind her from his shackles.

"I can call him myself if it's alright with you," Josh said.

Nancy thought she was put on the spot. Her ego wouldn't let her to be the first to extend an olive branch to Rodney. She didn't want to call Rodney by herself. However, she knew that she had to keep it real and practical if they were to move forward considering all she'd said earlier. She said to Josh, "You can call him if you like. It's alright with me. Don't be surprised he would decline to come to my place. Give it a try first let's see the outcome."

Nancy was right. Rodney declined Josh's invitation. He was hanging out with his friend, Scott, in a bar. They were chilling out with some beer that Friday night when Josh called. He put Josh on hold to enable him leave the noisy bar for a serene area to talk to him.

"Give me a minute Scott. I'll be right back," he excused himself. While outside the bar, Rodney explained to Josh, "Hey Josh, I don't mind joining the conversation but not at Nancy's apartment. Our relationship had been estranged for over two years. It would be a gradual process before we bond and develop a normal relationship. Then I would be free to visit her," Rodney remarked.

Nancy heard Rodney clearly over the speaker phone. It was *done* deliberately by Josh.

"Come on Rodney," Josh responded. "I'm your brother. Nancy is our only sister. We know we have individual weaknesses and collective differences. It's time we put those behind us and move on as a family.

Please come down here. You should be a part of this transition. This invitation is sudden sort of and outside your plans; but family comes first, especially when there's a serious matter at hand."

Rodney was hit by that. He had a little remorse. "I know what you mean Josh. I can't hold a perpetual grudge against Nancy who's my younger sister by the way. I admit I'm the adult here. But right now, I'm at the Club 5 Restaurant and Bar with Scott. I'll have to find a way to discharge him."

"Tell him that something came up in your family that needs your attention," Josh suggested.

"Good idea. How long will you be there?" Rodney asked.

Josh answered jokingly, "I'm here for as long as the sumptuous dinner lasted and the liquor flowed. Anyway, I'll wait until you get here. How long would that be?"

"Ha," chuckled Rodney. "I'll see you soon," he answered evasively. "I've got to talk to Scott a little bit. See you guys in a little bit," Rodney said. He turned off his cell phone and returned to the bar.

Nancy broke her silence. "Rodney confirmed what I've said about us being estranged. It would be a pleasant surprise if he came here this night."

"Let's give him the benefit of the doubt. If you noticed, he sounded positive kind of," said Josh. Josh dished himself a little more of the macaroni and cheese. "This is so good," he said. "I've been eating like a pig."

"Knock yourself out, Dude. It's for you brother," Nancy said, sipped her coke and continued reluctantly. "I want to share one more thing with you. This has bothered me since mom left the hospital."

"I'm listening."

Emotionally, Nancy asked, "Are you aware mom had drafted her will?"

Surprised, Josh took a deep breath, stared at Nancy with mouth agape. "I didn't know that. You're not serious, or are you?" he asked.

Nancy continued, "The troubling part is that we, her children, were short-changed."

"How do you mean?" He cuts in swiftly.

"Remember I spent all the nights with her at the hospital. Mom's health deteriorated in one of those days while she was there. I deliberately didn't tell you that. She thought she might not make it alive out of that hospital. My lord, she scared the hell out of me that day.

Her lawyer, Mr. Buckman, was over there after you left. They discussed the content of the will he'd drafted for her in details. I saw the draft the lawyer brought along with him. From what I was able to read, we weren't the key players in the picture, sadly," Nancy said.

"How did you know that?" He inquired.

"I just told you I was a curious and nosy peep tom. The lawyer was careless at some point. He left the draft on the table and I saw the potential beneficiaries." Her anxiety made her perspire and got Nancy drenched. She lit a cigarette. "You don't mind if I smoke, do you?" The cigarette dangled between her lips as she asked for his permission.

"No. It doesn't bother me. I smoke occasionally myself," he responded. "I'm shocked by what you've just told me."

Nancy took a deep draw of the cigarette and puffed out a long tapering smoke away from Josh. "You've not heard everything. This part will rattle you," she continued. She drew her last smoke of the cigarette and extinguished the light. The cigarette was barely smoked anywhere close to the stub. "I'm trying to quit. But the habit is too hard to expunge," she said. "I lit up out of anxiety and barely smoked it as you've witnessed. Smoking is one disease that's difficult to curb. Anyway, back to the subject. "Mom apportioned about sixty percent of her will to Frank, her gigolo."

"What," Josh exclaimed. "Are you serious?"

"I'm more serious than a heart attack. This isn't a joke. It was one of the red flags that prompted me to invite you for a chat. It's either we do something to stop this or get nothing when she'd gone," she said emphatically.

"It's very disturbing that mom was more interested in her gigolo than her children. You said it rightly. We have to act fast to reverse this crap before we hear stories. There's no more time to waste because tomorrow is unpredictable," he concurred.

"Anything could happen the next minute after now. That's where it's very worrisome. The thought of it and the whole information was overbearing for me alone. You're the only one I could unload my mind to," Nancy said affectionately.

Josh checked the time on his cell phone. "Rodney is still not here as he promised. What are we going to do now? This issue is all inclusive. It's been about an hour I spoke to him."

Club 5 Restaurant & Bar

Meanwhile, Club 5 Restaurant and Bar had boomed with business since 9 pm. The second and last Fridays of the month were the busiest weekends for the bar. Exotic dancers would perform and display their female contours. Some would give lap dances to entertain the male customers in exchange for money.

Scott managed to convince Rodney to hang on and savor that moment. Both of them drank heavily that night. In addition, they danced dirty and received endless lap dances from the strippers.

The good time overwhelmed Rodney. He was physically disabled and emotionally drained to say no to the moment for the sake of his siblings. He pleasured himself by the continuous body contact and erotic feeling emanating from the strippers. Rodney reciprocated by stuffing five and ten dollar bills inside the dancers' underwear at the private areas or the buttocks. Familiar strippers always went to him due to his generous patronage.

The euphoria of the moment carried him away. "I'll call and apologize to Josh whenever I leave here," he thought. But he didn't. He totally disregarded his conversation with Josh and that he might also be waiting for him. He'd become very tipsy and Scott heavily drunk. But give it to Rodney; he'd never wanted to be pulled over by the police for drunk driving. It was him who'd always dropped Scott off at his house. He always did the driving since he was more sober after they'd hung out.

Scott's driving license was revoked due to drunk- driving a couple of years ago. The cops pulled him over one night following a dangerous driving and erratic changes of lanes without signals. The cops suspected he'd been drinking because he staggered after he was ordered to get out

of his car. Breathalyzer indicated a body alcohol level much higher than the limit allowed. They cited him for driving under the influence (DUI) of alcohol and took him to jail that night.

However, Nancy and Josh went on with their evening and deliberated without Rodney. Nancy pushed the idea to have a dinner outing with Elsie, their mom. "That would be our time alone with her. There won't be distractions from this employer, that lawyer or any gigolo then. Rather, dinning together would provide a bonding among us. Then an opportunity to feel and study her countenance. Where necessary, we could ask for her forgiveness if it came to that. What do you think?" She pushed it over to Josh.

"That's a wonderful idea, Nancy. But before that, I would suggest we see her lawyer and pick his mind. He might provide us an advice on the best approach to mom. Attorney Buchman has been mom's lawyer, adviser and close confidant for many years. I'm sure he played a great role in her will. That's why it's important we see him first. The outcome of that meeting might determine the best steps to approach mom," he suggested.

"That's also a nice idea," she agreed. "I totally agree with you. Mr. Buchman came across as someone with great understanding and wouldn't hesitate to intercede on our behalf. What's your availability next week? How about I call his office on Monday to make an appointment to see him within the week?" Nancy suggested.

"I'm not sure what my schedule would be at the moment. I'll let you know by tomorrow then I would've crosschecked my work schedule," Josh promised.

"The quicker the better Josh," Nancy pressured.

"I'll also inform Rodney to join us," Josh chipped in subtly. He topped his glass with tequila as he watched Nancy's body language following his comment.

"It's up to you. I'm ok with or without him actually. I'm not bothered either way," she responded curtly. There was a brief silence. Then Nancy broke it. "How soon would the dinner be after we saw her lawyer; the same day or next? It would save time and convenience to follow up with

mom while the zeal and information were still fresh in my opinion," she suggested.

"Same day isn't doable. How about we sit and analyze what we've discussed with the attorney after the meeting. That would lead us to the next step and date for the dinner. Also, you would have to inform mom and get her availability. A day or two after seeing Mr. Buckman isn't bad at all. There's no hurry. If we're doing this, we've got to plan it well," he submitted.

Nancy countered. "I respect your opinion. But I see no need for all that protocol or foot-dragging about this. It takes but few minutes to review and analyze our conversation with the lawyer, if we meet with him earlier in the day. We could still take mom out for dinner in the evening if she's available. A stitch in time saves nine. Dude, we need to act quickly and move on."

"If you say so, it's alright with me," Josh agreed. "In that case, try to secure an appointment on Friday with Buchman. You could notify mom about that day. Monday, as you suggested, would be a good start to make the contacts. That would leave them enough time within the week for their businesses. I believe both of them would accommodate us on Friday. Mind you, mom doesn't have to know we met her lawyer. That's our innermost secret."

"Never," she cut in. "She'll never, ever know that. She might later but not now."

It was 11.05 pm now. "Whoa," Josh exclaimed. "Time flies like electricity." He stood up. "I have to be on my way, sister. I guess we've covered enough ground tonight. Any other thing we're missing?" he asked. While he waited for a response, he lifted his glass and downed the remaining portion of his tequila.

"I think so. I'm trying to recollect what it is again," she quipped. She rolled her eyes towards the ceiling and thought for a moment.

They've enjoyed each other's company for the past two and half hours. Hanging out for dinner and a chat had eluded them for a long time. Nancy missed doing things with her younger brother as they used to before.

"This is weekend dude. Relax. Get you some more drink buddy and

chill out. I'm not a stranger to you," she attempted to persuade Josh to hang on a little more. "I'm enjoying your presence. We've got to be getting together often."

"The feeling is mutual. I wish I could stay longer. I'll have to be at work in the morning because the assistant store manager won't show up. She'd complained of a stomach cramp today and will be visiting her doctor tomorrow. The buck falls on me and you know what that means?" he asked rhetorically with a chuckled.

Josh had worked for a luggage company for seven years. His impeccable customer service and punctuality had earned him a supervisory position after three years of hire as a store associate. The store manager appreciated his loyalty and planned to recommend Josh for a higher position whenever there was an opening at any store within their chain. That promise was the tip of the iceberg for Josh. Therefore, it was work first and pleasure last for him.

Nancy rebound with another topic she'd been thinking about. "Oh yea, we skipped Frank, the gigolo, in the whole picture. That was what I was trying to remember all the while. We have to touch on the guy whom mom had put as her primary beneficiary over us. Can we talk for a few more minutes if you could afford it?"

"Yeah, that's very important," he responded with deep interest. He sat down again. "We might as well go over that. It was nice you remembered it. I was going to mention it to you but also forgot."

"I'm glad I remembered this when you were still here." She leaned forward towards him. "It's my guess mom would be sensitive when it comes to Frank. This should be handled very carefully. How do we approach her about this?"

"Before that," Josh started, "Were you aware that mom filed for marriage at the registry?"

"What," she screamed. "Mom filed for marriage. Are you serious? With whom?"

"I'm more than serious," he responded.

"How did you know this? I'm curious."

"My ex-girlfriend, Laura, told me. Do you remember Laura?" he asked.

"Yes, I do. So you're still in touch with her?"

"Not necessarily. I ran into her at the mall recently. We exchanged phone numbers. She called me two weeks after and invited me to have some coffee with her if I was free."

"Hmm," muttered Nancy. She rolled her eyes in disbelief. She wasn't convinced Laura initiated that move. "Whatever," she teased with a smile.

Josh laughed. "Seriously, there are no strings attached. You don't believe that by the look on your face. We're just friends now." In a sharp deviation, Josh said, "Anyway, here's the whole story." Flashback

Josh recounted his meeting and conversation with Laura at the Star Bucks a fortnight ago. The location was across the street to the 76th District Court where she worked as a court clerk.

Laura was the first to arrive at the venue that evening after work. The beautiful blonde with long hair and blue eyes ordered her favorite mocha slush. She sat by the window to be able to spot Josh easily. Laura busied herself with her iPod. She connected to the free Wi-Fi in the café and browsed the internet until Josh arrived. Laura searched for stores that had ladies classic dresses on sale.

Josh walked in not long after she'd settled down. He beamed a huge smile as he made his way towards Laura. He opened his arms for a hug and said, "Look at you. You're still as beautiful as an eagle."

Laura stood up for a hug. With his arms wrapped around her back, Josh made full eye contact with her. "Your beauty never fades," he whispered into her ears. "You're still fresh and evergreen. Tell me the secret," he asked with a flattery.

"I'm flattered. Please don't blow up my head," she giggled. "You're also more handsome as well," she replied.

They broke the body contact and sat down. Josh sat across the table from Laura. They reminisced and exchanged ex-lovers' pleasantries. The usual tale of old romantic escapades, feelings, and affection dominated a significant part of the entire conversation that evening. That mutual feeling was superficial and short-lived. The duo had no plans to rekindle an old flame that had already flickered off. The decision to break up initially was mutual and amicable between them. That was five years

ago. They parted ways to pursue individual interests, which were incompatible. None wanted to be a distraction to the other. Whereas Laura enrolled in a community college to study criminal justice, Josh pursued a career in retail business.

Laura lived with her college boyfriend she'd known for four years. Her love for Dave was obvious. She couldn't help eulogizing him inadvertently before Josh. They met as course and classmates in the community college. Their bond grew stronger because they consistently shared the same classes and courses, unlike other students who moved on after prerequisites. Laura and Dave sat together in the class ninety-nine percent of the time. At some point, it became deliberate for Laura and Dave to register for the same classes every semester so they could be together, after they learned that they were doing the same program. Their love gradually developed and kept them inseparable since then. It morphed into serious thought and arrangement to tie the knot. Laura got her present job as a court clerk after graduation. Her friend and soul-mate, Dave, worked as a private investigator.

Josh was inwardly jealous, but he tried to stay positive, as he patiently listened to Laura's short biography. He was happy for her even as he struggled to conceal his jealousy. He'd not been particularly lucky with relationships. He'd just broken up with his girlfriend he'd been living with since three years.

His girlfriend, Rita, had accused him of cheating. She claimed that she read some flirtatious messages he'd sent to a female whom she'd suspected to have had some crushes on Josh. Although Josh denied all that, he couldn't sell his explanation to Rita who wouldn't buy them. Rita was exceedingly jealous and decided to break up. However, both agreed to continue to live together, without romantic attachment, for the custody of their three-year-old girl. Each was free to date whoever they pleased but outside their home. Although they kept private dating respectful of each other, they still kept their options open to reconcile anytime for the same reason they chose to live together. They would likely explore that options for their daughter, Natalie's, sake.

After she'd heard his story, Laura sympathized with Josh and offered some words of consolation, "Don't let that bother you. Put it behind and move on with life for the sake of that innocent child," she advised.

But she deviated to a new topic quickly to get off from his private love affair. Laura wanted to talk about the major reason she'd invited Josh. "Get you something to drink," she offered. "We were carried away and forgot about this all the while," she said.

"He ordered some cappuccino. While it was being arranged, Laura switched the direction of the conversation.

"How's your mom buddy? When was the last time you saw her?" She asked sarcastically and waited for his reaction. His response would become her precursor for subsequent revelation or follow up.

"I saw her recently. She just got discharged from emergency admission at Hollywood Hospital," he revealed.

"Wow." She exclaimed. Her mouth was agape with surprise. "I'm dumbfounded because I saw her three weeks ago, although it felt like yesterday." She wondered how unpredictable life could be. "Life is such that somebody seen today could be no more by tomorrow," she said. After a brief pause, Laura asked, "How's she now?" She asked affectionately.

"Oh, she was fine the last time I saw her," he answered.

That was Laura's opportunity to tell Josh about his mom, Elsie, and her gigolo, Frank, who'd visited the registry to file documents for marriage. She paused to gauge his body language. Laura knew that Frank was too young for Elsie and her children may not approve that marriage.

Josh was shocked. He fought hard to suppress his surprise. He knew well enough to comport himself to get more information from Laura.

"Oh yeah. What date did they pick for the marriage?" he asked subtly with a fake smile. He pretended to have had an insider knowledge about the marriage.

"In two weeks or so," she responded. She understood Josh was pulling a prank and decided to mock him. "You guys must be in top preparation now I guess. What're the plans in general? Hope I'm invited?" She sipped her drink while Josh choked on the question.

He came clean with Laura. "You must be joking," he laughed. "We don't know about that. You've just told me. To be honest, I've not been in touch all that with mom until her erstwhile admission at the hospital," Josh answered.

"Are your other siblings out of touch with her too?" she asked.

"I guess so," Josh responded reluctantly. "But we're working to correct our mistakes."

"Yeah, she should be frustrated by that. Her husband is dead and children are out-of-touch. Your mom needs a life and a company. She's also human," she opined. "What's your plan moving forward?"

"If that's her choice, nobody can do a thing about it. But in my opinion, that guy is too young for her. He's about my age group. That bothers me. Mom needs somebody older at her age. She's not a diva," he said bluntly. "I'll discuss that with my sister. Is either we support or stay out of her way."

Laura sympathized with him. "I'm sorry if I brought an upsetting news to you. As my friend, I'll always have your back. At least, I owe that to you. I just didn't realize you guys didn't know about the marriage arrangement. Anyway, I trust you'll handle the situation maturely."

End of Flashback

That was the much Josh remembered from the meeting he had with Laura. It became an additional agendum on the table.

Expectedly, Nancy was saddened. "Your story has now confirmed my suspicion. What shall we do?" she asked.

"I'm not sure at the moment. Let's start with a persuasion to convince her to drop that idea. An older man, to me, is much preferred to a gold-digging gigolo," he said. "We can't do much if she chooses to proceed with her plan. We abandoned her sort of for a while. If we're around, these crazy moves would've been nipped in the bud. Part of the blame is ours also."

Nancy said lividly, "We shan't let this guy destroy her or displace us from our rightful place. Let's obstruct or disrupt that marriage at the venue if she can't be talked out of it. That's my opinion if mom becomes obstinate. It may sound radical; but that's how change comes."

"We keep our fingers crossed," Josh said. He rose to leave and meant it this time. They've already agreed to stop the marriage. Though, the plan of action to achieve that was indefinite. Nancy stood and saw him to the door.

"Anyway, do your part. I'll call you tomorrow as I said. I'll take care of Rodney as well." When he got to the door, Josh turned around and

said, "Thank you for the dinner." He hugged and kissed Nancy on the cheek. "Have a good night sister."

"Thanks for coming. Good night. Please drive safely," Nancy responded.

He opened the door and walked towards his car. Nancy held the door ajar and watched until he drove off. She locked up and retired to her bedroom for the night. She stripped herself and changed into a pink flowing nightgown. Nancy climbed into her queen size bed and dimmed the bright light bulb on the nightstand. Laying on her back, she guessed at the ceiling. Her thought wondered and swiveled between her conversations with Josh to the imminent feud because of Frank.

"Rodney was another outlier out there, "she thought. "This urchin is neither here nor there. He plays no significant role in any of these," she muttered to herself. That was the extent of resentment Nancy had for Rodney. Sleep took her over as she wondered where Rodney would fit into the unfolding process, assuming they win their mom over.

Chapter Three

The guilt of his varied nefarious activities haunted Rodney. He knew he'd wronged everybody, his mom especially. His dad, Terry, Josh, and Nancy, were the three other most important people in his life. Rodney had infringed on Elsie's belongings uncountable times. He'd pilfered her purses several times, engaged in petty theft of her cash and pawned her expensive and valued jewelry for a pittance. That wasn't enough. Rodney had duplicated Elsie's master bedroom key and gained unfettered access to her secret and important documents such as will and life insurance. The bad company he'd kept had influenced and spurred him on to become foolhardy and adamant. As Elsie's oldest child, he had a sense of entitlement to her wealth. That was the reason he went all length, outside murdering her, and tried to lay his hands on a sizable chunk of her wealth. So far, he'd succeeded and had got away with his antics. It would be a matter of time before he was busted.

Terry was accused and blamed as a bad mentor to Rodney as well as an accomplice. As father and son, the two were the closest best friends since Rodney's childhood.

He lived and grew up in a bad neighborhood with Terry. That negatively shaped his character. After his parents had broken up with

their marriage, young Rodney preferred to hang out more with Terry, although he was still under shared custody.

The simple reason was that Terry was more lenient with him, unlike Elsie who was tougher in terms of discipline. Rodney hated to be asked to study or scolded. His mom was sternly when it came to those in order to put him in check and under control. Terry was preferred because he was the exact opposite.

At ten, Rodney had enjoyed too much freedom from Terry. He'd snubbed his mom occasionally, when she'd pulled up to get him.

To disallow unwanted arguments from cantankerous Terry, Elsie gave up at some point out of frustration. Rodney stuck to Terry and therefore wound up in that neighborhood until he turned seventeen. He spent lesser time at the suburb with his mother.

Terry's lifestyle posed a bad influence on Rodney. That negative influence spoke to Rodney's incongruent attitude to his siblings later on. Terry was an ex-convict who'd been involved in numerous felonies. He'd served some jail terms before. So he'd been acclimated with the prison system because he'd been in and out.

Notwithstanding, Elsie gave Terry a second chance in life. She agreed to remain with him on the condition that he turned his life around from crime.

Terry couldn't reciprocate her gesture because he lacked discipline and self- restraint. He continued with street gangsters, alcoholism and gambling, which prompted Elsie to split with him.

Unlike his dad, Rodney had never been to the prison before, although he was on constant runs with the law usually over minor infractions. Cops always pulled him over sometimes for traffic violations involving DUI, driving with expired vehicle insurance. He'd been to jail overnight, just one time, for possession of marijuana. Never had he stayed in jail beyond a night or two at the most.

The next day after he'd become sober from Friday night's outing, Rodney called and apologized to Josh for reneging on his promise to join them for dinner and family talk. Rodney had maintained a close and constant communication with Josh because the latter had always been responsible, calm, calculating and intelligent.

Josh wasn't bothered either. That was why he got along well with Rodney. He'd had Rodney's back always as well as the middleman and mediator between him and Nancy. Sometimes, he'd been the intercessor for Rodney with their mother. It was due to Josh's intervention that Elsie had agreed to bail Rodney out of jail because she'd become sick and tired of his vicious cycle long ago.

Couple of months ago, Elsie was livid that the cops interrupted her sleep in the night because of Rodney. Angrily, she informed Rodney that she would never return to the police station any time soon because of him.

That night, two police officers had pulled Rodney and Scott over around 3 am on their way from the club. They were drunk and drove recklessly. The cops recovered some marijuana from Scott and took him straight to jail without context. Rodney was lucky that he wasn't the driver that night. The police decided they would release him to a responsible adult that was related to him.

The cops contacted Elsie that night. The cell phone on her nightstand woke her up. Drowsily she answered, "Hello."

"Hello," responded one of the cops. "This is the police."

Elsie was jolted out of her bed by the call. "Sorry, who's this again?" She asked looking at the wall clock. "Do you realize it's only 3.20 a.m. in the morning?"

"The Police," responded the cops. "I'm sorry to bother your sleep. We have one Rodney here in our custody. He claimed that you're his mother. Do you know him?"

"Yes, I do. He's my son. What happened?" she asked nervously.

"We pulled him and his friend over for DUI. Rodney's blood alcohol level exceeded the normal limit. Unlike Scott, his friend, we decided to spare him the jail tonight because he was the passenger. However, we asked him to provide a responsible adult to get him home tonight. It was only on that condition we would release him. That was how we got your name and contact. Could you come and get him?"

She answered, "Yes," reluctantly. Officer, where are you now?" she asked courteously.

"Actually, we're around the corner from you," said the cops.

Elsie was still mad that her sleep was interrupted midway. She'd planned to wake by 6 am to get ready to leave for the office by 7 am. They were expecting the inspectors from the State licensing and Accreditation Agency for Home Health Organizations that day. The staff were to meet early in order to review, arrange, organize and keep all required documents up to date and handy before the inspectors would arrive. It would be a long day dealing with the inspectors. She knew that well because she'd been doing that for years. It wasn't in doubt that her business might lose the license and close down if it didn't meet the state requirements.

She'd barely had three hours of sleep before the cops called. She got up from her bed cranky and changed from a light red nightgown into a pair of black sweat pants matched with a black top. Elsie grabbed her cell phone and made towards the front door. From her peephole, she could see a combination of alternating colors of bright light emitting from the strobe on the police car in front of her house. She opened her door and waited at the front porch for the police to disembark.

Officer Terence, on the front passenger's side, was the first to hop out. He reached the back door of the car and helped Rodney, who was on handcuff, out of the car to his feet.

Officer Ross emerged from the driver's side. He had a two hundred and fifty dollar ticket on his hand. He unfastened the cuffs from Rodney before Elsie, who'd approached the police car.

"Mam, we regret to wake you up this night," Ross apologized. "But on one hand, it's better for your son. It could have been worse."

"I appreciate that. At least you kindly didn't take him to jail. You saved me a trip to the police station. Thank you so much." There was a mix of sadness and happiness in her tone. But she pretended nicely before the police.

"You're welcome," Ross acknowledged. As he handed Rodney the ticket he said, "Sir, I cited you for only excessive consumption of alcoholic beverage beyond the legal limit. This is a Christmas for you this night. If I have to pull you over next time in a similar condition, it doesn't matter whether you're the driver or passenger, I'll take you straight to jail. Your friend is in jail now because he was behind the

wheels while drunk. We can't say this enough, 'Don't drive while drunk.' "You guys should always remember that you're endangering your lives and others' when you operate automobiles while drunk. You could be killed or kill innocent people on the road. Please don't drive if you feel you've had too much to drink. It's safer for you to call someone or the police to pick you up than to get yourselves or others into trouble. Now you've forced your mom up from her sleep this night. Anyway, it's up to you to settle the ticket or we see you in court." He turned to Elsie. "Goodnight mam. My apologies again," Ross concluded. They went into their car and drove off.

Elsie angrily drove Rodney back to his house, which was about three miles away, that night. She'd warned him severally about excessive clubbing and drinking, especially during the week. What annoyed her most was because Rodney was her oldest child who should be exemplary to his younger siblings.

Not quite two weeks after that incident, Rodney ran a traffic light at night. Unknown to him, the next corner was a speed trap. Out of nowhere, a cop jumped into the road behind him and flashed his light. Rodney didn't stop immediately. He dragged the cop in a slow drive for a little distance and finally pulled up. He didn't want to appear to be fleeing from the police and didn't feel like stopping either. That was exactly why he drove slowly.

The speed cop interpreted that action as fleeing from the police. He arrested him on two counts of running a traffic light and fleeing from the police. The officer called for a backup and a tow truck. He impounded Rodney's car and took him straight to jail from that point.

"Here comes another time for bail," Rodney thought within himself. His mom wasn't his best choice this time. She'd warned Rodney strongly, after the last incidence, not to call her again concerning any runs with the police. Rodney pushed that button anyway.

But Elsie ignored his calls and messages all night and even when the day had broken. She was very angry. "It was time he learned some hard lessons of his life," Elsie said.

As his other alternative, the police wouldn't release Rodney to Terry either because he had a bag full of long criminal records. For

six years, Terry tried to stay on the sideline to clean up his criminal background. He wanted to start afresh and had therefore, enrolled with a Rrehabilitation Center for alcohol and drug abuse. So he was clearly out of the question to bail Rodney.

By 12 noon the next day, Elsie still didn't show up at the Hollywood Police Department. It dawned on Rodney that his mom meant business this time. He decided to take a gamble on Josh as his last attempt for bail.

Josh didn't go to the police station by himself after he was called. As usual, he contacted his mom and pleaded with her to help Rodney. It was a couple of hours before he convinced her to rethink her previous decisions. Later on, they went together to the police station and got Rodney around 3 pm. Josh had been a primary source of information for Rodney about his mom and sister.

The get together dinner he skipped at Nancy's apartment became one of Rodney's regrets. He thought he wasn't reciprocating enough or at all to Josh's continuous kindness. However, he couldn't afford not to be at the club either, not while his buddy, Scott, was there. He was certain Josh would accept his apology anyway.

Josh worked that Saturday because the assistant store manager was absent. He was busy with a customer when a call came from Rodney around 12.30 p.m. He returned his call during his break. Josh told Rodney about the discussion he'd had with Nancy. The plan to see attorney Buckman and take Elsie to dinner afterwards was also communicated to him. "Our biggest concern was about mother's will. She'd also planned to marry Frank, her gigolo, in a fortnight. These are the primary reasons we've planned to have separate meetings with mom and her attorney respectively. Rodney, you need to be part of all these," Josh said bluntly.

"I know that, Josh. I've been a slacker and I apologize. There's a lot on my plate. But I'll definitely step up my role," Rodney said pretentiously.

Unknown to Josh, the issue of the will he'd just referenced had ticked Rodney off. He felt like somebody was piercing his heart with a sword. But he waited calmly until he'd heard all Josh had to say during his short break time.

"Respectfully, Rodney you need to get over all your malice and animosity and join your family. That was exactly what Nancy and I decided to do. As you're aware, I didn't visit Nancy that much, but I did last night. We've planned to do same with mom and apologize to her. This is your opportunity to mend fences with Nancy too. For crying out loud, you're the oldest amongst us. You should take the lead and not keep aloof. Grow up brother, you're not a kid anymore." Josh gave him a piece of his mind. "I have less than 2 minutes to the end of my break. I want to ask you directly, "Would you join us to see the lawyer and have dinner with mom afterwards if Nancy confirms the date?"

"I sure will," Rodney responded. "Please give me heads up so I could prioritize my program. That's all I need."

Break time was over. "Look, Rodney, I've got to go now. I'll post you as soon as I know the date and time. However, be looking at next week's Friday tentatively. We'll talk again before that time. Talk to you later."

"Bye," Rodney said and hung up. What he'd just heard puzzled him. He'd been standing by the window in his living room all the while. He reached for a leftover tequila at his tiny dining area and emptied it into his glass. He'd been drinking that since an hour and a half. Rodney returned to the window again clutching his glass. He took a sip from it while reflecting about the conversation they've just had. His mother mostly occupied his thought and concern. He was concerned whether Elsie had found out that he'd altered her will. "I'm screwed if mom found that out," he thought. For the next few minutes, he tried to recount how he got hold of Elsie's will. He looked morose through the window glass into the street in a flashback.

Flashback

Elsie had called Rodney on a Friday night just as he was about to step out of his house. She'd asked him to help her the next day with a few errands and to fix some things around her house. Her mom always asked him for errands and works around the house because he was a handyman. Her reason was that, "I'd rather pay my child to help me than let my money fly out to someone else." But she'd never left him alone in her house anytime he came around due to his near zero credibility. As her

son, she had no choice than put up with him the best way she could. To alienate her child would neither serve a purpose nor sober Rodney up either. "To bring him closer was far better," she thought. She invited him over to do things around her house for the above reasons. While in the house, it became an opportunity to interact with him and to make a firsthand assessment of his personality. Those were important issues for her whenever Rodney was over her house during the weekend. The services he offered were secondary issues. She was rich enough and could easily afford services from whomever she wanted.

None among Elsie's children had spare keys to access her house. They'd usually visited and spent much time as they wanted when she was home. A certain level of distrust existed because of lapse in family closeness. That vacuum was bridged for Elsie by her gigolo. Frank became her closest confident all the while. Undoubtedly, he had spare keys to her house.

The opportunity opened for Rodney on that sunny Saturday afternoon when he came around to help his mom. He got to the house as she was wrapping up a phone conversation with her lawyer about her will. Rodney eavesdropped their conversation and became interested. He chose not to go inside. Rather, he stealthily left the front door for the back door to conceal his presence. He didn't want them to whisper if she knew he was around. Therefore, he carefully lurked behind the door and listened to the last word Elsie had spoken. He was able to put things together based on what he'd heard from her side of the conversation. He snuck back to the front door immediately she hung up the phone. Deliberately, he stood there for five minutes to erase any suspicion before he rang the doorbell.

Elsie needed him to fix some electrical wirings in her basement and to unclog her kitchen sink. Rodney dragged the work in order to buy some time for himself. He had a divided attention. Part of that centered on how to catch a glimpse of Elsie's will to know what was in it for him, how much, other beneficiaries and their percentages. He knew better not to take anything to chance with his mom.

When it came to Josh and Nancy, Elsie might not give a hoot considering their sour relationship. She'd been unhappy that they drifted apart despite her efforts to get them on the right part.

Rodney was bothered when Frank was mentioned in her mom and attorney Buckman's conversation. It was worrisome that this gigolo would decimate what was for Elsie's biological children and even her grandchild from Josh.

A thought sprung up inside him. He rushed the remaining part of his work in order to pursue this new idea before it would escape him. A bunch of keys dangled on the lock at the door of the kitchen. That door led into the back area of the building. A among the bunch was certainly for the master bedroom. Rodney hatched a plan to duplicate the keys. "How do I get these keys now," he wondered inside. An idea rolled into his mind. He told his mom that her white mini Cadillac SUV needed to be cleaned. He offered to do a drive-through at a commercial carwash business down the road.

Elsie would be home until 6 pm and would thereafter, join her friend at a birthday party. She accepted Rodney's offer innocently and without suspicion. If she had a slightest premonition of an impending menace behind this unusually kind gesture, she would've been quick to decline it. Sometimes, she'd deliberately put Rodney to test to measure how much change he'd acquired. This time, she purposely chose not to tell him that she left a hundred dollar bill in the glove compartment. Surprisingly, she got it wrong this time. The money wasn't tampered with. The issue was that he'd spent far more time at the drive through than she'd expected. Other than that, her car intact. In fact, nothing was tampered with at all.

The temporary trap he'd scaled wasn't his immediate target, although there was a high temptation at a point to steal the money. That would've been too obvious, therefore he restrained himself. He thought that his mom would remember that the money was there. The focus was on the bigger plan he would execute in the coming week. He was certain Elsie would have a copy of the will in that house by then.

Four days after, Rodney returned to Elsie's house while she was at work.

Scott dropped him off by 10.00 a.m. and sped off. He wanted to lessen or eliminate the possibility for anybody to see him clearly, identify and accurately describe him or his car to the police after that home invasion. He left Elsie's vicinity entirely and parked at a distance further

away. He stayed inside his car and watched when Rodney would step out of the house so he could quickly snatch him up.

Rodney chose to come that early because he wanted to have a field day to ransack Elsie's house for the document. The will would be amended and returned to the exact spot before Elsie would return. It should be a fast process given the available time. He gained access into the house through the back door with one of the duplicated key. While inside, Rodney went straight for the metal safe in the master bedroom. He tried various keys until he found the exact match to the safe. Luckily for him, the will stared him in the face when the safe popped open. He grabbed and quickly scanned over it. Disappointingly, he was the least favored among all the beneficiaries. "It was time to go," he thought. He locked the safe and quickly made his exit towards the back door.

The getaway car must be ready before he would step outside. Like Scott, he needed to shield his identity and cover his tracks before he would escape. Rodney remembered that Ms. Carlyle, an octogenarian and a retiree, who lived across the street, always peeped through the window. It was necessary to were enough disguised because of her. So he covered his ears, wore a pair of dark glasses, pulled his baseball cap over his eyes and wore a thick jacket with long sleeves over a thick workman's dungaree and caterpillar boots. It was a pretty quick operation.

Ms. Carlyle was a pensioner and a widow. She'd lived on that street and in the same house since Rodney was a child. Her husband passed on five years ago. All her children were raised and grew up in that house. Though none lived with her presently. In good weather, she usually sat outside on her porch for cool breeze and sun. During chilly and ugly weather, she retired inside the house and peeped into the street through her living room window. She knew almost anyone in the neighborhood or anything that went on around it because she was always at home. For that reason, neighbors nicknamed her, "Inquisitive" because she was into everybody's business.

People in her neighborhood wondered whether she ever slept because she knew every minutest details of things that had happened.

Rodney called Scott to pull up. Scott was there in a split second. Like a flash of light, Rodney rushed into the car and they sped off. All the activities put together lasted about ten minutes.

Scott drove a Grand Am salon car. He'd kept a close surveillance for Rodney throughout the invasion. The aim was to alert him to flee or hide if Elsie came home unexpectedly.

Wednesdays were usually busy for Elsie. That was the day she met privately with any of her staff and business associates. Rodney chose that day because he was aware of her schedule. But he didn't throw caution to the wind while inside her house.

When they drove to a comfortable zone outside Elsie's street, Scott opened up, "I caught a glimpse of this old lady peeping through her window from across your mom's house. Do you know her?"

"Where did you see her?"

"I just told you it that it was the house opposite, right across the street from your mom's," Scott snapped.

"Oh, I know who it was. It was Ms. Carlyle. People there call her "Inquisitive." With a-forget-you wave of his right hand, Rodney continued, "I doubt whether she would recognize me. First, I didn't come with my car, which I believe she knew. She doesn't know yours either. Importantly, my mom kept her at a distance. If they ever related, it was usually casual. Mom would not listen to or believe her blab. I know that for sure."

"Oh, that would work in your favor," Scott remarked quickly. "What about me?" he asked curiously. "Couldn't she describe my car if anything went wrong?"

"That's if she remembered the exact make of your car, color and even license plate number," Rodney responded. "Remember this happened so fast. I doubt whether she could describe anything that would help the police to make a sketch. But be on your guard because she would be on the same spot when we return this document," Rodney cautioned. "You want to bet?"

The content of the will, which Rodney had painfully described, didn't surprise Scott. Elsie had disfavored her children in her will due to lack of chemistry or bonding between them. She considered them incapable to manage her business and estate if she died. She'd rather have somebody else manage the business than let it go moribund a short time after she'd passed on. That was why she allocated only thirty percent of her entire

estate to her three children. Rodney was the least favored among them, followed by Josh and Nancy respectively. She had more trust in Frank, in collaboration with her attorneys, to manage her affairs.

Frank had been around her, for the most part, and had been learning her business operation. He'd earned thirty percent of Elsie's estate for himself. Additionally, he was mentioned as one of the trustees of the remaining forty percent, which would go towards her charity foundation.

Interestingly, Frank and Elsie would be officially coupled in about two and half weeks from that Wednesday. Elsie thought she made enough provision for her children. She also left an instruction in her will for her estate administrators and attorneys to elevate any of her children who displayed leadership qualities, integrity and maturity in the future, to the position of directors.

Although he wouldn't attain it, that provision was very encouraging to Rodney. He thought his mom was clever to have left that room of opportunity in her will, at least for her siblings. At least, either one of Josh or Nancy, or both, could become a director in Goodwill Home Healthcare. If that happened, he would have an economic solace in them.

Frank was his biggest nightmare. Rodney saw him as a usurper and an unwanted threat to their inheritance. He'd vowed to go any length to stop him. However, the immediate mission to accomplish was to change the content and language of that ill to put Rodney at the pinnacle. He thought about switching sides with Frank but decided to delete him from the will entirely.

The question now is where to make the changes. The commercial business centers weren't an option because they would raise lots of suspicions. Chances were that the operators might call cops. Charges may be brought against them for conspiracy to steal and alter a legal document. The worst part was that Elsie would hear about it quickly because news spread like a wildfire.

Scott suggested that they ask Hannah, his girlfriend, if she would like to help.

Hannah had been a professional secretary for a few company

administrators until she decided to go private. As a private secretarial service enterprise, she had some good equipment to take on assignments from big companies. Besides, she was very computer savvy.

Rodney objected to that idea at first. His concern was that Hannah was too familiar and too close to comfort. "What if she ran her mouth or decided to inform the cops?" Rodney queried.

Scott tried to convince him. "There's nothing to worry about her. She's a professional and does this for a living. Companies and private people bring businesses to her because they trust her. If I knew my girl very well, she's well versed with confidentiality and privacy laws. Honestly, you have to worry about whether Hannah even has time for this ad-hoc job. She's very busy. Importantly, would she like to be associated as an accomplice to this criminal activity? No. She doesn't need this job to be honest with you. You're not doing her any favor, but the other way round. These are what to be worried about. This is forgery, pure and simple. It's against the law. The Hannah I know lives a pretty much clean lifestyle. But leave that for me to handle," Scott submitted.

"The point you raised about the ad-hoc nature of this makes some sense. Anyone who accepts this illegal job on a short notice would definitely set a cut throat bill," Rodney noted.

"Rod," Scott said. He used to shorten his name to "Rod" occasionally. "Monetary consideration shouldn't be paramount at this time. I'd rather we expedite this process and return the damn will where it belongs. That's most important now. To contain your cost isn't bad. But right at this moment, it should be your least consideration. If Hannah accepts to help, I believe her charges would be fair enough." Scott added a light but sarcastic sexual jokes. "If she goes hard on us, then I'll pay the balance with romance in the bed." They laughed wildly. "Come on dude, I'm heading that way now," Scott concluded.

Rodney posed a question to Scott. "Hey, what do you think about Frank?"

Scott's answer was swift. "A gold-digger pure and simple."

"That is worrisome to me. I know my siblings feel the same way," Rodney said.

"We could teach him a little lesson of his life if you like that," Scott suggested. He paused to hear from Rodney.

Inside him, Rodney was glad that Scott had volunteered to participate. "What kind of lesson?"

"Stalk him a bit and beat the daredevil out of him," Scott responded bluntly without batting an eyelid.

"That doesn't serve any useful purpose. I would like to disrupt or stop the marriage between him and my mother. I can't wait to dispossess him of any part of the entitlement she'd appropriated to him in the will. Anyway, that's what I'm about to do now. But killing is out of the question buddy," Rodney warned.

"Here's my idea; kidnap him a few days prior to the marriage. If that didn't work, we could waylay him on his way to the wedding, beat the crap out of him and carjack him. I guarantee he wouldn't smell the venue when he's on his way to admission. This option would definitely bring about the postponement of the marriage. Then, you guys would have all the time in the world to talk your mom out of it."

"Not a bad idea if properly executed. But it's got to be you, buddy, who would have to execute it. I've got to remain in the dark because I'm involved. Hope you get that?" Rodney asked.

"Of course I get that," Scott retorted. "Do this; provide me with his picture, itinerary, of course some bucks for beer and weed, then I'll deliver," Scott requested with a big laugh.

"Sure," Rodney said emphatically and happily.

They pulled up in front of Hannah's house, disembarked and went inside.

Hannah was hesitant at first. "I don't mean to be rude. But I don't want to identify with any part of this. It's your mother's document, but you don't have her permission to alter it. You want me to do something illegal. I'm sorry, I'm not doing that," Hannah declined to Rodney's surprise.

The guys became stranded. Scott blinked his right eye to Rodney to relax.

"Let me see you for a minute," Scott said to her. The two walked inside Hannah's bedroom, while Rodney waited. Scott held Hannah

by her two arms with a close eye contact. "Please honey, I understand where you were coming from. Honestly, I explained this to Rodney beforehand. But there's something at stake here. This guy is worried because one gigolo wants to wipe off and rob them of their inheritance from their mom. This is exactly why I've brought him here. Please kindly assist him. You're doing it for me honey." Scott maintained the eye contact and caressed her arms at the same time.

"Alright. I'll look at it because of you. But count me out if anything happens later because I'll deny you," she said sternly.

They walked backed to her work area. Hannah took a look at the document.

"Look guys, the original document would be visibly mutilated if you make corrections on it. The best solution is to reproduce the entire will and make the required changes with the exact fonts used by attorney Buckman. It'll look original and decent that way. That's my opinion," she suggested.

In about an hour, Hannah was done with the document. Scott had explained how urgently it was needed to Hannah when they arrived. She'd put other jobs aside and tackled that for Rodney. But she discovered a little twist that would present a bottleneck to Rodney.

"Guys don't be in much hurry to return this new document. If you noticed, the attorney put his seal on the original one." She pointed at the seal on the document. "You need to authenticate this one as well to make it real," she advised.

Rodney was disappointed but happy at the same that she spotted that on time. "Thank you so much. You've saved me a big problem. I'll handle that," he said.

They left for the car. Before they drove off, "Dude," Rodney called out on Scott, "You've got your hands full now. I need you to work on the attorney to get his seal for this new document. Can you handle that for me?"

"I'll try dude. My buck's adding up you know," Scott chuckled. "Give me the same information that I'd asked about Frank and leave that for me," he said confidently. "I need their photographs for identification. If

you tell me a bit about their movement and addresses, especially where Frank lives, the type of cars they use, we're good to go."

Rodney went on to describe attorney Buckman and Frank to Scott. "The attorney's office address is right here on the will. It'll be available anytime you're ready to work on him. I need that seal affixed on this new document by tomorrow at the latest. His picture will be available for you this evening. I'm not sure about the type of car he uses as at now," Rodney said.

"Frank works two days a week for my mom. He also waits tables in a big restaurant somewhere downtown. That's how he met my mom because she loved their food and visited his restaurant often. Frank waited on her most times. I believe they clicked in that process. My mom bought him a brand new red Malibu. Yeah, this might help. He and my mom visit Elite Night Club together and often too. He might be vulnerable to us if he comes there alone this Friday. We'll take a chance on him out there. I'll point him out to you, if he's there, and stay out of it. It's up to you to handle him. You need to screw him up with your bad punches. Panel beat him real good in a way only specialist hospitals could fix me. Then I'll see how the damn wedding would go on. But you've got to be discreet about this."

Scott interjected while Rodney paused to hear it.

"Since you talked about discretion, how would this go? We can't start a fight or beat up someone without finding or faking a believable reason. Otherwise, we'll be risking long jail time."

"I thought about dealing with him outside the club. But it might be interpreted as stalking. So we'll rather do it inside the club. I'll be the catalyst. We'll catch up with him wherever he's sitting in the club and find any little reason to punch him. I'll claim that I asked him politely about the lady he'd been kissing because he's still going out with my mother. He responded that it wasn't my business. He got mad in a split of second and threw some beer at us because I said he was cheating on my mom. He got you involved because he said that he didn't care after he drenched you with beer. That was why you punched the daylight out of him. Does this make some sense?" Rodney asked Scott for his opinion.

Scott bought that idea out rightly. "That claim makes perfect sense if we'll stick to it. But we must know what type of beverage Frank will drinking so we could drench ourselves with the exact type. We could build a solid case against him if we get the logistics right. We'll go after him straight from the bathroom. Nobody should see us when we spill beer on ourselves. That'll definitely get us busted and screw us up."

"There's no doubt about that," Rodney concurred. "On the issue of drink you've just mentioned, I'm aware Frank likes Heineken. He downs lots of it like water. I've seen him many times in the club. There's one exception here: please don't touch his car. Leave it alone so we could erase any semblance of jealousy or bottled up anger if this escalates." He dotting a wry smile on his face and continued, "That car is my mom's. That parasite uses it. Please spare it or else I'll be working against myself." Rodney paused briefly and continued again, "I'm thinking about how we'll get hold of the attorney's seal. I don't want to keep her will beyond tomorrow. It might be traced back to me if she looks for it. I definitely won't like that."

There was silence. Each tried to come up with a solution for Buckman.

Scott broke the silence. "To get this seal is the hardest part. But a couple of ideas came into my head. "How about I waylay the attorney this evening when he's leaving his office. I'll force him back into the building and into his office respectively. That option would work if the building has a secured access. The attorney will definitely give up the official seal if he sees my fingers on the trigger. Alternatively, I could try to break into his office by midnight today to get the seal. It's tough either way. Camera would be everywhere. This isn't easy at all. Anyway, anything for you buddy," he said and tapped Rodney twice on the back. "We see how it goes," he concluded.

"Burgling his office tonight is a better idea. Many of the occupants would've been gone by then. You'll be cloaked in the dark to make security camera pictures blurrier. It's better to avoid any personal contact with the attorney. As long as he's not dead, the attorney is most likely to remember and describe your looks to law enforcement. Then the police will definitely hunt us down and hurt us in every way unimaginable." Rodney paused and said appealingly, "My friend, whatever you

do, please shun violence. Do not pull the trigger on Mr. Buckman. It'll be a big risk to wade into." He stared hard into Scott's eyes for few seconds. These guys had been friends for many years. Rodney knew he had to warn Scott in advance or suck up his havoc.

"No plans for that at this time I promise," Scott responded.

"I'll take your word for it," Rodney agreed. "With that said, what's the damage my friend?"

"Dude, drop only five hundred bucks as a good friend. It's a huge risk to take however you look at it. It could cost my life or long jail time. But I'm not guaranteeing success tonight until I try. Buckman's office environment, with the security men on constant patrol all night, is presumably precarious. But I'm very sure we shall succeed with the gigolo unless he's not at the club," Scott said with assurance.

"Ok, let's get out of here," Rodney said. "Please drop me off at home."

Chapter Four

Before dark that day, Scott drove around Buckman's office building for a surveillance. He discovered that the entrance locks were very firm and secured. The door and window furniture was made with polished solid mahogany wood. A security guard patrolled that premise and two other office buildings in the next compound. The premises were littered with security camera in addition to powerful search light, which lit up the frontage. Scott was unperturbed by the risk he was about to face.

It was 2 am in the morning. Scott had returned and parked his rented car in front of a liquor store, a few blocks from attorney Buckman's office. He waited for the guard in a stationed patrol car to leave. He planned to break into the building through a vulnerable side window facing a poorly lit street. The headlamps of his car were shut off to provide a thick cover of darkness while he waited noiselessly inside.

By 2.20 am, Tom, the guard, moved from his spot to the next premise. "I've got to act now before this son of a bitch returns," Scott thought. He cranked his engine without revving it and rolled the car without light towards the dark street. While there, he cautiously crawled out of his car and made towards the window immediately. He used his right heel to kick in the window thrice. Suddenly, he spotted a tiny

hidden camera above the window. The camera had already captured him because it had a night vision capabilities. To his advantage, Scott wore a dark face mask, which revealed only his eyes, under a baseball cap.

The impact of Scott's kicks activated the alarm in the building. He noticed the security patrol car closing in on the building. The strobe produced brighter light as the car drew nearer. Scott ducked behind a flower tree in the dark and watched the direction of the guard. Obviously, he didn't want to run head-on into danger.

Tom had raced back to the building to find the probable cause for that unusual alarm that time of the night. He'd already sped past the Hyundai, which Scott had hidden in the dark on the street. It struck him that that car wasn't there initially. He reversed his patrol car and halted behind the Hyundai. Tom pulled his pistol from the holster and remained calm in his car for few minutes. The Hyundai was visibly unoccupied. "The driver might be somewhere around, "he thought suspiciously. He disembarked after he'd called 911 for backup. With the gun and a flashlight in his right and left hands respectively, the Tom carefully approached the Hyundai to get some details.

Scott knew he would be in serious trouble if he allowed this guy to get his vehicle information. "Time to act," he told himself. He took a big risk. He rushed out of his hideout and attacked Tom from behind. He gave him an uppercut, which sent him off his balance. Scott suspected Tom might use his gun and rushed him again. Before Tom could regain his balance from the first punch, he'd delivered a second punch. Scott wrestled his pistol off his hand and the notebook on which Tom had copied his vehicle registration number. He restrained himself from firing at Tom with his security rifle because that would draw an attention.

Scott remembered that Rodney had forewarned him against any type of violence. Scott knew that danger had loomed. Therefore, he hurriedly took off in his car along with Tom's work pistol and notebook, before the cops arrived. About a mile away, Scott threw the gun into a pond outside Tom's vicinity. He tore out the page on the notebook where Tom had written his vehicle's details and chewed it up. He burned the entire notebook when he got to his house. Luckily, he wore a pair of gloves, which prevented his fingerprints from littering around.

Tom still lay unconscious when the first two responding cops

discovered him. He managed to narrate what had happened to the cops. The only thing he remembered was that the getaway car was rented because of the license plate and the color of the car.

The cops called an ambulance to take Tom to the hospital. He sustained a broken neck from the punches he'd received from Scott. His upper lip was lacerated. The police took charge of the building security for the rest of the night. Two other cops arrived when the ambulance was getting ready to leave. They stayed behind to keep surveillance over the office buildings. The two cops who'd arrived earlier escorted the ambulance to the hospital.

The remaining police officers patrolled Buckman's office building with flashlights and a dog. They were cautious in case there was another hoodlum still lurking in the dark. They patrolled the buildings from 3 am until the two security guards dispatched to replace Tom arrived.

All the cops, however, returned to the office building by day break to review the security camera for further investigation.

Rodney was disappointed but not very surprised at the outcome. He knew it was a game of chance for Scott to succeed or fail. That was agreed on from the onset. Scott had signed a disclaimer that he wasn't guaranteeing the outcome of the burglary attempt. He was happy that Scott wasn't caught in the process. That would have spelt a double jeopardy for them. Perhaps, if Scott had been questioned, Rodney would've been mentioned or linked into the process. They decided to put the past behind them. They looked forward to concretizing the next plan about screwing Frank up real good.

In the interim, there was a temporary plan to return the original document back to Elsie's safe. That was a risk on Rodney's part. It was better it was there in case his mom needed it than not. He'd not given up on securing the seal to complete his fraud later. It was heartwarming for Rodney when Scott agreed to pull his second idea on attorney Buckman in person. That was something to look forward to with optimism.

The duo returned to Elsie's house again the following day the same way they'd done the previous day. Rodney returned the original will to her safe. He held on to the forged will as Hannah had suggested until an official embossment was affixed. On his way out of her room this

time, Rodney stole eight hundred bucks from his mother's night stand. Out of that, he squared off Scott five hundred bucks. The remaining was reserved for food and drinks at the Elite Club the next day.

Elsie came home around 4 pm that day to a big shock. Her nightstand had been tampered with. Rodney had mistakenly sat on her bed while he ransacked her draw, but forgot to straighten it out. Her petty cash for miscellaneous expenses had gone. That tipped her scale. She knew that her privacy and safety had been violated. Elsie took a quick glance at every part of the house for any signs of a break-in, everything was intact. That was baffling. "How did this happen?" she asked vaguely. "I know I didn't leave my bed this way. How did the money develop wings?" These questions and several unanswered others popped up inside her. She called the police.

The responding police officer, Sergeant Fredrick, wore a pair of gloves while he examined Elsie's house. He walked around her building and checked for possible burglary but there wasn't any. The officer decided to ask her neighbors whether someone saw or knew anything since Elsie's doors weren't tampered with. He saw Ms. Carlyle looking at his direction from across the street. She'd been sitting at her porch since the officer arrived. He walked up to talk to her.

"Hello, I'm Officer Fredrick, a sergeant from HPD. How're you doing mam?"

"Very well thank you. How're you?" Carlyle returned the greeting. She spoke with a sluggish pace due to old age.

"I'm well, thank you. Please did you see anybody entering or hanging around the property across earlier today or even previously?"

Ms. Carlyle hesitated to speak initially. She wanted to speak anonymously if the officer would guarantee that. She was aware how much her neighbors hated her in their business. Elsie wasn't any different. Carlyle avoided Elsie, even more, became she was powerful, wealthy and well connected.

Following Officer Fredrick's assurance, Carlyle recalled seeing someone, exactly the same height and built, as Elsie's first son. "This person went in and out of that house the previous day and today," she

said. She gave a rough time estimate he came and left and the method of transportation used. But she didn't see anything on him both times.

"Please don't quote me," Carlyle said. "I can't say for sure who it was because the face was covered. But my gut feeling told me that was Elsie's first son," she said smartly.

Officer Fredrick returned to Elsie and asked whether any of her children had a spare key to her house and had probably came there in her absence.

Elsie rebuffed any attempt or suggestion to link any of her children to that incident. She was quick to make an alibi for them. She told the Officer that none of her three children had access to her house in her absence. She noted that Rodney only came there on invitation whenever she was home.

"I'll invite your first son for a little chat," Officer Fredrick said.

Elsie wasn't pleased by that. "I can assure you none of my children had a hand in this," she responded. "Anyway, I won't interfere with police investigation. Do what you please to get to the root of this."

"The individual I just spoke to said she saw two men yesterday. One of them dropped off the other at your house and continued on his way. About ten minutes later, the same car picked up the guy he'd dropped from the same spot. They repeated that move today for a lesser time. The eyewitness speculated about your son," Fredrick continued, "I didn't make that up."

Officer Fredrick jotted down some information on his notepad quickly and continued with his inquiry. "Does anyone have access to your house beside your children?"

"My boyfriend, Frank, has keys to my house. But he doesn't come here without my knowledge."

"Have you asked him just to make sure?"

"I already called him. He said he didn't come here," she lied. Elsie hadn't call Frank yet. But she'd planned to do so later, since the officer had raised the question. She realized that she would have to call Frank ahead of the police because it was a criminal offense to lie to a police officer. Deep inside, she knew Frank wouldn't come to her house that time of the day unless she sent him on an errand. Frank had been busy

within the week. He'd been working overtime at the restaurant due to a sudden surge in the number of guests from out of town.

Before he departed, Officer Fredrick informed Elsie that he would include the eyewitness account in his report. He also took Rodney's contact number from her. He advised her to change all the locks immediately and install camera and burglary alarm around and inside her house since she lived alone. Finally, the officer promised to increase patrols on her street. He left her house for the police car. He made some calls from the car before he departed.

Elsie called Frank while the Officer was making calls from her driveway. Her game plan was to preempt the police officer. She briefed Frank about how to respond if Officer Fredrick called. "I told him that I called you about twenty minutes ago in case he asks you," she told Frank.

Elsie called her son Rodney to know whether he came to her house in her absence. He didn't pick up the phone. She left an urgent message for him to call her back once he received her message.

Rodney didn't take Elsie's call on purpose. But he returned her call after he'd listened to her message. With a pretense, Rodney expressed so much surprise about what happened and denied being around her house.

Elsie left the matter to the police. She hoped that the perpetrator would be caught some time. The new plan was to change the locks and install some camera. Now the questions is, "Who would be trusted to handle the job, Rodney or an unknown handyman?" That was a slow but thoughtfully decision she had to make later.

Chapter Five

Elite Club usually filled up and bustled with guests on Fridays. Members, who felt like it, danced to the endless beat of the live band, which entertained at that moment. Rodney and Scott were always part of the moment. But this particular Friday was different. The duo had a premeditated plan to execute against Frank. To make it effective, they wore the clothe they thought was suitable for their plan.

Rodney deliberately wore a black t-shirt. Black was suitable because nobody knew it'd been wet with beer before they confronted Frank. That would be a big blow to Rodney. The shirts were drenched in advance to feign a reason to beat the daredevil out of Frank. It was also important to forestall any accusation brought by the police or a witness that the brawl was premeditated.

Scott had a free flowing light blue shirt on top of a white pair of khaki jeans. The whole idea was because white apparel would reveal beer stains easily. He didn't need a lot of acting to do. All he needed was to show that Frank splashed him in the process.

These two guys strategically positioned themselves to monitor Frank's movement. All they waited for was the right opportunity to descend on him. However, they continued to drink, reordered their drinks and enjoyed the moment while still keeping an eye on him. So

far, the events, which surrounded their plan, seemed to have played out in Rodney's favor.

Elsie had seen her doctor that Friday on appointment. The result of her test while at the hospital revealed an unexpected health issue. Her doctor subsequently kept her under observation most of that day till evening.

Doctor Sukra, had been Elsie's primary doctor for many years. She'd been an internal medicine doctor for a long time. It was Sukra's idea to keep Elsie that day while she consulted with some specialists about recent changes in her health. Dr. Sukra treated Elsie, based on their recommendation, observed her for the day and discharged her in the evening. Based on Elsie's recent health development and history, Dr. Sukra decided to put her on restriction from any alcoholic beverage for four months. She might be cleared on her next checkup if she showed some improvement from the recent discovery. Until then, she wasn't allowed to sniff or taste any drop of liquor or beer. She was also advised to get enough rest and reduce stress, including driving if that was possible.

Later that Friday night, Elsie was seriously tempted to hang out. She'd planned to visit Elite club that weekend to have some good time. But the doctor's order had shattered that plan. Elsie had been a reasonable and disciplined woman with her own flaws as well. She knew that Dr. Sukra wasn't there to monitor or enforce her restriction. It was her choice to live or die if she flouted her doctor's order and continued with excessive drinking. Elsie definitely chose the second option, which was to be alive. Therefore, to hang out that night became one of her remotest and moribund priorities. There was a heightened temptation to drink with subsequent health consequences. Her restriction, however, did not incite or inflame her to jealousy not to trust that Frank could hang out alone. She would like him to be with her for the night. But she shrugged off her selfish urge to keep the young man from getting some beer that Friday night.

It was Frank who took Elsie to the hospital for her appointment. He hung around the hospital all day during her observation before he finally brought her home. Beyond that, Frank took Elsie to her business meetings and to visit her loyal clients during the week. He needed a break to get some beer that night. Elsie didn't object to that at all. What

Frank didn't say was that he was going as far as the club. He knew that would raise Elsie's eyebrows. Recently, she'd been suspicious of a particular girl who'd covertly flirted with Frank at the club. If she knew that, she would've definitely discouraged him from going to the club alone.

Tracy was very good looking and obviously younger than Elsie. She liked Frank without a doubt and had always stared at him whenever they met at the club. Frank had variously caught Tracy's eyes and had consciously taken notice of her. But his hands were tied because Elsie was always with him at the club. Besides, Elsie paid his bills and therefore, deserved some respect from him.

That loophole, which Elsie created that night, exposed Frank to dual vulnerabilities. The mild part was the likelihood to meet Tracy unrestricted. On the flip side, it was advantageous for Rodney who'd prepared to vent his bottled up anger on Frank.

He'd never liked Frank, a guy who was younger than himself, as his mother's soul and bedmate. "Yes, it was my mom's right to choose her friend or partner," Rodney thought, "But Frank was too young and a slight to her," he concluded. Moreover, because Frank was favored over Elsie's children, worsened the situation. Rodney's interpretation was that Frank enjoyed more privilege around his mother than himself. The rumored content of her will recently confirmed his belief. That was exactly why Frank had to bleed for it.

Frank showed up around nine pm that night, about an hour behind Rodney and Scott. Some familiar faces at Elite club knew him through Elsie, who'd been a gold member. Elsie took Frank to the club the first time and also sponsored his membership. That was the first time Frank came to the club in three weeks since the last time he was there with Elsie. Only closer friends of Elsie at the club knew that she had some health issues. Frank was warmly welcome by friends some of who had inquired about Elsie. He acknowledged each one of them before he visited the bar to order a drink. After he'd grabbed his drink, he sat down on a vacant seat away from the bar.

Tracy came towards Frank with her charming smiles a few minutes after he'd sat down. She saw Frank the first time he walked into the club alone that night. Frank beamed a flirtatious smile in response. Tracy sat

beside Frank. She offered a handshake and introduced herself, "Hi, I'm Tracy."

"I'm Frank," he responded with a handshake.

"Nice to meet you alone, although we've been seeing each other from a distant," she said.

"Likewise here," he said. "Please take a refill on me," he offered. "What are you drinking? Don't tell me its water," he joked. They laughed.

"No. It's martini. That's fine. I'll do another one," she accepted. Frank ordered it.

They talked and tried to know each other a bit more.

"What happened, I didn't see your lady today?" Tracy asked sarcastically. "I hope I'm safe?" She chuckled. "I don't want someone to blow off my head," she teased.

"You're fine," Frank said. "She couldn't come today."

"I see. What do you do for a living?" Tracy asked.

"I'm a chef and a waiter at a restaurant downtown. What about you?" Frank asked.

"I work with Bank of America as the assistant manager of a branch," she responded. "Let me see if I have a card." She fished and produced a business card from her tiny purse. "Here's my card," she offered. "You could call me anytime within next week, whenever you have the time."

"I will," he responded. "I hope you visit my restaurant sometime also," he left an open invitation for her.

"Sure, I will. We'll be talking on the phone and possibly work out some arrangement from there," Tracy suggested.

That was the first time they'd sat freely alone and conversed.

Meanwhile, Scott had urged Rodney for them to move into a swift action against Frank. It seemed like a perfect moment for them. But Rodney restrained him to save Tracy the embarrassment. Unlike Scott, Rodney was more rational, disciplined and decent. Rodney weighed

Let Me Die

things first before lounging into them. Scott has a poor judgment of things sometimes.

Back to their conversation, Tracy said, "I'm sure you noticed how much I stared at you those days you were here with your lady. I really like you. I know it feels awkward to say that since I know you have somebody. But I feel she's too old for you. I'm not trying to disparage her. It's just an opinion," Tracy said. "But I know I like you. You're a fine guy."

"The feeling is mutual," Frank responded. "We'll be friends, though secretly for now. Is that alright with you?"

"Not quite," she responded. "Anyway, we give that a try. Perhaps something better comes out of it. I know it's hard to jump out of a relationship swiftly, especially, if it's working out well. I'm being human this time," Tracy said.

"Thanks for understanding. You're aware that Elsie is well known around here. That's why I said secretly. Nothing stays on forever. One day I would like to marry and have a family. It's definitely not by her; you know that right?" Frank posed a rhetorical question to make Tracy feel good.

"I guess so," she responded. She took a sip of her martini. The floor was abuzz with music. Many people were dancing on the floor. "Would you like to dance?" Tracy asked Frank.

"Not yet," he responded. Frank was avoiding the exposure that Tracy was all about then.

"Is that a no?" she asked.

"I won't say that. But I'll pass for now. You know why?" he responded.

Frank wasn't aware that Rodney was around and had been watching. He didn't know Rodney that well and they weren't close. All frank could say about him was that Rodney was Elsie's first child.

Scott was running out of patience. He knew that if he didn't act, he wouldn't spend any of Rodney's five hundred bucks. He downed the beer in his glass and went to dance on the floor. He stayed within Frank's vicinity to keep an eye on him and to wait for Rodney to show up.

Tracy stood up. "Alright, call me whenever. I've got to catch some fun on the dance floor."

"I'll be in touch I promise," Frank said.

"I'll be expecting," she said and left.

The coast was clear the moment Tracy went to the dance floor. Rodney left his table for the bathroom. He dumped his beer on his t-shirt. The empty bottle was hurriedly buried within a pile of trash in the bathroom. He left the bathroom quickly and went after Frank.

Scott knew something was in the offing when Rodney left his table. He wasn't doing any serious dancing anyway. He'd deliberately hovered around unsuspecting Frank, who didn't know him, while he waited for his cohort to emerge.

Frank was shocked to see Rodney, his mistress' son. He thought he got away unseen with his secret admirer, Tracy. "Oh no," he muttered to himself. "What a night." Things would turn ugly because he knew Rodney and his siblings weren't his friends. But he managed to flash a friendly but wry smile at Rodney, unaware the latter was up to no good.

"Dude, so that's how you treat my mom and spend her bucks on other bitches," Rodney said.

Frank was agape and surprised. "Hi Rodney, how're you?" he stood up and offered him a friendly handshake.

Rodney didn't care about any fraternity.

"I'm serious, is this how you treat my mom?" he repeated.

"Alright," Frank muttered. "Can I say something here?"

"Say what?" Rodney yelled. "You think it's funny right?" He asked aggressively.

"What are you talking about? I don't know what you're talking about," said Frank in a calm gentlemanly voice.

It wasn't funny to Frank anymore and never was. He wasn't out for any trouble, especially with his mistress' son.

Rodney was making up accusations to find a ground to attack Frank. But Frank ignored him. Rodney figured that he'd better step up his act before it watered down. The time to pull his last move was now.

Scott drew closer to them and posed as an intervener. When he

Let Me Die

thought no one was looking, Scott quietly tipped Frank's glass of beer while Rodney continued to rain abusive utterances at Frank.

"Oh lord, why did you throw your drink at me?" Rodney yelled and surged forward towards Frank. An altercation, which he'd bred, finally ensued.

"I didn't throw any drink at you," Frank yelled back. "It seems you're up to something this night," Frank remarked.

"You splashed me too," Scott yelled. "I'm just an intervener. There's no remorse or an apology from you, huh?" he said angrily.

Scott swooped on Frank immediately and pummeled his face. The first three hard punches from Scott gave Frank a cut on the nose and lacerated his lower lip. Rodney stood there watching and complaining without restraining Scott.

The dance was disrupted and the music stopped. The focus was now at the scene of that fracas.

Frank was saved by some guests and a few friends of Elsie's who rushed from across the hall and pulled Scott out of him. Frank couldn't fight back because Scott didn't give him any chance. Scott had held him down to the ground and unleashed heavy blows on him. Luckily, Frank didn't sustain life-threatening injuries.

The club manager, Paul Honkers, called the police. An ambulance arrived within a few minutes and took Frank to Dr. Sutra's clinic, which was the nearest around, which was also where he'd just come from with Elsie a few hours ago. He was treated and later released. But Frank wore a bandage across his nose for a period.

Two policemen responded in separate cars. It was strange to the police because the Elite club admitted only mature and professional people. The club had seldom reported any affrays since its eighteen years in business. The management was superb and the organization was orderly and excellent. There was private security arrangement, which was hardly used because of the quality of the members.

"How come this happened this time," the cops wondered.

Everyone was taken aback. Nobody volunteered to talk to the police because nobody knew the genesis of the fight. They wanted to give tickets to only Scott and Frank after they'd heard from both sides. The

59

cops spared Rodney of any ticket because he was not directly involved in the physical scuffle. But the severity of bleeding suffered by Frank made them change their decision.

The club manager made a case to have the damages and losses, which the business had incurred for that fraction of the night, be taken care of by Rodney, Scott and Frank due to disruption. The manager had noted, albeit as a snide remark, that Elite Club was for real adults and not adolescents.

Subsequently, the cops arrested Scott and Rodney. They were transported to the station in separate police cars. The police towed the car the duo rode to the club and Frank's Malibu to the police station.

Rodney was freed by a bail posted on his behalf by Elsie. Scott wasn't as lucky and connected. He'd remained in jail for three days until Hannah gathered some money and bailed him.

That was as far as Rodney recalled during his flashback after he'd spoken to Josh, his brother, on phone. The entire crime and fights happened less than a week before Elsie was rushed to the emergency. They were still very fresh in his mind and still under investigation.

Chapter Six

~🙰

The events that preceded Elsie's hospitalization weren't jokes to her. As she reminisced over them from her couch, Elsie believed that the altercation between Frank and Rodney and the fight, which Scott started, contributed to her heart attack.

Among his siblings, Rodney was the first to see Frank. Frank didn't visit Elsie a lot at the hospital because he didn't have much breeder from the restaurant. That was basically why he didn't cross paths with any of them.

Since Rodney set his eyes on Frank at his mom's house, Elsie knew that both men disliked each other. That'd been very troubling for her because Rodney came to her house mostly on weekends when Frank was likely to be around. Elsie thought that their dislike for one another would definitely escalate into something on towards one day at the rate it went. She decided to address it early to nip an imminent trouble in the bud. Her plan was to invite Rodney, Frank and her attorney, Buckman, over to her house in the evening of the fateful Wednesday she slumped. Unfortunately, she didn't know she that wouldn't see her house until another three days.

Elsie posted that bail for Rodney, after his arrest at the club, because Josh convinced her that the former was protecting her interest. Outside

that, she'd been long fed up with Rodney's irresponsibility. Moreover, she wanted to hear Rodney's side of what led to the fight much as she wanted to hear from Frank... The police gave her a copy of their report, which at the time, stated that it was a mutual combat. But she didn't want to rely solely on police report to form her opinion.

Rodney was the first to talk to his mom after the fight. The reason was to preempt Frank's account and attempt to discredit him. His mom was disgusted by the childish and irresponsible acts he'd displayed. But after he was bailed, Rodney reversed that notion. He painted a picture of Frank as a cheat, liar and aggressive. He created a persona of a son who would do all it took to protect his mother's interest anywhere.

Elsie took his story with a grain of salt first at first. She believed him on one part as her son. On the other part, she didn't because her son had been irresponsible and a liar himself.

Frank hadn't been much of a headache since she met him a year ago. Whereas her children didn't care much about her, Frank had been there for hers. He came across as sincere and a hardworking guy. Elsie hardly believed that he did all those things Rodney had accused him of.

"Thinking about it, people could change overnight, you never know," she thought to herself about Frank. All the same, she was livid that Frank was messing with another woman, who was even younger, behind her. But she didn't want to be ahead of herself until she'd verified Rodney's report. She was hurt the more because Frank was about to step into a bigger responsibility as her husband in a few weeks.

Since two weeks after her discharge from the hospital, Elsie didn't want to see or have a long phone conversation with Frank on purpose. She fronted lack of time as an excuse because she had some catching up to do from where she left of her business. Eventually, she decided to hear what Frank had to say because she wanted to put that matter behind her. "It's not impossible for Rodney to frame this guy up out of jealousy?" she thought. She invited Frank over so they could go out for lunch. That wasn't her real plan. It was her decoy to make Frank come with her Malibu rather than his rickety old Ford Ranger.

Expectedly, Frank jumped at the invitation. He showed up at her

house around 1 p.m. That was his first visit since she came back from the hospital.

Initially, Elsie received him very warmly. She tried to conceal her anger. "Get some drink from the bar and relax."

He poured himself some vodka and sat next to her. "How you've been?" he asked.

"Ok. How're you?"

"I'm good. I've been missing you so much, that's all. It's been a while. Hope you're seeing some improvement?"

"Yeah, I'm getting there. Thanks for asking. Excuse me please," she said.

"Go ahead," he responded.

She picked up the remote control and turned the volume of the television down.

"You've been alright," she asked.

"Yeah," he responded.

Elsie turned towards Frank and asked with a slow and calm voice, "What happened between you and my son, Rodney, at the Elite Club that led to that exchange leading up to a fight with his friend?" As he was about to answer, she jumped in again, "Before you start, how're you feeling? Are you still in pain from the injuries Scott inflicted on you?"

"I'm much better now. The first two days after the attack were like nightmare. But I'm quite better now," thank you. "I'm glad you brought it up. I've been waiting to tell you this. It happened on the Friday I brought you back from the clinic. Unfortunately, a few days before you were admitted. I was relaxing at one corner inside Elite Club having my drink. Unexpectedly, your son was coming towards my table. I was happy to see someone familiar at least. I got up to greet him with a handshake. I didn't know that Rodney had a different agenda. Out of the blues, Rodney started yelling at me. He accused me of cheating on his mom because I came to the club by myself. I couldn't even get in a word despite excusing myself several times. He called me every unimaginable names with the associated curses. I've never been so embarrassed in my life because it all happened before the people we know at the club.

63

Some of them had asked about you when I got there. I remained calm and refused to be provoke all the while. But Rodney wouldn't stop.

When yelling didn't produce any result, one Scott, whom I later found out was Rodney's close pal, tipped my table deliberately and spilled my drink. The two accused me of getting them wet. Scott jumped on me while I was still seated and turned me into his punching bag. He was determined to hurt me. Thank God for the onlookers that pulled him out from me. Someone had called the police who arranged the ambulance that took me to the hospital. That was it."

Elsie starred at Frank for a minute. "Sorry to hear about that."

"Thank you."

"I would like to know why Scott should hit you if you did nothing to them. Be honest," she said.

"That's all that happened I swear to God. I didn't know his reason up till this moment," he answered. "My best guess was that it was a planned attack.

Elsie looked intensely into Frank's eyes with disbelief.

"Did Rodney put his hands on you in this whole crazy fracas?"

"I don't think he did. But I couldn't believe he stood there and watched his friend beat me up and he didn't stop him."

"But my thing is this, why the altercation and fight start in the first place. Something must be wrong that night. I understand you and Rodney don't get along that much. But what started that fight?" she insisted. "It's difficult to believe your story because your presentation was so smooth." She paused. "You're not hiding something from me, are you?" she asked with a fake smile. "I've heard Rodney's side of the story. I also have police report, just to let you know."

"Honey, what can I hide from you at this stage? We'll be getting married in less than two weeks and live our lives together. Honestly, your son started it all. It baffled me that he lied to the police that the fight started because I pushed him." Frank paused and nodded his head. With a sudden meek tone, Frank continued," Elsie, I'm looking into your eyes and telling you that none of their fabrications about me was true. Not even one. These guys just walked up to me and assaulted me. I didn't put up any fight. I couldn't even defend myself because Scott

pinned me down to the chair. I'm pretty sure these lies were premeditated to justify and cover their act. Rodney and I don't get along as you know. That explains it all," Frank submitted.

Every other thing that had happened mattered to her. But Elsie was particularly interested in the girl who'd hung out with him. It was Tracy who'd crept into her mind when Rodney told on Frank. At last, she'd got to her main subject area. "Who was the girl with you?" Her voice was steady, calm but stern.

"There was none. I was alone. One lady happened to sit at the same table with me. That's all. You're aware of the usual casual seating arrangement at Elite Club. Anybody could sit and leave at will. You know this very well, Elsie," Frank said with frustration.

"I'm not buying any of those stories Frank. Something is fishy here. You and I had been going to that club together. This time you snuck in there without me for a date, probably a younger woman…."

"I didn't go with anybody," Frank interrupted. "I told…

Elsie retorted. "Please don't interrupt me. Can I finish?" she cut in. "I introduced to that club and put your name on my membership account. We've always gone there together. Because I was sick, you secretly went with another woman because I gave you a membership card. "Yeah, what can I tell you?" Elsie was really hurt. She was convinced that Rodney had her back in that very situation.

Frank continued with his defense. "Honestly, I didn't go with anybody at all. These guys made up that story to discredit me before you. I'm very positive that Rodney framed me up out of jealousy. Some young men my age can't stand others dating their mother or older sisters. I went without you but not to cheat. I just wanted to unwind myself after a long week.

"You dropped me off from the clinic after we've spent all our day there. I wanted you to be with me, but you wanted a time off, which was understandable. You never mentioned that you planned to go to Elite Club. For crying out loud, nobody would be in your way. But you gave the impression that you were going to TGIF. I hate lies and deception in any form," she said.

"Someone with a clear intention doesn't hide things from the spouse.

You action confirms to me that you've been robbing Peter to pay Paul in this relationship. I take care of you. You get nearly everything you ask from me and then turn back to take care of younger women on my account and cruise them around town in my car. Although we far apart by age, you're still an adult. Where's your conscience? I'm not a fool. I took you into my arm and have planned to bequeath almost half of my entire estate to you over my children. That was how ungrateful you were to me. I'm so disappointed in you. You should be ashamed of yourself."

The doorbell rang when Frank was about to say something. "I'll get it," said Frank.

"That's ok." Elsie got up and went to the door. "Who's that?" She peeped through the hole.

"Mom, it's me," Nancy said.

Elsie opened the door. "Hello my baby," she greeted Nancy with a bright smile. She turned around and went back to her puff chair.

Nancy figured out right away something was amiss. Deep inside, she didn't mind a big feud that would oust that 'good for nothing' gigolo. Like Rodney, Nancy couldn't stand Frank. They've been talking about him. But that was her first time to see him. She welcome anything that would kick his ass as long as it didn't hurt or kill him.

Nancy came to check on her mom as she'd been doing since Elsie was hospitalized and discharged. She sauntered slowly into the living room behind her mom. Since Elsie was discharged, Nancy always came to her house in the evenings, after work, for one week. She'd assisted her with grooming, either prepare her meals at home or brought some food with her from the restaurant.

Elsie specifically asked Nancy for help to cut Frank off. But on her own, Nancy had planned to help her until she got stronger. That strategy would also pave the way for reconciliation. Before she got there, Nancy had decided to invite her mom to the dinner in person, out of respect, than to call her on phone.

Frank rekindled the discussion again after Nancy had settled down. He'd sobered up his tone and pleaded with her. "As I said before, none of those happened. They were all fabricated, if you would believe me. I'll not deliberately indulge in acts that would hurt you or tarnish my

image. You've been nothing but kind and nice to me. I can't screw up our relationship due to worthless people of things. I've been very excited about the impending marriage and have been waiting patiently for that day. You know I love you so much. Believe me, I really do." Frank reached out his arms to hug her, but she rebuffed it and stepped back.

"Wow." Nancy exclaimed. Now he'd confirmed what Josh had told me. Her eyes almost fell out of their sockets. Her mouth became agape in surprise. But she sat still, comported herself and listened attentively. But she pretended not to show any interested in their business.

Elsie lost her cool at this point. "So my son and the police ganged up to lie on you right?" I'll show something now. She grabbed the police report from the table and waved it at Frank. "This is the police report. It collaborated what my son had told me. I don't believe you," she emphasized. Her cell phone rang. 'Please excuse me."

Elsie picked her phone from the center table. "Hello," she responded to the cab driver. "Are you here now?" she asked. Alright. Please pull up in my driveway. Thank you." She hung up and stood up. Elsie moved towards Frank and stretched her right hand towards him. She opened her palm. "Can I have all my keys please?"

Frank was surprised because he didn't see that coming. He'd come for lunch and not to be dumped. He was slightly hesitant.

"Please, I want both my house and car keys?" she demanded with her arm still stretched in front of her.

Frank dug inside his pockets for the keys and handed them over to her.

Nancy watched all that from her position behind her mom. Frank must have noticed that she was rejoicing because he was facing her direction. As an indication that she wasn't a fan of Frank in the least, Nancy made a fist and waved her hand victoriously. She was careful not to be caught by her mother.

"Thank you," Elsie said derogatively. "There's a taxi waiting outside to take you home," she said. Elsie saw Frank to the door. Elsie opened and held the door for him. "Alright, I'll see you around," she said.

"Ok. Bye," he said with a wry smile. Frank descended the steps in front of the porch. He didn't express anger or remorse as he entered

the taxi to leave. He stuck to his defense tenaciously. While inside the taxi, Frank didn't cast a final glance at Elsie to show he would miss her. He looked right in front of him since the driver already knew his destination.

Elsie stood in-between the front door and watched until the Buick disappeared. She shut her door defiantly and joined her daughter in the living room. She was aware that she was going to miss him regardless of her erstwhile bravado. She fought back her emotions before her daughter. Elsie knew Nancy to be as curious and inquisitive. She wasn't ready for any questions and answers that moment. Deep inside, Elsie had already resolved to give Frank another shot at it, that's if Frank would still be interested. No matter what happened, she was determined to teach the young man a lesson or two, which was never to take people for granted and to value whatever privilege and opportunity he has because he might lose them the same way they came out of carelessness.

Chapter Seven

"You worry a lot about nothing," Nancy told Josh on the second-floor hallway leading to attorney Buckman's law office. They'd scheduled to meet with Buckman by 4 p.m. that Friday. "I didn't expect Rodney to join us from the onset because he never did. So I'm not bothered by his absence anymore because I already knew it would happen," she said.

"It's worrisome because he's the oldest among us. I'll be happier to see him turn around from his nonchalant lifestyle to a life of responsibility. Mom cherishes it more when we're united, I know that well," Josh said.

Nancy followed up, "Let's see what happens again this evening. He has another chance to join the dinner. He's aware of this, at least you informed him."

Rodney had already decided not to meet or attend the dinner planned with attorney Buckman and Elsie respectively. He didn't want to be called out on any of his atrocious behaviors. He suspected that his mom thought he intruded her home, but she had no proof. Rodney chose to keep at bay from harsh words, which might be inevitable.

But the knowledge of his family's itinerary became a source of information and an advantage for Rodney. The most important for him was

to know that Buckman was in his office, at least, that evening. Therefore, Scott would have to take care of his unfinished business.

So far, the meeting between Nancy, Josh, and attorney Buckman had been fruitful and almost rounding up. Attorney Buckman played nice host to them. They weren't that close over the years but he still didn't brush them aside. The principled attorney showed some courtesy to them when they got into his office. He left his swivel chair and met them at the door.

"Hello fellows," he extended his hand for a shake, "How're you?" he asked. He shook Nancy first and Josh next.

"I'm fine," Nancy responded.

"I'm alright too. How're you?" Josh asked.

Still standing, Buckman responded, "I can't complain." Using a simultaneous hand gesture, Buckman said, "Come on and have a seat here." He pointed at the corner where he'd kept beverages in his large office, "There's coffee there, water and pop in the fridge. Please help yourselves." He sat down on the swivel chair behind his desk. Nancy sat across from him, while Josh fixed himself some coffee at the corner.

The conversation was semi-formal. Attorney Buckman fielded their questions very carefully in order not to divulge confidential information between him and Elsie. The duo wanted to confirm if their mom had finalized her will and what's there for them. The attorney didn't delve deep into that to protect Elsie's privacy and confidentiality. However, his body language portrayed the content for them.

"I'm not allowed to disclose the exact content of your mother's will. It's confidential," Buckman said. "But I could tell you, as friends now, that it isn't excellently favorable on your side."

Nancy and Josh looked at each other in shock. They weren't too surprised. At least, the attorney had confirmed part of their worries.

Josh broke the silence, "Why was that; I mean why did my mom go that route; do you know?"

"You want my honest truth?" asked Buckman. "She'd not been happy with you guys. You need to step up your game a bit."

"Do you know why she'd been mad at us?" Josh followed up.

"It worries her that you guys don't come around enough or show any concern. That's the much I can tell you," Buckman responded.

Nancy cut in, "Could you help us out please; what shall we do?"

"Good question," he said. "I'll talk to my mom, if I were you, to find out her exact anger or frustration," Buckman advised. "I'll then try and work out things with her. Perhaps, she would calm down and reverse things to your favor," he suggested.

"We'll be having a dinner outing with her tonight. That's part of our plan to discuss with her," Nancy said. "We've been concerned also about the lapsed or you can call it loose relationship between us and her, which you've just confirmed. We're prepared to mend fences and start with a clean slate," Nancy submitted.

Buckman was elated to hear that and he showed it. "Very good. That's the way to go. I'm sure she'll like that. It'll be her first outing since she was discharged, which is coming, especially from her children and no other person," he said sarcastically as if he was given them a message about Frank.

"That reminds me," said Josh. "I'm not sure if it's proper to ask this; is it true that my mom had concluded a wedding arrangement with her boyfriend, Frank?"

Buckman was quick to throw that back at Josh. "I'll leave that to you guys to find out from your mom when you meet later. It might be inappropriate for me to comment on her private life."

"I apologize," josh said.

"Oh no. You don't have to," responded the attorney. It's good to ask questions because you never know. Please ask if there's any other thing you would like to know. I'll answer as best as I could if I know the answer."

Nancy and Josh exchanged an inquiring looks at each other. None appeared to have further question.

"It was a very good meeting. Thanks a lot," Josh said. He shook hands with Buckman.

"My pleasure," said Buckman.

"Thank you so much for the warm welcome, answering our questions and your advice," Nancy said.

"You're welcome folks. That's what I'm here for. I'm so happy you guys realized the importance of seeking a good relationship with your mother, my client. I'm here to help you whenever you need me. Try and reconcile your differences tonight and put that behind. I wish you luck," Buckman said.

"Thank you again. We'll definitely be in touch," Nancy said excitedly.

Everybody stood up and shook hands again. Buckman saw them to the door and they left.

The time was 4.51 pm. It was still a long time before 6 p.m., which they'd scheduled for the dinner. Rather than go home and be late, Nancy and her brother hung out in front of a bar on the busy road. They strategized and organized their questions based on information and the advice from attorney Buckman. Nancy left by 5.20 p.m. to bring Elsie. She lived twenty minutes away, to the restaurant, which they'd chosen from that area.

The Middle Eastern restaurant was only three minutes' drive from where Josh was. Josh sat alone at the pub for the next thirty-five minutes before he left for the restaurant. During his solo wait time, Josh had called Rodney as a final reminder of their last plan for the day. Rodney didn't pick up the call. Josh called Laura, his ex-girlfriend, for a chit chat. He wanted to occupy himself as the time rolled by.

It was Laura that gave Josh the tip off about Elsie's marriage plan. He'd not spoken to her since the last time they got together for coffee. He briefed her about the present development and also asked if there were any recent changes in his mom's plan.

Laura told him that nothing had happened since the last time Elsie filed her papers. As a matter of fact, Elsie was expected at the marriage registry in about one week to be married to Frank. They planned to touch bases again soon. She wished Josh well with reconciling with his mom.

That recent hint from Laura reassured him that his mom was still pursuing the marriage to her gigolo. Something to talk about at dinner. He left the pub for the restaurant.

Let Me Die

If anyone could predict the future, attorney Buckman would've left his office earlier than 6.30 p.m. after he'd met with Josh and Nancy. His staff had closed and left by 5.30 p.m., but he stayed behind to work on a client's case due in court by 9 a.m. next week's Monday. He was the defense counsel in the fraud case. Friday was the only time he had to study the case because he'd planned a short trip out of town with his family over that weekend.

Scott pulled up his rented car at the car park of Buckman's office building. For a moment, he monitored movements around the building and also watched out whether attorney Buckman would emerge from the building. Because camera were everywhere, he swung into action immediately. He'd already taken a big risk to do this. However, the emerging darkness played to his advantage at least to shield him a bit. He'd disguised his regular appearance to avoid leaving any traces behind for the cops. He was attired in business casual with a black blazer top worn over a black shirt and on top of a pair of blue jean pants. That was a deviation from his regular pair of blue jeans and a t-shirt. Scott also buried his head in a bowler hat, wore a pair of glasses and dotted a fake mustache.

It was 6.30 p.m. Most of the offices in the building had closed for the weekend. A few cars were still left at the lot. A hand full of visitors who had late appointments, with the offices that were open, still milled around the building. The guard patrolled the three office buildings and stationed at different spots occasionally.

Scott left his car around 6.35 p.m. for Buckman's office on the second floor of building one. He carried a concealed toy pistol with him. Buckman's office number was 201. He gently knocked on the door to avoid drawing attention from the surrounding offices.

The unsuspecting attorney Buchman was alone in the office. "It might be the security guard," he thought within himself. Unlike him, the attorney didn't peep nor ask to know who it was before he opened the door.

Scott pushed himself inside against attorney Buckman. He quietly shut the door behind them and pulled the fake gun out.

"Who're you?" the frightened attorney queried.

"That's not important now," Scott responded. He advanced towards attorney Buckman with the gun pointed at him. "Where's the company's seal?' he asked gently.

With both of his hands up in the air, "I don't understand what you're talking about," Buckman said nervously.

Scott grabbed Buckman tightly by the collar of his shirt and pointed the toy gun on his forehead. "Sir, I won't hurt you and don't want to if you cooperate with me. Can I have your official seal now?" he demanded. "Where's it?"

Still frightened, attorney Buckman gathered some composure. His hands were still up at gunpoint. "Please don't hurt me. I'll give you what you want," he persuaded Scott calmly. Buckman was too scared to look directly into Scott's face. But he tried to snitch in glances here and there. He needed s significant mark of identity that would help the cops sketch this robber if he came out of that ordeal unscathed or alive.

Still pointing the fake gun at Buckman, Scott loosened the grip on his shirt as Buckman reached for the office safe. He opened the combination lock and handed a small embossment machine in a tiny box to Scott.

Scott inspected it and confirmed that was exactly what he wanted. Without wasting further time, he backed towards the door. While he was doing that, he focused ceaselessly on the helpless attorney. Scott sternly ordered Buckman for the last time, "Hands up. Turn around and move towards the wall." Buckman did. Scott left the office quickly. He rushed down the staircase to his car and sped off. On his way, he pulled off and tossed the fake mustache, the hat, hand gloves and the eye glasses inside the glove compartment. When he drove about a mile, he stopped and pulled off his blazer quickly, dumped it inside the trunk with the fake gun and continued on his way. He pulled out his cell phone and called Rodney as he drove towards 'Guest Home' Motel where he'd reserved accommodation for five days. To stay away from his house was on purpose because the cops would definitely be after him at the least suspicion.

"I'd better make that catch difficult for them," Scott reasoned. "I've

got to chill out here for five days and watch the news until things calmed down."

Attorney Buckman locked his door behind Scott quickly and called 911 immediately. The police were on their way. But the patrol guard from 'Safety First' private security company was already there.

The private security company, "Safety First," had guarded three office complexes, within the same compound, for fifteen years. There hadn't been any issues all those years until the two incidence from Scott. Tom, the night guard, had barely recovered from the neck injuries he'd sustained from Scott a week ago. There came another trouble.

Oblivious of Buckman's ordeal, Elsie, and her children enjoyed a good camaraderie that night. The restaurant provided a relaxing ambiance with nice Middle Eastern musicians performing on the background. They supped and freely shared separate orders of nachos, fajita and quesadilla together. Unlike Elsie, Nancy and Josh had fruit drinks blended with shots of liquor. Due to her health, Elsie stuck to water laced with lime. The family re-established good rapport and agreed to sink all differences. It was a good outing for Nancy and Josh who'd wooed their mom and won her love and confidence back. Much as Elsie addressed all their concerns, she didn't want to entertain questions or discussions about her intended marriage to Frank.

"Mom, I agree he's your choice and had been there for you as you said, but he's too young for you. I can tell he's within our age bracket. Aren't you embarrassed by all that?" Nancy pitched.

"I'm not. Why should I?" Elsie asked.

Nancy followed up. "You need somebody older. Somebody around your age. I don't care if he's a few years younger or older; but let him be close to your age."

Elsie mellowed the conversation with a joke. She said sarcastically, "The younger, the better. I need a fresh blood and not another old folk like me who would be gasping for breath every minute."

They laughed hysterically and attracted a momentary attention to themselves from other guests.

Josh reinforced Nancy's position. "She's not alone in this mom.

That guy isn't the best fit for you. Please listen to Nancy and shove that decision."

"You're all in my business. For crying out loud, how did you guys know about the marriage in the first place? You must have been stalking me," Elsie joked and chuckled. "Seriously, that young man had been everything to me, from company to errand to what have you. Over time, I'd began to like him until it came to that decision."

Nancy cut in. "Mom, I thought you'd let Frank go. It's done and over with. It'll be a matter of time, but you'll get over it."

Elsie interjected. "There was a reason for that. I'm not going into details now. Things happen for reasons." She veered off the subject out of frustration. "Frank got into it with Rodney." She stopped abruptly. "That reminds me, where's Rodney; why isn't he here; you guys didn't invite him for dinner?" She waited for an answer. Elsie switched her glances back and forth Josh and Nancy.

"I left him a message an hour ago to remind him about the dinner. Then, Nancy was on her way to get you. As I speak to you, he'd not returned that call. That's typical Rodney for you," Josh said.

A call came in for Elsie from Buckman. "Please hold on," she said. She looked at her cell phone. It was Buckman. "Hello my best attorney," Elsie answered with a smile.

"Hello Ms. Snooker, how're you?" Buckman asked. Occasionally, Buckman addressed Elsie by her last name, Snooker.

"I'm better today. I'm dining with my children at the Middle Eastern restaurant around the corner from your office." She became curious all of a sudden. "You don't sound good to me attorney. What's the matter?" Elsie inquired.

Buckman narrated the brief torture he'd just suffered from Scott. He was careful not to reveal that he'd just met with her children prior.

The police entered Buckman's office.

"Can I call you back?" Buckman requested. "The police had just entered my office."

"Sure, call me later. I'm so sorry to hear that, Mr. Buckman. Go ahead with the police. We'll talk later." She hung up. Elsie shook her

head and sighed. "Poor thing," she said in empathy for Buckman who'd represented her for many years. They'd been like one family.

"What happened to him?" Josh asked curiously.

"He just got robbed at gunpoint in his office."

"Wow," Screamed Josh and Nancy at the same time.

"That's not good," Nancy said.

"That's so sad, "Josh followed up.

Also, both of them didn't disclose they'd met with Buckman earlier.

The night was far spent. The restaurant was busy with an endless stream of guests. It was a place to be on a Friday night. But Elsie forced herself to wrap it up. She'd enjoyed the food immensely and the rare company of her children. That outing became the genesis of a new beginning in their relationship and consideration to introduce her children into her business. She kept that plan and decision to herself. She planned to disclose it by Monday when they meet again at her office.

The trio walked out together. Josh gave Elsie a kiss on her cheek before she got into the car. He tailed Nancy's car out of the parking lot and they parted ways. Nancy took her mother home in her SUV.

In the meantime, Rodney had visited and retrieved the machine from Scott at Guest Home Motel. He'd already affixed attorney Buckman's official seal on the new copy of the will, which he'd amended.

While Elsie was at the restaurant with his siblings, Rodney invaded her house for the third time and replaced the original will prepared by Buckman with the new one he'd produced. That was a replica of the old. He'd expunged Frank from the will entirely and planted himself where the latter was before. Rodney gave thirty percent of Elsie's estate to his brother and sister. The remaining went to the charity foundation as it was originally.

Procrastination on Elsie's part gave Rodney that easy pass. She didn't replace the old locks as Officer Fredrick had adviced. Rodney had gained easy entry because the duplicated copies of the keys he had still fitted her locks.

Chapter Eight

The police couldn't get Scott's fingerprints again from Buckman's office just like they couldn't the other night he attacked the guard. Scott had been careful not to leave any trail. He had hand gloves on all the time he'd attacked. The cops reviewed and compared the security camera during both incidence for any connection. They were able to connect the two incidence because they pointed at the same individual in their opinion as experts. But the police was frustrated by not having a good lead so far. They were confined to the blurred image of Scott from the other night, the heavily disguised picture of him from the last robbery and the description they'd obtained from Buckman and his statement.

Before the police left that office building, Sergeant Sandra said to him, "Mr. Buckman, we'll be following up on this case. We'll be in touch whenever we need your help. This case will be transferred to the detectives for further investigation. That department will contact you."

"Do you know the detective who'll be handling the case?" Buckman asked.

"I have no idea at this moment, sir. But the detective in charge will certainly contact you as soon as he's ready to work on this case," Sergeant Sandra answered.

Buckman left his office with the two police officers at the same time.

Next Monday

Elsie met in her office with her children by 5 p.m. It was scheduled for after business hours to enable the participants, including attorney Buckman, who had a case in court that day, to attend. Kester and Janet, the office manager and nurse supervisor for Goodwill Home Healthcare respectively, were part of the meeting. Josh and Nancy were there on time. It wasn't certain whether Rodney would make it or not. But they gave him the benefit of the doubt as usual.

In his usual style, Josh had talked to Rodney the next day after the dinner. He'd hinted him why it was very important that he showed up on Monday. They'd made a giant stride to understand each other and were about to move forward to consolidate their bond.

Surprisingly, Rodney showed up at the meeting. His decision to attend was in part because Josh had spoken to him prior to the meeting. Coincidentally, Terry, his dad, also spoke to him right behind after Josh. As if it was prearranged, Terry reinforced Josh's persuasion of Rodney not to slack again. His dad tried to sway his negative and pre-emptive conclusion that the purpose of the meeting was to witch hunt him. He'd always used that decoy as an excuse to keep away.

Terry had stopped by Rodney's house that Saturday night to check on him. A call came in from Josh to Rodney after Terry had just entered his house. Terry eavesdropped their conversation. He was able to figure what the discussion was about from Rodney's responses. He seized on that opportunity to reinforce Josh's message. He encouraged his child to join his siblings and never hold anything back from them because the future was oblivious. His advice drew from his past experiences after repeated incarceration due to drug and alcohol. "I used to be a young man like you. Several opportunities to go to school and learn some life enhancing skills or trade stared me in the face. You know what, I shunned those and chose the wrong path due to bad company. Like me, my friends at that time, either didn't know any better, or deliberately shrugged off responsible paths to success to do drugs for fast money. We followed up with alcohol and women the moment we earned some change. Now that I could think straight, our income then was a change compared to the present.

None of us advised each other or called our bluffs because we didn't know any better or were carried away by what we considered enjoyment then." He lit a cigarette and continued.

"My son, it's always easier to over indulge and dwell on the wrong side of life, which leads to temporary cash or success, if you choose to call it that. But if you stay positive, endure and remain dogged in pursuit of education and hard work, it pays off abundantly in future. This latter path guarantees a better future and unending comfort. That's the way to go. Make the sacrifice now that you're young and have enough time. All it takes is to endure a temporary hardship and to concentrate, and the sky is your limit."

"I don't want you to go down the wrong path like me. Of course, I regret to have indulged overly on drug, alcohol and lived a bad life on the street. Those were the reasons that I've landed in poverty today, hopelessness and worst still, divorced by your mother, my lovely ex-wife. As I said earlier, this life is oblivious. Who would've known then that the same Elsie would be this bastardly rich, successful and influential woman around the community today?" He flipped off the ash that had built up on the cigarette. He took his first draw since he lit up.

"Dad," Rodney jumped in, "I have some beer in the fridge if you care for it," he offered.

"Yeah. I can take a beer. It's Saturday night, isn't?" He asked jokingly.

Rodney got him a Budweiser from the fridge. Terry twisted it open and quaffed down some mouthfuls.

"This beer is dead cold," he remarked. He released a long burp and continued with his admonition. "Son, the bottom-line is that you've got to be around your brother and sister. Join them and be around your mother. You still have the opportunity to improve your life. You could enroll and take some classes in school. Luckily, there's no age barrier to seek knowledge."

"I should've followed Elsie's advice back in the day. We met while in high school. I lost interest in school after graduation but she continued to take classes gradually in a community college. Her plan was to transfer her credits to the university. She did eventually and went on to study social work." Terry paused again for to smoke and drink. His cigarette

had burned to the stub. He took a long draw from the stub and got nothing out of it. The cigarette had actually extinguished by itself. He tossed the stub on the ash tray and sipped his beer again.

Rodney interrupted with a question. "So what were you doing all the while mom was going to school; Where were you?"

"Where was I?" Terry repeated. "That's a good question. I was lured into the street. I sold drugs and abused alcohol. I thought I could make it big within a short time because I minimized going to school as a waste of time. But all that glitters are not gold. Streetlife comes with some hurdles as well. About seven months into petty drug dealing, the cops caught up with me one night and whisked me off to jail. I was charged and arraigned before a judge.

Luckily, the judge was lenient. He gave me a year and half in prison as a warning. He said that he didn't want to waste my life serving long jail time because he had children my age. The judge advised me to get into the college after I've done my time, but I didn't.

The irony was that your mom listened to her parents' advice and continued with her studies without stopping. As the only child, her parents worked their butt off and gave her the necessary tools to succeed. She was really focused and she succeeded. But here's the surprising part. Elsie still kept up with me when I was in jail and notwithstanding that we led two incongruent lifestyles that time. I didn't think her parents liked me as her choice for husband. But to my surprise, she accepted when I proposed to marry her. Again, I wasn't anywhere close to success when she graduated with her bachelors in social works. Remember, I'd thought that I would make it big before she was done wasting her time in school. It wasn't so. A short time after graduation, Elsie got a job at Hollywood Hospital. Soon after, you were conceived," he lit another cigarette.

"As time went on, her parents became older and sickly when you were born. Actually, Elsie and I moved into a house nearby to keep an eye on them. They went into a nursing home because my wife's workload increased and left her no time to take care of them as she wanted. We used to visit her parents together at the nursing home." He smoked his cigarette and continued, "Anyway, I'll let her tell you more about her parents and the nursing home saga. I'll never forget how much Elsie

nudged me to go to college and leave the street alone. I didn't listen. I give her that credit till tomorrow. Contrary to her advice and warning, I continued with my old ways.

At some point, she put me in a drug and alcohol rehabilitation program. I became a little sober, not for too long though. After a little time, I relapsed. I didn't follow up with the rehabilitation program and they put me away. I stole from Elsie to sponsor and sustain my drug habit. The poor girl couldn't take it anymore. She filed for a divorce." Terry drank his beer and shook his head with regret.

"I still have another beer," Rodney said.

"I can still use that," he concurred. Rodney got it from the fridge and kept it on Terry's table.

"Thank you, he said.

Terry continued with his topic. "If I must confess, I should blame myself for your poor upbringing. We shared a joint custody of you when you were younger. Sometimes, I didn't release you to her. I didn't scold or correct you as I should during your early teenage years. I let you remain with me in the poor neighborhood. That probably influenced the choices you made today. Your mom didn't want you there, yet I wouldn't let her take you. Don't you recollect some of those days?"

"I do," Rodney responded.

He said soberly and penitently, "Son, I owe you an apology for my stubbornness to give your mom a free hand to instill positive discipline she'd wanted in you. You could've turned out differently today. That's why I talk to you always to change your ways for the better. Always think big, have a larger mindset, look beyond your immediate surroundings and aim higher. Set a goal for yourself and put plans in place to achieve that goal. You still have many years ahead of you comparatively, though you aren't a kid anymore." Terry twisted the second beer and took a sip from it.

"Outside Elsie, nobody have ever spoken to or advised me like I'm speaking to you now. I came from a broken home. My parents lived together for few years but weren't married to each other. If not for my mom, my dad didn't care that much and therefore, he didn't provide adequate resources for my upkeep. He went from one woman

to another and dropped babies here and there. He didn't even know some of those children. There wasn't a father figure around me. It still wouldn't have a positive impact if there was. From what I know now, his level of ignorance was high and he wallowed in a wanton arrogance of merely being the man." He drew in some smoke from his cigarette and puffed out.

"On the other hand, my mother wasn't literate either. But suffice to say she pushed, pressured and advised me to go to school to any length because she realized the importance. It was a wrong decision on my part not to pursue education. I still regret it until this moment. She deserved her due and I'll never forget her as long as I live. That would tell you the important roles women play in their families. It may not pertain to all of them. I'm referring to women with integrity, compassion and concern about their children's welfare. You must listen to your mother because she wouldn't deceive you. Respect and work with your wife, also, if you ever get married. I pray you do because it's beautiful to be paired up. If I'd listened and possibly remained married myself, life would've been far better than it is now." He drank his beer again.

"This is my final thought. Consider yourself the luckiest person on earth because your half brother and sister care about you. You don't know how happy I feel that Josh calls you. Son, it's not always like that in most families so don't take it for granted. Some siblings might use blackmail to oust you from sharing an affluent mother at the slightest opportunity." Terry reached his conclusion. "Anyway, please don't fail to attend that meeting on Monday. It's very important. You never know, it might be a life changer for you."

Rodney had listened attentively all the while. He broke his silence finally. "I'll not forget. I'll definitely attend this time, I promise." he responded. Rodney appeared serious this time. He seldom talked that much. That made it more complicating for his siblings to decode his position most times. But he was a good listener who bottled up things in his mind.

Buckman later got in touch with Elsie by phone when he got home that Friday. Buckman went beyond just her attorney to become her most trusted confidant and advisor in business and family matters.

Expectedly, the robbery incident and the dinner respectively came up in the discussion.

Elsie was very excited to reunite with her estranged children the first time in six years. She unloaded her new plan for them to Buckman during their conversation. She was cognizant that Buckman was usually busy but persuaded him to squeeze out a little time to attend the meeting. His contribution was invaluable as well as inevitable towards the anticipated changes she needed to make in her will.

The outcome of the meeting was positive. The future leadership and administration of Goodwill Home Healthcare, a privately owned company with over forty-eight clients, was reviewed to include Elsie's three children. Her purpose was to position her children as the future leaders. That was the most important achievement arising from the reconciliatory dinner. Luckily, Janet and Kester agreed to mentor Nancy and Josh as interns and apprentice respectively. In order to align, Nancy went to nursing school and while Josh pursued health administration.

Sequel to that development, an additional office space was created for the duo. In these dual paid long-term positions, Nancy attached to Janet, now certified as a nurse practitioner, and Josh worked with Kester. When not in school, Nancy and Josh shadowed their mentors at the office. They had an uphill schedule that required them to follow up with school assignments and also shadow their mentors. Some field works was inevitable for Nancy as long as Janet was involved.

Janet used to visit clients' homes for various reasons. Outreach visits served as customer service to clients and were used to address their concerns. Unscheduled site visits or rounding on nurses and caregivers were used as checks for duty performance and professionalism. Janet lent some help to the site nurse for hardcore nursing treatment when required. Sometimes, she teamed up with Ivory, the social worker, to market the services of Goodwill Home Healthcare to hospitals and potential clients. Janet also assessed clients in order to follow up with their physicians' recommendation on plan of care at home.

All these played to Nancy's advantage and knowledge base. She had a handful and wide range of experience to tap into.

Kester taught Josh the unique role of management in the company.

Mostly confined in the office, Kester coordinated, directed and made business decisions, including hiring and firing, but not without consulting with Elsie, the chief executive officer. That was Goodwill Home Healthcare business model. Josh learned delegate and decentralization of authority. He worked closely with the administrative secretary who was the first port of call and also embodied management secrets on her fingertips. Josh learned more about other units during rotation. He was particularly interested in enrollment and registration, which were the source of clients' demography, insurance, even Center for Medicare and Medicaid – CMS- and patients' medical history. That was important because it fed directly into patients' database from where data was abstracted for census.

Despite his herculean schedule and against his mother's advice, Josh still kept his position as a supervisor in the grocery store. He eventually thinned it down to part time for weekends only.

In contrast, Nancy quit her old job because her present status robbed her a breathing space. No matter how long that lingered, the two knew it was temporary and optimistic when they were done with school.

The reward for Janet and Kester for loyalty was automatic pay raise. They were also included among the trustees of Goodwill Home Healthcare.

Rodney wasn't left in the cold. As a handyman, he was paired up with Bryan, the guy who'd been in charge of repairs and installation. Rodney was incompetent in more technical area of computer hardware and software. But Bryan groomed him on general repair and installation of medical and office equipment.

Elsie was disturbed that Rodney was deficient with basic skills to install and set up computer system and lack of knowledge of information technology. Essentially, Rodney wasn't suited to lead the maintenance department. She thought that something needed to be done to bring him up to speed in that area.

Subsequently, her will would be modified to reflect the changes made in Goodwill Home Healthcare future leadership and organizational structure.

"Here's the will," Elsie said. She gave attorney Buckman what she

thought was the original copy of the will he'd previously prepared for her.

Buckman looked it over with suspicion. But he reserved further comment until he reviewed it in his office.

Rodney's eyes nearly fell out of the socket as he watched the unfolding details. The document to be revised was the new will he'd just tampered with. That took him outside his comfort zone. He knew Buckman would uncover his deed and wondered what would happen after. He shut his eyes momentarily while his mind wondered. "The cops would definitely connect the dots and hunt for Scott and me."

Buckman was quick to notice Rodney's disposition. Ironically he asked with a smile, "Youngman, are you still with us?" It'll be a matter of time for him to find out that he spoke to the mastermind and culprit behind the series of attack at his office.

"Yes. I'm a little tired and sleepy because I stayed up late last night," Rodney lied.

The meeting had almost come to an end. Buckman's cell phone went off.

"Excuse me," he said. "Hello, this is attorney Buckman," he answered.

"Hello Mr. Buckman," responded the caller. "This is detective Valerie. How're you today?"

"Hi, I'm fine," answered Buckman with a little seriousness in his face. He looked vaguely at the entrance door due to his concentration.

"I'm wondering whether you're available to speak. I'll come to your office. I need to talk to you about the robbery incident last Friday," Valerie said.

Buckman got up and stepped aside to the corner. "I'm not in my office at the moment," he responded.

Valerie followed up. "When would you be available today?"

"In the next hour for sure," he responded curtly.

"Can we meet in the next hour then?" Valerie asked.

"That'll work," Buckman confirmed.

"Alright, I'll see you then, Mr. Buckman."

"Perfect," responded Buckman.

"Take care." She hung up.

Buckman rejoined the meeting. In his lowest of tone, he whispered into, "That was a detective from Hollywood Police Department. We'll be meeting in my office in the next hour."

She was surprised at the speed of the investigation. Elsie responded, "That's fast? I'm impressed with HPD. That was a quick response."

"Do we still have much to discuss?" Buckman asked.

"Not a whole lot. I believe we've touched on the important issues," she responded.

The meeting halted briefly as Elsie flipped the pages of her notebook to double check the agenda. From his look, Rodney was increasingly disturbed. He overheard the whisper and realized that it won't be long for things when things would begin to unfold. It wasn't in doubt that he'd been the family's black sheep and the enemy within.

Elsie broke the brief tranquility. She addressed her attorney, "I know you've got to go. Grab a quick bite before you leave." She pointed Buckman to a buffet table with assorted types of lunch meat and vegetables. "Fix yourself some sandwiches and salad. Join the buffet, everybody," she said. She led the way to the buffet with Buckman.

Everybody fixed sandwiches in disposable paper plates, according to their choice of ingredients, with Greek salad on the side.

Buckman enjoyed the black forest ham. Elsie was a big fan of honey roasted lunch meat. While they ate, the two of them went aside for a brief tete-a-tete. They liked the outcome of the meeting. It was more of a reunion for the family and reorganization by Elsie. At that moment, she'd been reassured that there were heir apparent, trustees and estate administrators, if something happened to her.

Buckman was a little younger than Elsie. Their age difference was infinitesimal. By any chance, they would age at equal rate and retire probably within the same age bracket. There were chances that he could administer Elsie's estate if he was still strong and lived longer. Otherwise, he'd set up his law firm for two of his children who were now in law school and some younger lawyers who worked in his office to manage in the future. They would most likely implement Elsie's directives in future if they didn't live that long. He swallowed the last bite of his

sandwich and sipped his sprite, another of his favorites. Buckman wiped his mouth and hands with a paper towel.

"I have to excuse myself now," he said to Elsie. He gathered his folders and file from the table and hurried towards the door. "Have a goodnight everybody," he waved.

The attendees chorused, "Goodnight" in unison, some with a mouthful of sandwiches and salad.

Elsie showered Janet and Kester with thanks and praises. They'd overstayed their official time to be part of that meeting. Five minutes later, both of them left the family for their respective offices and went home from there.

Chapter Nine

The formal part of the meeting was over. The family settled in for informal discussions. Elsie wasn't quite done with the reunion. She deliberately didn't want to put private family affairs out in the open. Her intended marriage, preparation for her last days, and other personal businesses of her children were for their ears only. She treated each of the afore-mentioned topics one after the other.

She began with an interesting area to them. "Guys, I've shoved the marriage to Frank aside. I thought about your point of view deeply, your emotion and decided to take your sides. My initial motivation was to have a company when we weren't together. Thank God, it's resolved now." She smiled.

Nancy cut in. "Mom, we had our plans for that marriage as well. A real bad plan you don't want to know," she said. Everybody burst out in laughter.

Elsie's eyes opened wider. "Just curious, what was that bad plan?"

"Mom do you really want to know?" Nancy asked.

"You don't want to know that mom," Josh added.

"Why not? It's all over now. For the heck of it, please tell me," Elsie insisted.

"Just briefly," Nancy started. "We planned to print protest placards and flyers to carry into the court. Also, we arranged to plant someone who would rise and drag the bridegroom position with your Frank. The registrar would be confused in the process. Our part was to rise and protest anytime the registrar asked whether anyone objected to that marriage. With all those fracas, the registrar, more than likely, would suspend the marriage until the family reconciled."

Their mother flipped her fingers in dismay. "Really. You guys gave this a serious thought. By the way, how did you find out about the marriage? Someone must have been stalking me huh."

Everybody laughed hilariously. Elsie had a pretty sense of humor.

"This marriage must have caused hypertension and serious insomnia to you guys," she added. "Rodney, you've been too quiet all these while," Elsie picked on him. "What was your role in all these? You and I were in touch and saw each other more often, he never mentioned any of these to me. You're dangerous," she teased.

If she understood that Rodney was just physically present and worried by the unknown, Elsie would have left him alone. The man wasn't the same again since Buckman took the fake will away. The outcome the alteration of the will and the robbery was something no one else, but Rodney, could predict. All the same, he got himself together and pretended along with a fake smile. "I'll leave that for Josh to answer," he said jokingly.

As if all hell had broken loose, Josh picked up from there with an inadvertent exclamation. "Oh, Rodney was much bigger on the whole plan than anyone of us. Mom, Rodney hatched a plan to kidnap Frank on his way to the wedding. That would've happened an hour before the time. You wouldn't even have seen the guy in the registry to begin with. An impostor, as Nancy already mentioned, was designated to take his place. That was the whole arrangement to flop your wedding. Assuming that'd happened, we figured there was no way you would've accepted the imposter. If the plan went well, please tell me how the registrar would go on with that wedding? Never," Josh concluded.

Everybody fell into an uncontrollable laughter when Elsie retorted, "Really." Back to Rodney again she continued, "Rodney, you didn't show

throughout we saw that you guys knew anything about the marriage let alone your intended machinations. Son, you're really dangerous as I said earlier. I'm just joking," she covered up quickly.

"That's behind us now. Thank goodness," Nancy said in a lighter mood. "We're moving forward now," she added. Nancy was very elated. She reached out and hugged her mom very passionately for a few seconds.

"It's all well and good," Elsie continued. "I have an important request to make from you guys. Before that, I'll start with a story about the last days of my parents, my life, and motivation." She took a sip of water from the bottle.

"As my parents' only child, I grew up with much love, care and affection from them. They encouraged me to aspire and strive to reach any height possible. Mom and dad worked hard to make sure I had the best they could afford. The advice they gave me then have guided me to this day. They'd told me never to forget who I was, where I came from, where I was heading and never turn my back on my benefactors.

Their support notwithstanding, I still worked very hard to put myself through college and became a social worker. I didn't receive any handout when it came to a personal effort to succeed. That part boiled down to personal responsibility. I realized very early in life that the onus of success lied entirely with the individual. Luckily for me, Hollywood Hospital employed me as a case manager after I graduated. My parents never asked me for anything except when I gave them or asked them if they wanted anything. Rather, they nurtured me towards entrepreneurship and self-dependence, which regrettably eluded them during their life time. But I didn't turn my back on them one bit after they retired."

Continuing, Elsie looked at Rodney and said, "I lived with my parents until I dated and married your dad on my twenty-eighth birthday. That was the first and only time my parents and I ever lived apart from each other. But it wasn't more than a mile apart. Terry and I agreed to be close to keep an eye on my parents. I shopped for them on weekends. Sometimes, I took my mom for shopping and sight-seeing. I cooked meals during the weekends to last my parents for a whole week. Their laundry and house cleaning were also done during the weekend.

As they got older and weaker, I made it a point to stop by their house every day, on my way from work, to check on them before I got home. That was my routine until their last days on earth," she said emotionally. Tears welled up in her eyes. Nancy wrapped her left arm around Elsie's shoulders and massaged them to console her.

Elsie gathered herself again and continued. "My job schedule became very tasking and absorbing at some point. It became more difficult for me to see my parents as early as I used to before. Sometimes, when I got there after work, they were already tired and in bed. There wasn't an opportunity to chat with them. All the same, they understood my predicament because they've been there before, as my dad used to tell me. The chores I used to do over the weekend were affected because I barely had time to rest

My mom suggested that I put them in a nursing home to make it easier for me. Although my dad didn't like that idea, but he joined her anyway. Dad so loved my mom that I can't remember any time he'd refused her request.

The decision to put my parents in the nursing home wasn't easy. I was reluctant initially due to the negative stories I've heard about some of those institutions, not all of them mind you. At first, I'd thought my parents were lucky to have caring nurses and aides at the facility I took them to. I was wrong. The learned differently when my dad suddenly demised two years after due to diabetes. That hurt me a lot in any way imaginable. My compassion heightened for my mom because they were so close and inseparable. Dad's death affected her significantly. She became a lonely widow at sixty-nine. While they were there, the nursing home provided them a single room to share as a couple. Imagine how my mom felt all the while she slept in that bed alone after dad expired."

She drank a little bit of water again. Overwhelmed by emotion, Elsie grabbed a couple of Kleenex from her table and dabbed off tears from the corners of her eyes. Her children empathized with her even as they listened to her stories with rapt attention. She was yet to get over her grieve after many years she'd lost them.

Rodney was the only grandchild born when their grandparents were alive. But he was still a toddler when they died. He voluntarily uttered a word for the first time. "What were your parents' names?"

Let Me Die

"My dad was Joseph Pelton. Mom was Eunice Pelton. They were married for forty-seven years," Elsie replied. "Guys I know you're getting tired. I'm getting to the major reason for this whole story. It won't be long, I promise."

Josh interjected. "We're with you. Go right ahead."

"Anyway," she continued, "I started to spend more time with mom at the nursing home after my dad died. She needed someone around until she got over her loss. I stopped by every day to see her."

She gestured at Rodney as she said, "I must give it to Terry, your dad. "He went with me most of the times. He also supported me a lot when I was grieving. I'm eternally grateful to him, although we aren't together anymore."

Josh interrupted. "I don't mean to take you back. In which hospital did grandpa pass? I'm just being curious."

"Oh," Elsie exclaimed. She obviously didn't expect that question. "In the same Hollywood Hospital that I use till this day. I was born there also. For some reasons, my parents loved that hospital. It might be why I do too." She glanced at her wrist watch. It was 6.45 p.m.

"Whoa." Time is flying," Elsie said casually. "Here's the saddest part of the story. Two years after dad expired, mom was diagnosed with Alzheimer's disease. The burden of care increased. I was totally lost on what to do. I wanted to keep closer eyes on her but my hands were tied because I couldn't be at the nursing home and my job at the same time. I thought about withdrawing her from the nursing home for a private home care arrangement. Mom needed a compassionate caregiver while I was gone. That arrangement was concluded. There was the need for me to move into a bigger place in order to accommodate her comfortably. I bought a bigger family house with four bedrooms and three bathrooms."

Nancy had to jump in here otherwise she would forget her question. "I'm just curious mom," she said. "What was Terry doing all that while; was he working?"

"Hmm," Elsie took a deep breath here before she answered. "That's a long story. I won't go into the details now. I'll leave that alone," she responded. "But to answer your question directly; no, he wasn't working."

Elsie snuck a quick glance at Rodney. As far as that went, he was unperturbed because he already knew about his father's history and had experienced part of his lifestyle firsthand.

"Every arrangement was in place, including a contractual agreement with a homecare agency for long-term care," Elsie continued. "Before we processed documents to withdraw my mom from the nursing home, I thought I'd discuss with Ms. Rose, the Director of Nursing or DON as they called them. I was being courteous to her considering how long my parents were there. I realized that a unilateral decision could backfire sometimes. Since Ms. Rose was an expert in that area, I needed to tap into her experience and advice. By the way, the nursing home was called Holy Rosary Nursing Home," she chipped in suddenly.

"As expected, Ms. Rose didn't want to see my mom leave. Mom was one among a few of her residents that had been in that facility the longest. She thought my mom was doing ok with them. She compared economic and safety issues between nursing home and homecare agency. Rose argued in favor of the nursing home as more affordable in terms of financial spread, facilities such as physical and occupational therapies, recreational activities and peer groups. On the safety side, Rose thought that the presence of nurses twenty-four hours round the clock was a huge plus. According to Rose, nurses were more likely to respond quicker to and provide residents with expedited access to the hospital if they became sick or during an emergency. That would likely be different with a caregiver who provided only menial help and companionship but wasn't a trained medical personnel. She got me when she offered to have mom regularly assigned to a supposedly veteran certified nursing assistant who would provide one-on-one care.

"That was where Ms. Katrina Wright, a CNA, as they were popularly called, came into the picture," Elsie said. She stopped her narration to fight back tears dripping from her eyes. She struggled to contain her emotion at that point. "I can't help crying whenever I remember this incident," she said in between sobs.

Nancy grabbed her right arm and locked their fingers together. She gently shook Elsie's hand until her mom got over that situation.

"I'm so sorry everybody," Elsie apologized with a voice laden with emotion. "I didn't mean to be a cry baby often. Every time I remember

how awful Katrina treated my mother, I'm saddened by that. I fell like choking her." She raised her eyeglasses and dabbed tears from the corners of her eyes and replaced it. "I'd always blamed myself for allowing that happen because I totally believed Ms. Rose. I shoved my plan after she sold me that one-on-one idea with that sheep in wolves clothing.

Katrina Wright was said to be very caring, professional, experienced, respectful and energetic. She'd been working at that place for thirty years since she was twenty-two years old. She was fifty-two then, not too far apart from my age. I thought mom was lucky that somebody with the maturity, experience and understanding of how the world operated, would take care of her. Katrina always appeared cheerful with a flash of smiles whenever we visited my mother. We developed some trust in her in the process. Katrina became my reliable source of information. We exchanged our numbers. Sometime she told me mom was alright that I shouldn't bother to come down unless I wanted to. She knew my work could be excruciating some days. I was totally convinced that mother was in good hands. I gradually cut down on my weekly visit from seven to four days. But I was there unfailingly the days Katrina was off.

Here's the straw that broke the camel's back. My instinct told me to make an unscheduled visit to Holy Rosary nursing home on a day Katrina didn't expect me. It was around 4 o'clock in the evening during dinner time. My understanding was that all the residents, with few exceptions, were escorted or taken to the café to eat. Some of them could ambulate while others like my mom were pushed in the wheelchair to the café. The residents had free seating at available tables with others. Eating at the café provided an interactive and socialization opportunity among their peers, especially for those of them that were still alert and oriented.

The CNAs fed those who couldn't feed themselves. They ensured that residents assigned to them ate and assisted wherever. Good CNAs even assisted their colleagues, who had heavier workload, with their residents.

Katrina didn't expect Terry and myself that day. She was entirely taken aback when she saw us entering the facility. Mind you, none of us had seen her. Katrina was rattled and confused. She asked a male CNA

to assist her. She took to her heels towards my mother's room and raced her down to the café.

The poor guy thought that a resident fell or some other bad thing had happened to a resident. Without delay, he turned around and ran behind Katrina only to discover that my mom was still in bed while others dined in the cafeteria. Katrina threw a blouse over my mom quickly, brushed her hair and together, they bungled her roughly into the wheelchair. Katrina raced my mom on her wheelchair to the café before we got to her room.

Mom wasn't in the room when we got there. We went to the café to see how she did with her meal. With Alzheimer's, mom had lost the ability to help herself. Katrina was sitting beside her at the table with three other residents. Tell me who wouldn't be happy to see his or her mother in good hands and mixing up with her peers?" Elsie asked rhetorically. "But was that the case? Of course not," she said emphatically and with utter dismay. "I learned later on that Katrina had been putting up a mere hoax that made me to believe that everything was perfect."

Elsie sighed. She took a break for a moment. She popped a pop and emptied the content into her tall drinking glass. She sipped out of it from a straw and continued.

"Shortly after, I kissed my mom and we went home. What did Katrina do next? She scooped a half-filled spoon of rice and tossed into mom's mouth. She swallowed it without hesitation. Mom was very hungry as I was told. Katrina saw three female CNAs walking down the hallway of the building. She yelled and asked them where they were headed. The girls were going to smoke cigarettes. What Katrina did next has never seized to hunt me even as I speak to you."

Elsie began to sob again. She was a kind-hearted woman full of compassion. Little things moved her to tears.

"The same Katrina I'd entrusted my mom to, dropped the spoon immediately and abandoned my mom to join the cigarette party. Yes, my mom was hungry and ready to eat, like many other helpless residents in that café who were probably starved by their caregivers because of cigarettes or chit chat.

How did this despicable behavior come to light? Guess what; it was through Brad, the male CNA, whom Katrina had asked for help with mom. The guy was sitting at table across helping those old folks to eat. He witnessed everything that happened, from our visit until the cigarette incident. Tears welled up in his eyes when Katrina abandoned and denied a handicapped old woman some food because of cigarette.

Brad was visibly exasperated because mom was ready to eat her dinner, which was a rarity with most residents in her condition, but was denied. The source had it that Brad was glued to his seat, inside the café, speechless. He looked morose towards the door until Wanda, a female CNA, walked in to get some ice from the machine.

Wanda knew that Brad's disposition was quite anomalous. That was the first time she'd seen him in that unusual mood since she'd known him. The guy, I was told, was always happy and easy going. He cared about the residents sincerely and was always eager to help other CNAs. For a guy that joked like a pet dog, never complained or whined, took things easy and avoided fracas to be angry and teary about Katrina's awful abuse of a resident, he must have been seriously hurt by that.

That was how Wanda felt. She was greatly concerned about his mood. Wanda wanted to know what the matter was with him. All Brad said to her was, "You ask Katrina." At that point, Wanda left and told another CNA called Sahel, who was a fink to the management.

Ironically, the same Wanda had once cautioned Brad, when he was still new to the facility, to slow down the pace of his work. She'd noticed that Brad was constantly cleaning, grooming and helping about ten or more residents assigned to him nonstop. He viewed Brad's honest dedication as an indictment to many of the CNAs, including herself. It was because they loafed around, chit-chatted, smoked and did whatever for the first few hours before dinner during the evening shift. Wanda told him what their trick was. They waited until about two hours to the end of the shift before cleaning up the residents. Anything to the contrary would pin him down to the floor and make him clean those that were incontinent nonstop.

Brad knew better than that and didn't fall for it. The guy was had a bachelors in accounting. He happened to be there because he couldn't find a suitable job. He hung on to what he could get and continued his

job search from there. He had to eat and pay his bills so he went the easy route and became a CNA.

On the other hand, Sahel had a good camaraderie with Brad. She didn't have any difficulty extracting information from him about what happened. Brad was open to Sahel, although he didn't want to tell on Katrina. It was Sahel that told Holy Rosary management.

Brad didn't narrate the incident to the management directly when they asked him two days later. In my opinion, he should've told the management, not about Katrina only, but on all the girls who'd abandoned the helpless residents to smoke. That's where he missed. The authority would have taken some steps to discipline them as a deterrent to others. That was exactly why some people foot- dragged to put their loved ones to the nursing homes. But I must say that the action of a few mindless workers wouldn't have to be used to judge the company or the entire industry. To be fair, some nursing homes are excellent," she admitted.

"How did you hear about it," Josh asked.

"Sahel told me about it a week after it happened. She'd disapproved Katrina's behavior and wasn't one of her fans either. She told me out of compassion. Sahel declared that Katrina neither cared about nor bothered with my mom beyond my visits. She made her look excellent on the surface the days I visited. She and her cronies put up the same pretense before Ms. Rose who'd trusted and recommended them to family members. Those were the group who were mostly interested in the paychecks and had zero interest on the residents.

Following that abuse meted to my mom, I decided it was time to move on. I re-enlisted the services of the Home Care Agency I'd dropped a year ago temporarily while I worked out logistics for Home Healthcare Services.

I withdrew my mom from Holy Rosary without negotiating with Ms. Rose anymore since my courtesy wasn't reciprocated. Ms. Rose let me down because it seemed like she encouraged and condoned the abusive behavior of her workers. It was unnerving that Katrina still worked there despite the treatment she'd meted to my mom and probably, other

residents as I heard. None of the girls was suspension or reprimand for such callous behavior against those old folks. It was terrible."

The home health care company that I'd arranged would provide nurses and physical therapists who would visit mom at home for treatment and assessment as per her schedule. A doctor would stop by from time to time to check on her. He would recommend when mom would come to his clinic or go to the hospital. Thank God, I had a good insurance from work. Also, some of the services would have been covered by Medicare as well. Some skilled nursing assistants would have to work on rotation for twelve hours a day. They would prepare light meals, feed her, help her with transfers, bath, or shower and become her companion until I get home.

There was nothing personal against homecare agencies. The choice for home healthcare was personal because of the medical service package involved. Also, I preferred only certified nursing assistants who'd been screened by the agency. That was exactly how I became interested in home healthcare business. That interest resulted in establishing Goodwill Home Healthcare Services as you could see today," Elsie said with a grin on her face.

"I'm surprised why you didn't sue them?" Rodney wondered.

"I didn't think about it then. My focus was to resettle my mother and move on. That was it. Mr. Buckman would have sued them probably, if I'd known him then," Elsie answered.

"A lawsuit would have been appropriate for their malicious act in my opinion," Josh added.

"But you could still sue them; can't you?" Rodney followed up.

"I can't anymore due to the status of limitation in this state. My case had gone beyond that limit," she responded. "But looking back now, I regret that I didn't sue them then at least to get justice for my mom and peace of mind for me."

Nancy joined. "Back to your story. How did you pack it up with the nursing home? I'm very curious to know the end of this appalling story," she asked.

"It was a sad ending," Elsie responded. She shook her head profusely as she repeated that sentence. That was the sore part of the whole ordeal.

Unfortunately, my mom became sick on the eve of her final departure from the nursing home. She was rushed to her favorite hospital, which you know by now. The doctor diagnosed her with malnourishment and dehydration. Her blood sugar was dropped off and on, which resulted to a partial stroke. Mom was found unresponsive in the middle of the night she was admitted.

The midnight supervisor called to inform me about the development that night. I rushed down to the hospital looking all crazy. On arrival, I saw various shades of medical personnel coming in and out of my mother's room. The supervisor told me that she was coded after we'd spoken. I almost fainted myself. I've never been that scared and distraught in my life. I cried continuously because I could imagine her pain from uncountable needle sticks she was receiving. The doctors and IV nurses struggled to find a good vein to start an IV on her. CPR was just introduced in 1960. Before then, either 1958 when it happened, it used to be mouth-to-mouth resuscitation. Medical personnel took turns to infuse oxygen into her lungs as the respiratory therapist was getting ready to hook up the oxygen on her. Everybody ran around to assist one way or the other. Her temperature and blood pressure dropped. Series of injections were ordered by the collaborating doctors on the scene.

Thank God, mom finally opened her eyes. She was immediately transported to the ER with oxygen and IV. She remained in ICU on life support. Mom passed on three days later."

Expectedly, she was emotional. The events that culminated to her mother's demise became her nightmare after those many years.

Nancy had assumed the spontaneous role as the comforter in chief. She held her mom's hand like she'd been doing to provide some succor.

Her entire story was summed up to an advanced directive.

"My children," she called them out. "I would like to beg you for one thing. I want you to pay attention."

They stared at her very attentively.

"Please don't put me at the nursing home. I started Goodwill home Healthcare for the primary purpose to be cared for at home if I become incapacitated. It was unfortunate I couldn't do it for my parents. But at least I tried to provide quality care at home for my mom, although it

didn't happen as planned. I hope it doesn't come to that point. But if I become weak and handicap, please get competent medical professionals to attend to me at my beautiful home. At least, the infrastructure is on ground. You could get me to the hospital whenever it's necessary and return me to my house after. No extensive hospitalization of nursing home. I don't want to be a burden to you and money won't be the problem either.

Like my mom, if I'm coded or something serious happens, please do not resuscitate me beyond regular medical attention. Let Me Die if it goes beyond that. I don't want to be stuck severally with needles. It's unnecessary and a punishment to add extra pain when I'm bound to die anyway. I don't need life support. That'll cause you emotional drain too. "Don't replicate all I went through with my mother for yourselves," Elsie instructed."

Rather than Elsie, Nancy became emotional this time. "Mom you know that's a hard instruction to follow. You know I'm right. How could we watch you die without doing everything in our power to save your life? I want you to live for as long as God could keep you for us. Don't even go there." She was a bit upset.

"I understand that," Elsie said curtly. "How about the pain and agony you'll go through while I'm on tubes and yet unresponsive? What use is that for you when I can't talk to or chat with you? I may not even hear you. My memory might be gone. You'll see only a physical but useless being. What does it matter to you then? That's where my long story was headed. This directive is already in my will. My attorney will have a copy and my doctors will have power of attorney. There's no way you'll flout my directives. I hate to sound harsh. But I love my children very dearly and hate to see you tortured."

There was emotion all around and absolute decorum in that room. Elsie broke the silence.

"I took out five million dollar life insurance for you guys. There's nothing to worry about. My burial is already provided for. I've already acquired a tomb besides my parents. We'll arrange a time when you'll see the spot. Please split the money I'll leave peaceful among yourselves. There'll be a lot of it after the burial. The percentage will be specified when Buckman and me adjust the will.

Each one of you has a place and role in Goodwill Home Healthcare Services now. This is the best day of my life. Now I know that I won't die in vain. I'm not also worried about what'll happen to the company that I've worked hard to build. The ball is in you guys' court. It's up to you to take your studies very seriously and take up the mantle of leadership when I retire.

The children were happy with the business aspect. Each expressed maximum appreciation to their mom for making them a significant part of her life and business.

Josh rose up and hugged his mom. He kissed her on the cheek and said with full eye contact, "We won't let you down I promise. You can tell we're all happy."

Rodney was happy too, although with a limitation. His educational status would definitely Barr him from participating administratively. Nothing was lost, he thought, because the company would still be under the control of his siblings in future.

However, his immediate worry was about what was in the offing from their criminal activities still under investigation. The unfolding events would determine his place and part he would play in the largesse Elsie had just announced.

Nancy looked at her wrist watch. So did Elsie.

"We've spent enough time here guys, we've got to," Elsie said. She grabbed her purse and walked out with her children.

"Let's have a dinner at my house this weekend," Elsie said.

"Yeah," Nancy clowned. "Will you be there Rodney?" she pulled his legs.

That was definitely not Rodney's worries now. But he managed to conceal his feeling and pretended. "Of course I will," he responded.

Josh fanned the flame. "Don't pay any mind Rodney, I'll remind you," he mocked him.

"Please come with your girl and boyfriends respectively," Elsie threw in. "Especially you, Josh, I'll like to see my only granddaughter so far. And you Nancy, drag the new guy, hopefully son in law, to my house. It's time I saw who's stealing the show from my daughter," she got rough a bit.

"Mom," Nancy called her jokingly as if to say, "You're going too far."

Elsie's whole purpose was to know the people in her children's lives and where possibly concretize those relationships to extend her nuclear family. Nobody asked Rodney and he didn't volunteer any information about his relationship.

Chapter Ten

~

"We're looking at all possible leads in this case," Detective Valerie said to attorney Buckman while they were meeting in the latter's office. "As far as our investigation is concerned, all options are open until we crack this case. Every bit of information will be followed until we establish a motive for this robbery. Nothing will be taken for granted."

"I truly appreciate this detective," Buckman responded with a smile.

"You're welcome, Mr. Buckman. I have a couple of questions sir."

"Go ahead," said Buckman.

"You're a renowned defense attorney. Do you also do any form of write-up or letters for your clients?" Valerie asked. She drew out her notebook from her breast pocket.

"Of course I do," Buckman responded curtly.

"What type of letters do you write sir?"

Buckman heaved a sigh like, "where do I start from now," before he and responded. "Huh. Several of them and different types too. I write contract agreements, business letters and responses on behalf of companies that retain my services. I draft wills for my clients. I'm involved with letters concerning marriages, divorce, and settlements.

Let Me Die

Sometimes, I write responses on behalf of clients who've been slammed with lawsuit, debt collection and eviction notices by attorneys on the other side," Buckman recounted.

Valerie took the next minute to complete her note and continued with her questions.

"Sorry about that," she apologized. "I need to capture relevant information," she explained. "Do you recall writing any of such letters or write-up recently?"

Buckman thought about the answer for a few seconds. "Hmm," he exclaimed. "Yes."

"How long ago sir?"

"I just wrote a will for one of my clients about a month ago. The one before that was a contract agreement I drafted three months ago. These were the most recent. Anything before those was about six months ago and longer," he said.

"You said the contract agreement was still in draft?"

"Yes. It's not been finalized yet. I'm waiting for the draft to be returned after both parties have read through and unanimously agreed with the content," Buckman answered.

"Is the contract agreement for individuals or companies?"

"A finance company and an auto dealership company," said Buckman.

The detective jotted the information down and went to the next question. She crossed one leg over the other.

"How about the will, who was it for?"

"My very good client that owns Goodwill Home Healthcare," he answered.

As a follow-up, Valerie said, "I think I know Goodwill. It's down the road, about one and a half miles from here right?"

"Correct," Buckman echoed back.

"Yeah. They're taking care of my grandmother now," said Valerie. "I guess the will was for the owner?"

"Yes."

"It's been finalized I guess?" detective Valerie asked.

"Hmm," Buckman dragged and thought for a better way to present his response. "I would say yes and no. Yes, because I'd already finished the will and delivered it. No, because I'd just got it back today from Ms. Elsie to make some amendments." He showed her the file, which contained the will in question.

Detective Valerie flipped her notepad to a new page and continued with her questions.

"This is a very important question sir. Others were as well, don't get me wrong. But this seems to delve into more specifics. How do you usually sign formal or official documents you prepare for your clients?"

"Hmmm. It depends on the client and the type of documents prepared. Normal response letters may be signed and dated. A will, such as what I have here, may be embossed with an official seal. I'll show you what I mean."

Buckman opened Elsie's will in his possession. "Oh," he exclaimed. He grimaced. His smiles spontaneously turned into a surprise. Disbelief was written all over his face while detective Valerie looked on.

"This is not the original document I'd prepared. This is entirely different," the attorney said. He turned the back, looked it over in surprise. "Someone had tampered the document. The paper is different from what I'd used. Some words had been altered or changed entirely. To my surprise, my official seal is on this fake document," Buckman said. He showed the seal to detective Valerie.

"Excuse me a moment," said the confused Buckman. He went to a big safe standing against the wall behind Valerie and unlocked the metal bar across all the compartments. Buckman selected the key to the third drawer from the bunch and unlocked it. He drew out Elsie's file among many others and produced a copy of the original will. Back to the table with the detective, Buckman studied and compared both copies of the will with the detective. Both of them were baffled at the discrepancies. Unlike the original will, Rodney was now the prominent beneficiary in front and Frank was totally nonexistent. There wasn't much distinction between the color of the original paper, which Buckman had used and that of the fake except for the texture of the stationery.

Impulsively, Buckman said, "Please hold on a minute. I have to inform my client right away." He lifted his office handset to call.

Valerie surged forward quickly from across the table and said, "Please don't do that. It may negatively affect the investigation. I'll handle that myself. This might be the lead, if not the break we've been looking for," she speculated. "I would like to have copies of these documents," she requested.

"Sure you can have it." Buckman was aware that the law allowed disclosure of only the required information to law enforcement for the purpose of investigation. He was being careful not to break attorney-client confidentiality and trust. Buckman made copies of the original and fake wills for Valerie.

"Thank you, sir," she said. She cross-checked to ensure that she got copies of both documents.

"Do you need any other information or have further questions?" Buckman asked.

"I'm all set for now, Mr. Buckman. I'll get in touch as we proceed with this investigation," she said. "But I'll definitely talk to the parties mentioned in these documents, including your client."

"Alright then. It was nice meeting you detective Valerie."

"Likewise," she said. Valerie stood, shook hand with Buckman and left for her office.

Buckman sat still for few minutes and thought about the fake will. "This isn't good at all," he muttered to himself. "It's going to get ugly," he feared. He wasn't sure whether it would be preemptive of Detective Valerie's investigation or not if he called Elsie. He knew it was against the detective's advice. "I owe it to Elsie to inform her before she's taken aback" he concluded.

Elsie didn't pick up the phone. He left an urgent message for her to return his call. He knew that Elsie had longed for an opportunity to spend time with all her children. "She must be in a good mood today. I'll let that mood linger, at least for today, without tainting it with a bad news."

Back at the Hollywood Police station, detective Valerie, Sergeant Sandra and Officer Colman, a video review expert, got together with

the police chief, Superintendent Mark William, by 7.30 p.m. They were ready to piece the entire evidence together to find the motive and solve the case. All information about the recent robbery at attorney Buckman's office, burglary attempt and the latest interview between Valerie and the attorney, were assembled. Officer Fredrick's report on Elsie's home invasion and subsequent interview of Rodney and Frank was provided.

Scott escaped that scrutiny because Ms. Carlyle centered her description mostly on Rodney.

The next report came from Officers Ross and Terence's on the night they pulled Rodney and Scott over for DUI. These were the same officers that had responded to the affray, which Scott and Rodney had started at the Elite Night Club. They also filed report about the incident.

The cops watched both videos about the burglary attempt and armed robbery respectively. On closer review, officer Colman strongly believed that the same individual was behind those two attacks. The image was hard to identify because the perpetrator wore a mask the first night but put on a disguise during the robbery. On comparison, Scott's size and height matched on both of the videos and met the description from Buckman. Also, the two incidents were so close and was considered to reach that conclusion that the acts were perpetrated by the same guy. More significantly, the video captured the rental cars, which the perpetrator had used in both cases.

Unfortunately, there wasn't any verbal description by Tom, the Security guard from Safety First, who was viciously attacked and beaten to stupor by Scott that night. However, his notebook indicated that a rental car was used. That account helped to conclude that it was the same suspect.

It'd been established that the two images in the camera were the same person. Now who was this perpetrator and what was his motive? Detective Valerie produced the transcript of her erstwhile interview with Buckman and the copies of the will. She connected the dots between the original will, which attorney Buckman had written and the replica by Rodney, technically. The paper quality and texture differed, but the color was similar. Interestingly, copies of the original and the replica were embossed with the same simple machine. How did that happen? Scott might know something about it because that was his mission

during the robbery. They flashed back at the invasion of Elsie's house a fortnight ago which Officer Fredrick was the respondent.

During his investigation, Officer Fredrick had interviewed Rodney as one of persons of interest then. He tracked Rodney down at his work that evening. The Officer didn't pursue that case very seriously since Elsie didn't report anything missing and there wasn't any trail like fingerprints left by the culprit.

Rodney was the only one in because Ms. Carlyle had specifically mentioned and described him to Sergeant Fredrick. Luckily, Scott dropped him off at the warehouse where he worked after they'd left Hannah. That was the genesis of the alibi, which his mom had pointed out to the police officer.

Frank wasn't treated different. Fredrick got him on phone and followed up with him to the restaurant. Elsie was right again with her alibi for Frank.

Rodney and Frank were tentatively absolved from that incident.

But the recent robbery threw Scott and Rodney under serious scrutiny. The police had tied them together as sponsor and perpetrator respectively. Detective Valerie analyzed and compared the contents of the original and replicated wills. They narrowed it down to Rodney considering that Frank was featured prominently at the will drafted by the attorney. But he wasn't even mentioned in the replica, which Rodney had produced. In fact, Rodney had supplanted himself in the exact spot, which Frank had occupied in the original draft.

Sergeant Sandra reviewed the history of their previous arrests and bails for misdemeanor at that police department. Both men's files had continued to pile up at the station and had shown records of DUI, fights and affray always committed together by Scott and Rodney.

Officers Ross and Terence collaborated the report on DUI and fight at the club because they made the arrests, issued tickets and also wrote reports.

The officers recalled that Elsie had bailed Rodney, her son, who was Scott' friend, several times from that station. The police had speculated that Scott might be the guy captured in the camera. The officers

reasoned that the motive behind that robbery was to get the machine from Buckman to be used to authenticate the replicated will.

Chief Mark William decided to arrest Rodney and Scott for interrogation. But before that, he would like to interview Elsie the following day.

Valerie and Sandra got into Elsie's office by 9.10 a.m. on Tuesday. They'd waited outside her office in an unmarked police car until she arrived.

Elsie was caught off guard because she didn't plan to have an unscheduled meeting with the police this early. Her eyes shone like a cat under bright beam of a car headlamps. She was a bit nervousness unlike her. Elsie invited them to sit down.

"I have coffee and tea, Officers," she offered.

"No. Thank you so much," Sandra politely decline.

Valerie didn't accept either. But she was grateful. "I appreciate the offer. But I'll pass for now. Thank you," said Valerie. "Ms' Snooker, we're here to talk to you about a few things. I'm sorry we couldn't inform you ahead of time. It's the nature of our job sometimes."

"No worries," Elsie responded. "What's the nature of this talk if I may I ask?"

"We're investigating an armed robbery attack on Mr. Buckman whom I understand is your attorney. Your name came up in the process due to your business relationship with him. We're here to clarify a few things from you, mam," Valerie said.

Elsie cuts in. "I'm glad you mentioned my attorney. I'd rather invite him to join this discussion. He's only a mile and half away. I'll call him if you don't mind, please." Elsie dialed Buckman. That was also her opportunity to return his call since he left a message yesterday.

Luckily, Buckman was in the office and would arrive shortly. He suspended other discussions with Elsie until they were through with the police.

Ten minutes later, Buckman arrived. Valerie went on with her agenda. She'd planned to stop by at the former's office to brief him about the direction they were taken the investigation. His presence had elucidated her hassles.

The cops wanted Elsie to confirm ownership and content of the original copy of the will.

"Mam, are you familiar with these documents?" Valerie asked. She gave Elsie both copies of the will.

Elsie looked at them carefully. She snuck in a look to her attorney as if she wanted his approval before she would answer the question. She gave the documents back to Valerie and said, "The one with Frank written on it is mine." She pointed at her will to support her response.

Sandra spoke for the first time. "What do you say about the other document? Both of them bear your name," Sandra pulled a prank on her.

Elsie was confused and lost. She looked at her attorney in total disbelief. "How come there's a duplicate?" she asked. "We'd just met yesterday. I'm not expecting that you've already made the changes we discussed. Have you?" she asked curiously. Elsie wanted Mr. Buckman clarify.

But the attorney nodded in disbelief too. "It's also a big shock to me too," he proffered.

Sergeant Sandra waded in again. "Do you remember when your house was invaded in your absence?" she asked.

"Yes I do," Elsie answered.

"Officer Fredrick responded to your call. He'd recommended that you replace your door locks after that incident. Did you do that?" Sandra followed up.

Elsie exclaimed. "Oh my goodness. I've not. I totally forgot about that."

"Do you think somebody had duplicated your keys to gain entrance? It might be a possibility since the house wasn't boggled," Valerie suggested.

Elsie thought for a minute. "Hmm. I'm not sure about that. Frank, my boyfriend at that time, was the only person that had my keys with the exception of my bedroom. I can't think of anyone beside him," She answered.

"You mean none of your children had your keys?" asked detective Valerie.

"Of all my children, it was Rodney alone who'd touched my keys recently. Then he took my car to a carwash drive through center and back. That's all," she answered.

"How long ago was that?" the detective followed up.

"I'll say about three weeks plus now," Elsie confirmed.

"Hmm," exclaimed detective Valerie. She heaved a sigh and briefly made eye contact with Sergeant Sandra before she continued.

"Mam, did you ask Rodney to help you wash your car or he volunteered?"

"He volunteered," Elsie answered.

"About how long did it take Rodney to wash the car?" Valerie asked curiously.

Elsie thought that question was tricky. "What do you mean by how long?" she repeated after the detective.

"Sorry if I confused you, mam," Valerie apologized. "My question is whether it took him, say ten, twenty or so minutes to complete the task."

"He returned after thirty-five minutes or thereabout," she answered.

Sandra cut in. "How far was the drive through from your house?"

"About a mile. Just down the road."

"What took him that long? It was just a drive through. It doesn't take much effort," Sandra asked suspiciously.

"He said there were many people ahead of him," Elsie answered. Elsie added a comment that might implicate her son without knowing it. "Just like you, I wondered what took him that long."

Valerie turned to Mr. Buckman and smiled. "I'm glad you're here because I meant to call you on my way after I'm done with Ms. Snooker." She made a little note and paused in case Sandra had something to say.

"Sergeant, do you have more questions for her?" Valerie asked her colleague.

"Not at this time," Sandra responded.

Detective Valerie adjusted on her seat. She made a direct ye contact with Elsie and said, "We would like to continue this investigation with your son, Rodney. Just a little chat with him."

Elsie was disturbed by that development. "Detective, why talk to Rodney again?" she asked politely.

Valerie was very careful with her response in order not to hurt Elsie's feeling. "Mam, it's just a chat. We have to corroborate your information to establish all the facts. Our investigation has to be thorough and complete. We'll talk to anybody mentioned in the course of our investigation to get to the root of this robbery," Valerie explained.

Buckman spoke for the first time. "Don't worry about that. That's the nature of their business," he assured Elsie.

"I'm confident because you're here," Elsie said sarcastically to Buckman.

Valerie quipped, "As a matter of fact, we're looking at the possibility that your keys were copied, that's why we need to talk to Rodney."

"Whoa," Elsie exclaimed in disbelief. With a feeling of dismay, she said, "It's your job. I won't interfere. But my concern is how this unfortunate robbery on attorney Buckman extends to my son. I wouldn't believe Rodney would copy my keys, not within that short time. This is ridiculous," Elsie said out of frustration.

"Leave that up to us, mam. You'll see where this leads to eventually. We're not pointing fingers at your son right now. But we have to ask these questions to guide our investigation," Valerie said. The cops paused and completed their notes. "Anything more?" Valerie asked.

"No. I'm done;" Sandra said sharply.

The police officers rose to leave.

"Thank you for your time, mam," said Sandra. "And you too, attorney Buckman."

"My pleasure," responded attorney Buckman.

"You take care ladies," Elsie said.

When they got to the door, Detective Valerie turned around suddenly and said, "Mam, please don't discuss this with your son after

we leave here. We're actually heading out for him now. We don't want to compromise this investigation in anyway."

Buckman responded on her behalf. "There's no problem, detective."

The direction this case had pointed made Elsie very nervous and emotional too.

Buckman was ready to go back to his office. But before that, he said, "Well, you've heard from the horse's mouth. I called yesterday to brief you but you didn't pick up. You didn't know that the robber just came for my official seal, which I used for your will. From my experience dealing with the police as a criminal defense attorney, I suspect they're tying the seal to the will. But don't get all upset about this until we hear from them."

"It's not easy not to worry, especially when my son was mentioned," Elsie said with a sullen voice. She rubbed her palms together and looked up to the ceiling. "Lord please don't let Rodney have any part in this robbery," she prayed. "You know how close I've been to my attorney." She shook her head and said, "I'll cross my fingers and watch. I trust you, lord."

Buckman arched his arm around her shoulder and consoled her. He said in a whisper, "Exactly. We have to cross our fingers and watch. That's all we have to do at this time. Let's keep in touch. I'm in the office if you need me or if the detective comes back."

Elsie saw him to his car. She didn't utter a word to her staff after she returned to her office. There was a sudden but unusual mood swing. Her thought wondered as she sat quietly behind her table. "Whatever went on between my son and those inquisitive cops was better imagined," she said to herself.

Chapter Eleven

The scantly occupied and secluded Guest Home Motel provided a safe haven for Scott. The motel was situated at the cul-de-sac area of the Front lane street. This area blended more into a residential area, which made the motel very unpopular to potential distant guests who hardly knew that it existed. Guest Home was a fifteen room motel with poorly lit surrounding during the night. The fence consisted of steel metallic poles with crossbars around the light orange color ground floor building. For the landscaping, stunted tree-like flowers lined up the stretch of the black fence. A variety of colorful flowers decorated the front of the building.

It was a cheap motel owned and managed by a Lebanese father and his two sons on part time. The Gutera family, as they were known, bought and converted an old nursing home into a neighborhood motel with a popular banquet hall for rent. The family's main business was a gas station, which incorporated a fairly large supermarket.

Besides the Gutera family, five other staff worked at the motel. The daytime manager handled the business from 8A to 6.30P weekdays. Then one of the Guteras would take over from there until the following morning. The motel manager and his assistant switched shifts every

other weekend to manage the motel. The remaining workers did housekeeping, maintenance, and room service.

The Guteras mostly hired workers from the neighborhood and around as a way of giving back to the community in which they operated. They also wanted the motel to be in close proximity for the staff. Most employees knew from start that the earnings were meager, but they still hung in there. Some of them worked full time at the motel. Others used it as a source of supplemental income.

Since chilling out at that secluded motel, Scott streamlined the use of his cell phone. With exception of Rodney, he'd excommunicated every other person, including Hannah his girlfriend, to play it safe. A thirty-two inches television in his room was his only companion. Scott glued unto the TV two-four-seven. He'd constantly listened to the news to hear when the police would put out announcement for a man wanted for armed robbery. He'd became more security conscious since Rodney told him that a detective called attorney Buckman while they were in a meeting. Since then, they'd developed a secret code to communicate with each other about when and how to meet. Scott didn't leave his motel room since three days he'd lodged there. It was mainly a precautionary measure to shield himself from the cops.

Detective Valerie and Sergeant Sandra regretted not asking for permission from chief Williams to arrest Rodney after they interviewed him at his house. All the evidence tied him to all the crimes as a culprit. He may not necessarily be the perpetrator. They knew he wasn't the guy on the video but his accomplice. The cops neither harassed nor intimidated him or put up any act that suggested that he was a suspect. They were professional in their conduct and comported themselves well without giving Rodney a clue about the impending arrest. They later came back with an arrest warrant after Rodney had fled.

His inner instincts told Rodney to flee. His experience dealing with Hollywood Police Department had told him they would definitely reinforce and return. He join his buddy, Scott, at his hideout for the remaining couple of days. He stopped by a gas station to pick up bottles of water, snacks, and cigarettes. Rodney wasn't a habitual smoker. He needed that to relieve his tension. He knew his mom's BP would jump up if she knew Rodney had a hand in all these crimes.

Scott could care a little less about anything. He'd lived his life mostly in the street since he was thirteen. His parents served life sentences because of their complicity in a murder case, which they denied. Scott was raised by an aunt who abused drugs and had also cared a little about him. He'd been used to hard life and was unperturbed about the consequences of his action, unlike Rodney.

The police had drawn their strategy to arrest the suspects without complications. But they treaded with care and caution in order not to blow it open. They didn't want to ask Elsie about Rodney's where about. Also, the plan to put up Scott's image, which was caught on camera, on the television as a wanted man was suspended until the appropriate time. They weighed in on the negative effects of such strategy. It may result to the suspects fleeing and scampering for safety, which would be counter-productive.

So far, the police had made progress piecing the information they'd gathered together and narrowing down their lead to two suspects. However, Rodney was the only suspects who was clearly identified. Detective Valerie still wanted to have a clearer identity of Scott so there wouldn't be a near miss when they set out to apprehend him. An idea got into her head. It clicked into her thought that only officers Terence and Ross, who weren't directly involved in the case, had personally encountered Scott. She could use their help this time. Valerie invited them to watch and review the recorded images of Scott with her for possible identification. She needed about ninety percent confirmation for her to rely and act on it.

Terence and Ross had stronger conviction that those images were Scott's, unlike the other officers. They corroborated with Coleman. To reach a definite opinion, however, wasn't easy since they'd encountered Scott in regular cloth different from what was presented as disguised and blurry camera images.

With that said, Valerie decided to dig further into documented information of the suspects' at the Hollywood Police Department.

"Can I see the files for Rodney Snooker and Scott please?" Valerie requested politely from the clerk at the criminal record department.

"Sure." Corporal Miley sorted the files and handed them over to her.

The detective read their individual files meticulously with an intent to find a slip somewhere.

Elsie's personal information recurred on Rodney's file. That wasn't of much help for Valerie. She was particularly interested in information that would lead to the arrest of these folks before they would elude the police.

Hannah had also popped on Scott's file many times. She'd bailed out Scott often. Most times, it was several days after his arrest, because she had to arrange the money. It was a struggle for her since she wasn't financially stable like Rodney's mother, Elsie.

Something came up at last. "There you go," Valerie said with relief. She'd spotted Hannah's physical address squeezed in somewhere in Scott's file. "Sergeant Sandra, can we make it to Hannah's address right away?" she asked.

"I'm sure we can. It's just 7.30 pm," said Sandra.

They jumped behind the wheel of an unmarked black dodge charger and zoomed off. They were prepared this time to make an arrest, if there was the need. About twelve minutes later, they knocked on Hannah's door.

Hannah used to work from her two bedrooms old aluminum house. The guest room, which was on the immediate left to the living room, was her secretarial office. A door connected that room and her garage from where she received her clients.

This tall averagely built middle aged lady had just closed business for the day. She had a shower cap over her head and a towel wrapped around her chest up to her knees. Hannah was ready to jump into the shower when she heard the rap on her front door. That was unusual for her because she didn't receive unsolicited visits at all. Scott would've informed her in advance if he was coming around. He was out of town for all she knew. Hannah decided to take a gamble and stealthily came to the door. She peeped through the hole before she cautiously responded. "Who's that?"

"Police," Sandra responded from behind.

Hannah peeped again through the minuscule hole on the door to double sure. She let the officers inside.

"Hi, I'm Sergeant Sandra from HPD. With me is detective Valerie Orchard."

"Hi," Valerie greeted.

"Hello," Hannah acknowledged." Furthermore, she requested, "Please can I take a minute to get my cloth on. I'm not decent?"

"Do you have a gun?" asked Valerie.

"No. I don't," Hannah responded. "Officer, you can follow me into the room if you doubt me," Hannah offered innocently to reassure the cops.

"It's alright. Make it a minute," Valerie requested.

As soon as Hannah vanished into her bedroom, the eagle-eyed officers took a quick eye scan of her living room and kitchen. It was a simply furnished living room suitable for a sphincter with a low income. A couch at one end of the wall faced her 32 inches television directly. Her burst photograph, taken during her graduation from the Secretarial Institute, hung on the wall. Directly below it was a metallic silver table with a bouquet of flower on top of it. A red carpet with flowery design embellished the floor.

Hannah emerged exactly one minute later. She adorned a blue stretch jeans and a black tee shirt. She was nervous, scared, speechless and unaware of the reason the officers were there. She recognized Sergeant Sandra during one of her visits to bail Scott at the HPD. That was about it. She'd never had the police knock on her door in the recent time. That was troubling to her. But she was sure of one thing; she'd not been into any trouble. "Take nothing for granted," she said within herself. "Who knows whether Scott was up to mischief again," she wondered. "That would be known in a minute," she concluded.

Detective Valerie was the first to speak. "You might have wondered why we're here and whether you've done something wrong. None of that so far. You're not under arrest. HPD is cleaning up the files of some individuals who'd frequented the station for minor offense. The police chief wants to work with them and their relatives on those to reduce arrests, that's all. Your name popped several times in Scott's file so we thought we have to chat with you at our station, out of courtesy." The officers paused for her reaction. Like they did to Elsie earlier, they didn't

disclose the ongoing robbery investigation to her. Moreover, Scott was a higher flight risk than Rodney, whose mom was popular.

"Oh lord," She exclaimed. "Officer, please be frank with me. I might need an attorney," Hannah said nervously.

"There's nothing against you as at now. Take my word for it," Sandra reassured her. "You aren't under arrest as the detective had said and we're not handcuffing you either."

"Can I drive myself down to the station?" Hannah asked.

"No. We'll bring you back," Sandra cut in.

Sergeant Sandra opened the back door of the car for Hannah. Detective Valerie sat at the passenger's side in front, while Sandra. They left Hannah's house for the police station.

While at HPD, Hannah was briefly interrogated about her relationship with Scott. She'd denied any knowledge or being involved in part or whole with the shady businesses engaged in by Scott, her boyfriend. But she identified Scott as the same man in both the attempted burglary and robbery camera images. She knew it because she was familiar with the clothing he had on in those separate incidents, otherwise, it was difficult to say from his face.

"What's this guy's name?" Valerie asked pointing at Scott's image on the camera.

"Scott," Hannah responded briskly.

"When last were you guys together?" Valerie continued.

"Hmm," Hannah thought a bit. "It's been a little while."

"When you say a little while, what do you mean; how long was that?" Sandra cut in.

Hannah looked at the ceiling and thought momentarily. "I'll say about two weeks."

"That's not that long," said Sandra. "But you guys communicate though, right?"

"Not quite. I've not heard from him since one week," Hannah responded. She told a half-truth because it wasn't quite a week. Scott hadn't spoken to her in five days. He'd lied to her prior to the robbery that he was going out of town.

"Where's Scott now?" Valerie asked.

"He told me he was going out of town the last time we spoke. That's it," Hannah responded emphatically.

"I see," Valerie wondered. "That's strange. Did you believe that?" she asked Hannah.

"That's what he told me and I believed him. I have no way of telling." Hannah replied smartly.

Hannah was requested to make a statement on the sheet provided to her. While she was in the middle of that, Valerie interrupted Hannah with a question.

"May I ask what you do for a living?"

"I offer private secretarial services," Hannah answered. She'd modified and refined her job classification carefully because she'd been cautiously avoiding being entrapped by the cops.

Continuing, she explained, "I process documents mostly for companies and big corporations." She knew that she was being recorded and under the camera.

"Excellent," said detective Valerie. "You don't work for private people?" she asked sarcastically.

"Rarely or it depends, I could say," Hannah responded. She chose her words carefully.

"What if I'm Scott, won't you process my documents, if I have a need?" Valerie asked. She'd tried to entrap her.

"That'll be an exceptional situation. Don't get me wrong. Not all the time." Hannah explained.

"Have you worked for him before?" asked Valerie.

Hannah stammered a bit before she answered, "I've not." She'd lied outrightly out of fear she would be boxed into a corner.

"You sure?" asked Valerie. "Don't lie to me." She starred into Hannah's eyes.

"I'm positive," Hannah insisted.

Her response and body language to the last question rang a bell to Sergeant Sandra. It didn't quite fit.

The Detective decided to throw in a last joker. She handed Hannah both the original and fake copies of Elsie's will. She followed up with an open question.

"Do you know anything about those documents? Have you seen them before?" She watched Hannah attentively as she leafed through the wills.

"Never, ever," she stuttered and lied, and at the same time, broke eye contact with Valerie.

Sandra jumped in this time, "Are you sure ma'am?" she asked in a calm and measured tone of voice. "Think about it. You might have forgotten if it'd been a while," she threw in that subtly.

Hannah stood her ground. "I'm positive ma'am."

"Alright," Valerie said conclusively. She took brief notes of Hannah's responses.

"Thank you for cooperating with us," said Valerie.

"Not a problem. Thank you," Hannah responded as if she'd enjoyed the hot seat. However, she thought it'd come to an end and was very ready to go home and jump into the shower.

The officers were highly suspicious of Hannah's responses about Scott and the will. They took her answers with a grain of salt. Obviously, Sergeant Sandra didn't want to get her home without talking to the Chief. Left to her, Hannah should be in custody due to the huge risk involved if she was let off the hook. But she wanted to go about it nicely because she'd promised to take her home from the outset. Unfortunately, she might break that promise from the way things had gone.

"We'll get you home in a minute," Sandra said craftily. "Oh," she exclaimed like she'd nearly forgotten about it. "Please take a few minutes to complete that statement while I use the bathroom."

"As if you read my mind," said Detective Valerie.

They left Hannah in the chat room while they conferred with Chief William in his office.

"How did it go Officers?" Chief William asked.

Twisting her palm to indicate neither here nor there, Sandra responded, "Chief, I wasn't quite convinced she didn't have a hand in

replicating the original will, which attorney Buckman had prepared for Elsie. We learned in the process that she's a secretary by profession."

Valerie agreed with Sandra. "Hannah claimed to service only companies and corporations. That raised a red flag to me. I asked her if she'd ever help Scott to process documents before and she lied to me with a bold face," Valerie said with disbelief.

"So what's your opinion from your assessment?" the Chief asked them.

"In my opinion, she should be taken into custody," Sandra suggested. My worry is that she might jeopardize our investigation if we turn her loose. More than likely, she'll hint her boyfriend and then Rodney will definitely hear about it too. Certainly, they'll flee in the process and therefore, make it harder to arrest them."

"Not only that," Valerie jumped in, "she might be a flight risk herself."

"Hmmm, I didn't see her like that though. But you looks could deceive," said Sandra. "I think she's a decent person who'd associated with a crook in the name of love."

"From what I've heard so far, both of you seemed to agree on one point. So I'll say you go ahead and take her into custody to play safe. There's no guarantee she won't brief Scott or flee herself. Take her with you to her house. I want you to get her computers, printers, work stationery and any item that would be of help to this investigation and come back," the Chief instructed. "One more thing, "Don't put her on handcuffs. She'd not been accused of anything yet. Be as friendly as you could with her."

Back in the chat room, Sergeant Sandra declared, "Ma'am I'm sorry, the police Chief wants you in our custody in the meantime."

Hannah couldn't believe it. But she cooperated with them as they carried out their instruction.

Following Hannah's arrest, the police Chief deployed some undercover officers to keep surveillance at the residence of Rodney and Scott respectively.

The police towed Hannah's jeep Cherokee to the station in the middle of the night.

Chapter Twelve

~~

It'd been a busy week for law enforcement officers. Police activities had revolved so much around Elsie, Buckman, Rodney, and Scott. The week had already raced to Friday and would soon wind to an end. That Friday was scary because the Hollywood Police Department unleashed an onslaught on Rodney and Scott. Their cohort, Hannah, was already in custody.

That was the same day Elsie had chosen to hold a dinner party at her residence for her family and friends.

Josh made good on his promise to Elsie. He brought Natalie, his daughter and estranged girlfriend, Rita, with him. He'd worked out his differences with Rita, with the help of Laura.

It started after Josh had informed Laura that they had a successful dinner outcome with Elsie and that their follow up meeting with her resulted to a positive development. He'd credited that to Laura due to the tip off and also invited her and Dave to the dinner, which was scheduled for that Friday.

Laura was elated at their success, although she was surprised it'd happened sooner and easier than she'd expected.

Josh wasn't done with Laura yet. He needed her help to facilitate a reconciliation between Rita and himself, which their ego had stalled so

far. There wasn't much time left before Friday. The only way to get Rita to accompany him was to make up with her. So he tapped Laura for help.

Without procrastination, Laura got in touch with Rita. Laura deployed her masterdom in tactful speaking to redirect Rita's thought towards a larger picture in the near future.

"Listen Rita," she said. "I know you're hurting. It's within your right if Josh had done what you'd accused her of. But it's time to move past that and look at the larger picture in the future. Poor Natalie, your beautiful daughter, shouldn't be a victim of you guy's ego."

"Laura, I'm grateful for your call. I don't mean to be disrespectful. I don't miss Josh and really don't need him at this point. William Shakespeare saw the world as a stage where every actor plays his part and vanishes. I believe Josh and I had played our parts in each other's life. It's time to move on."

"I understand that Rita," Laura responded. "But your daughter has to come first. You would've noticed I used the phrase 'larger picture' before. Let's talk woman to woman now. Look, a woman wants to be love, live a good life, be financial secured from the man she loves whom she could proudly identify with and refer to as her own. Between you and me, Josh will be walking into power and wealth in a short time. He and Nancy had just learned they'll be in charge of Goodwill Home Healthcare in less than five years from now. Take my word for it, the disagreement between them and their mom has given way for a new beginning now. You don't want to walk away from these positive development out of ego and obstinacy. Please for your daughter's sake, you guys need to work things out. Are we on the same page?" she asked

"Seems like," she responded. "Can I ask you this, why didn't Josh man up to talk to me by himself when we live in the same house?"

"Good question. I was expecting it," she joked. You should know men by now. Between you and me, he'd told me countless times how he'd missed you. I'd encouraged him to reach you. I realized lately he'd been shy. Again, his ego had been in the way and had waned his courage. So I accepted to be his mouthpiece." Suddenly, she said, "You know

what, I'll ask him to follow up with you without further waste of time now that we've come this far. Is it okay that way?"

"Okay," Rita answered.

"Promise me you'll be nice and talk to him?"

Rita hesitated a bit. "Until I hear from him. I'll try my best."

"Thanks Rita. I'll follow up with you tomorrow."

"I'll be here," she responded.

Later on that Monday evening, Josh followed up with Rita. He'd been advised to speed it up before Rita relapsed into her former state of silence. For the first time after several months, Josh took Rita and their daughter out for dinner. Rita loved Indian food, her favorite. From the restaurant, they visited Lake Front Shopping Mall to shop for clothing and accessories for Rita and Natalie.

Rita wanted to look her before Elsie. In order to impress Elsie and Nancy this first time, she'd dress to kill. She got herself two sets of pant suits, black and cream colors respectively. Shoes and jewelry to match those dresses were among her list. She called and reserved a spot for Tuesday in her favorite hair salon. Her hair stylist assisted her to choose a classic style when she got there the next day. Of course, Natalie wasn't left out of any of those.

Like juveniles in love for the first time, the duo held hands as they walked around the mall. Kisses were exchanged very generously, oblivious of who was watching. Josh picked all the tabs. For the first time in nine months, Josh and Rita slept together, romanced and made love.

"I'm glad you accepted me back into your arm," Josh whispered into her ears while in the bed. "I didn't know how much I missed you." He kissed her affectionately.

"The feeling is mutual sweetheart. "You make me feel like a woman again. I've missed all these. I hope you stay together forever. I love you so much," Rita replied.

Chapter Thirteen

All was set for the dinner that Friday evening. Elsie couldn't wait to see her grandchild. So hardly did Josh and Rita disembarked the car than the excited Elsie carried Natalie into her arms and rocked her gently. She looked her over and kissed her forehead. "You're such a big girl," she said. She petted her as any regular grandmother would. Turning to Rita, she stretched her right arm and shook her, "I'm Elsie, Josh's mother."

"I'm Rita his girlfriend," she responded.

"Welcome to the family. I've heard lots of positive things about you," Elsie said.

Elsie had just sent an implicit message to Rita as an approval and acceptance. Apparently, Rita's dress- to- kill plan had worked. Elsie liked her the moment she sighted her. She admired her confidence and composure. With no time to waste, Elsie pulled Josh and Rita closer to her and whispered, "I want you to work on tying the knot soon. The bill is on me," she assured them.

"Whoa," they exclaimed. "Thank you. We'll definitely work on it," Josh said.

Josh and Rita walked around and introduced Rita.

Nancy stood up, when Rita approached her and shook hands with her.

"This is Rita my girlfriend," Josh said. He turned around to Rita. "This is Nancy, my lovely sister I've always told you about. Nancy and I are very close," Josh emphasized.

"Nice to meet you, Rita," said Nancy.

"Likewise," replied Rita.

"Please make yourself comfortable," Nancy became hospitable as usual. Please take good care of my beautiful niece. I'm sure we have plenty of time to chat later," Nancy said.

"Most definitely," Rita responded.

Laura and Dave, her guy, were also present. Laura met Nancy and Elsie finally. They'd looked forward to seeing and saluting her for catalyzing that healthy reunion.

Elsie recognized Laura as one of the court clerks she'd seen while at the court to file the defunct marriage process. Now the mystery of how her children had found out about the aborted marriage to Frank was finally solved. "It's a small world," Elsie muttered as she turned to meet Laura.

"I knew you from somewhere my dear. Where do you work?" Elsie offered a handshake.

"I work at the 76th District Court," Laura responded.

"So I was right," Elsie confirmed her guess. "I didn't imagine that my son knew someone where I'd secretly filed marriage papers," Elsie said sarcastically to Laura.

They laughed because each of them knew the underlining history behind that process. Elsie continued, "I'm a strong believer that things happen for a reason. The lord wanted to unite our family. Might not have happened if it was reversed."

"Yeah. I guess," Laura agreed loosely.

Elsie used that casual opportunity of silly jokes to put Laura on notice.

"Since you'd blown my cover, you owe me a serious favor."

That comment threw everybody into a hilarious laughter, including Rodney, who'd just sneaked into the party from the Guest Home Motel.

"You got that part correct," Laura responded. "Give me a nod whenever you're ready."

"Absolutely," Elsie exclaimed. "To give you a heads up, I believe you saw me whisper to my baby, Josh and his beautiful Rita a minute ago. I'll not jump the gun here until I hear Rita's opinion privately. I trust she won't let me down." She smiled and winked at Rita jokingly. "Anyway, you could figure where I'm running with this. If things go as planned, I hope they would, you'll handle a court process agreed by consensus for us this time around," she mocked herself

The word "Consensus" which she snuck in there triggered another round of laughter. The small crowd had a kick whenever Elsie mocked herself over her thwarted secret marriage to Frank.

"I figured that out already. That's for sure," Laura said with a smile. "Trust me, you don't even need to be there again. I got that part. I'm positive," she promised sincerely.

"Thank you my dear." Elsie leaned forward and hugged Laura.

"By the way, this is Dave, my fiancé," Laura chipped in briskly. Dave stood and shook hands with Elsie.

""How're you?" Elsie greeted.

"I'm well, thank you. How're you?" Dave returned the courtesy

"Great. Welcome to the party."

"Thank you," he responded while still maintaining an eye contact with her.

"Be sure to enjoy yourself. There's more than enough here to eat and drink. Don't even be shy or wait for the girls because they aren't waiting for you either. Help yourself to anything available here."

"Most definitely. Thank you," he responded gratefully.

Rita had eagerly longed to see Laura in person for the some reason attributable to Josh and her. She thought she owed Laura some gratitude for being persistent in persuading her to get back with Josh. She walked up to Laura.

"Hi Rita," Laura acknowledged her with excitement.

"Hi Laura," Rita responded in the same manner. They hugged each other warmly and held on for a few seconds to savor the affection. Rita continued, "Thank you for all you'd done. I'm glad I have the opportunity to meet you."

"You're most welcome my dear. I'm glad I was able to help. I'll still get in touch as I promised," Laura hinted.

"I'll be looking forward to it," Rita said as she walked away to sit down.

Nancy had kept low profile all the while her mom spoke with Josh and his crew. She didn't want to steal the spotlight or moment from Josh. She'd been washing down a well-barbecued rib steak and Greek salad with frozen margarita.

Leon, her new guy, had settled on the shrimp cocktail and baked chicken. He'd transported them into his gut with chilled corona beer.

The dust had settled and all eyes were now on Nancy and her guest. She had the floor and audience to introduce the tall slim and a neatly dressed gentleman with her. Without hesitation, she pointed at Leon and said, "Mom this is Leon, my friend." Leon stood up out of courtesy. "We've been together for about three months or so, right?" she looked at Leon for confirmation.

"About that," he concurred.

Nancy continued. "He moved down here from Colorado. So far, he's been a good boy," she said jokingly to everybody's amusement. "But we're still watching to see where this will lead to," she said with sarcasm.

"Welcome to Florida," Josh yelled from his seat. "Do you like it here so far?"

"So far, so good," Leon answered. "It's also been more interesting and welcoming since I met Nancy, your sister."

"That's good to know," Elsie said with a double head nod.

Nancy cut in sharply. "Leon, meet my brothers." She pointed her fingers to who she was introducing. "This is Rodney, the oldest of us all and you just heard from Josh, the youngest. I'm just the girl in the middle," she chuckled. "Josh and I have been very close from time." Jokingly she said, "Rodney does his own thing. You know how older dudes operate right?" She posited rhetorically.

Let Me Die

"Nice to meet you guys," Leon said and extended his hand to shake his potential brothers-in-law.

"Same here," said Josh. Josh, in turn, pointed and introduced his entourage. "This is Rita, my girlfriend and Natalie our daughter. Next to them is my very close friend, Laura and Dave her fiancé," he concluded.

"Nice to meet you guys," said Leon.

"Rodney, everybody but you brought a guest or an acquaintance. What's going on?" Elsie said. "I didn't mean to put you on the spot."

"But you already did mom," Rodney said. He smiled and scratched his head as he struggled for an answer. "Mom, don't worry, I'll surprise you soon," he lied to wriggle himself out of the spotlight.

"How soon?" Nancy pushed and teased him further. She knew that was the only way to get Rodney to talk. Otherwise, he wouldn't.

"As soon as you take Leon off the radar," Rodney joked surprisingly. He and Nancy had been trying to bridge their differences since the last meeting. They'd spoken more on phone to each other than before.

"Not to put you on the spot though, I'll take you up on that offer. I'll be on you until you spin that surprise," she ended with a giggle.

Rodney was the last person that came to the party after Josh. Security was paramount to him. Prior, he'd contemplated whether to attend or not. It was no-brainer to him that was an important family reunion, which he couldn't shy away from because it would send a bad signal.

The family didn't know he'd fled because of the cops since three days. It was Elsie's call that compelled him to be there. Her call had come in as he was dressing up to take the bull by the horn.

"Hello mom."

"Rodney, where are you?" Elsie inquired.

"On my way," he answered.

"Everybody's here but you Rodney. Hurry down here son. We miss you." She said affectionately.

"You'll be seeing me shortly," he promised. In about fifteen minutes, he got there as he'd said.

Scott remained calm and out of sight in the motel. He'd waited patiently to checkout the next day.

131

Meanwhile, Mr. Mark William, the police chief, had ordered surveillance around Elsie's house that Friday. They'd planned to hunt down Rodney and Scott that night, wherever they were and whatever it took. Tips had pointed the officers to various directions but without any specific locations. Ironically, the cops were an hour behind Rodney who'd been inside Elsie's house since 5 pm, before their surveillance.

Ms. Carlyle saw Rodney sneak into Elsie's house earlier. If she knew with certainty that the kid who'd grown up before her very eyes had masterminded a criminal activity, she would be justified that she fed Officer Fredrick the right information, especially if Rodney was caught. But in the meantime, Carlyle had glued herself to the window inside her living room. She'd peeped undistractedly at two unmarked silver and black dodge charger cars, in which two undercover officers had planted themselves for Rodney and Scott. She chose not to be a fink against the child of a powerful and connected neighbor. It might come with repercussions.

It was already 7.45 pm since the party started. The family and guests were having a good time with the food, drinks, and each other's company embellished with interesting and engaging conversations. They discussed basketball, football, music, and business, an obvious common ground for everybody. An interchange between Areta Franklin and Elvis Presley songs respectively, wafted some relaxing lyrics on the background. Elsie's large living room was the venue. A forty-six inches high-density television was permanently on the sports channel. It showed different sports highlights. Television sport gurus reeled out sports commentaries, which continued to fuel ongoing discussions, disagreement and argument among them.

Suddenly, a breaking news interrupted the sports broadcast on the television and got everybody's attention. It was 8 pm precisely. A female news caster appeared on the television screen. "This is a breaking news. "The Hollywood Police Department is looking for these men whose photographs appeared on the screen – clear pictures of Rodney and Scott were shown on the screen – in connection with forgery, burglary, and armed robbery. Rodney is believed to be the mastermind behind these criminal activities while Scott was the executioner. The police is asking for your help and tips to take these men off the street before

they do more harm. If you see any of these men, please call the police immediately. Do not approach them. Scott is believed to be armed and dangerous. Please do not approach him. Rather, call the police immediately. That was the breaking news," the announcer concluded.

Silence pervaded the room. Shock and awe held everyone hostage. They turned around and looked at each other in total disbelief.

"This is an utter nonsense," said Josh. "Are they out of their minds or it's a case of mistaken identity? They can't be serious."

Elsie and Nancy were totally tongue tied. Rodney pretended not to know nothing about that "crap" as he described it.

"To be double sure, Rodney, do you know anything about these allegations?" Josh asked subtly to clear up the air among their guests.

"Not at all," Rodney responded emphatically. "I don't know an iota of the crap they'd just said."

Elsie was visibly livid. "Didn't the police just talk to you three days ago?"

"They did," he answered. They know where and how to reach me. I don't know what it's all about and now came this crap," he lied.

Nancy rolled her eyes in surprise. "I didn't know there was police issue going on in the first place. Nobody had said anything to me. Josh, you didn't mention it for once?" she remarked.

"I'm shocked like you," Josh said.

That discussion revolved around Elsie's immediate family. The guests, including Rita, stayed out of that sensitive topic. They watched from a distance as the family struggled to figure out a solution out of this unforeseen trouble.

This was a hard pill to swallow for Elsie. She'd found herself in a dire-stretch and was concerned about what was proper and legal to do in that situation. As a patriot, her civic duty was to turn in her child to law enforcement, albeit against her wish. But she would let Rodney do that voluntarily.

"Rodney, I suggest you turn yourself to the police tonight since you feel strongly about your innocence. The earlier you get this allegation cleared, you'll have peace of mind and save family reputation. It's a

difficult and regrettable suggestion from to her child. I wish it'd never come to this," Elsie concluded.

Josh threw his support behind his mother. "Mom was right. You shouldn't let this linger longer than necessary before the cops conclude they had the right suspects, if you fail to turn yourself in. Your family is strongly behind you. We would like to see this nonsense cleared up sooner than later."

Rodney alone knew he'd hoodwinked his family to believe he was innocent from those allegations. Regardless, he'd rebuffed family entreaties to turn himself.

The breaking news repeated again by 8.30 pm. Fear and anxiety had built up within Elsie that the cops might raid her house in search of Rodney. That would portend serious consequences for her. Her integrity would be on the line if the cops accuse her of providing support to a fugitive. As tough as it was, she took the bull by the horn. Elsie invited her three children into her bedroom for an adhoc family conference.

Among their decision was to hire another attorney to represent Rodney. Elsie knew that Buckman wouldn't be an option since he was the victim of the robbery. Also, it would amount to a conflict of interest. However, she still called him for legal advice.

Buckman knew he shouldn't be involved. Kindly, he advised that Rodney turned himself in given the urgency of the situation and search for an attorney after.

They made the toughest decision to call the police. Elsie dialed 911. They left the bedroom for the living and joined the guests.

There was serenity in the living room. The guest showed some respect and empathy to the hosts. They watched the sports and analysis on the television quietly. The decorum was so absolute somebody could hear a pin-drop.

Rodney had calmed down finally and had accepted his fate. He waited to turn himself in whenever the cops arrive.

Within six minutes of the call, sirens blared from opposite directions of Elsie's house. Four police cars ground to a halt in front of her house. They were reinforced by the undercover officers already lurking around Elsie's vicinity. The cops alighted from their vehicles carefully. Quickly,

they gathered around the police car directly in Elsie's frontage from where they planned their strategy. In another minute, two uniformed officers stepped onto Elsie's porch and knocked on the door. Others strategically positioned themselves attentively around police cars to support their colleagues if there was any incident. Each of the two undercover agents went to the opposite sides of the building towards the back door. Guns were drawn for immediate response if push came to shove.

Josh let the cops in. Four minutes later, Rodney emerged from the house in handcuff without incidence. The police placed him at the back of the closest car. His family and guests watched from the porch. One of the officers stood by and listened when Josh was talking to Rodney through rear window of police car. The police gathered and conferred among themselves again while the squad leader radioed the police chief.

Rodney was driven in a fully armed police convoy to the station. Unfortunately, the family reunion party was brought to an abrupt end. Nancy stayed for the night with Elsie.

The staff at the Guest Home Motel wondered why Scott decided to go clubbing that Friday night. He'd never left his room in the night since he'd lodged there for four days. They smelled rat in that unusual behavior but nobody knew exactly.

They were clueless about the breaking news, which had declared Scott a wanted man. The television in the lobby usually showed foreign channels, mostly Middle Eastern and Indian. That was an eye service whenever a Gutera family member was around.

Only two entrances led into the motel. The front door was the main entrance and the only access at night whenever the rear was locked, usually by 9 p.m.

Unlike the staff, Scott could change television channels in his room. He'd seen the breaking news in that process. He fled the motel quickly before the staff got wind of it. His instinct told him Rodney had been nabbed. He'd not heard from him since Rodney left for the dinner.

The fear of the unknown sent Scott fleeing in a twinkle of an eye. He thought, if Rodney was truly captured, the cops might likely coerce, threaten or even persuade the latter to expose him. "I'll be captured if I should wait to check out tomorrow," he cautioned himself. The motel,

which had sheltered Scott for those many days, became precarious to him suddenly.

Before he left, Scott threw on his hooded gray sweatshirt over a gray tee shirt and wore them on top of a pair of blue jeans. He'd left a few minuscule items in his room deceive his host that he still occupied the room. That was the last time the staff saw him.

Chapter Fourteen

The police kept Rodney's arrest a guarded secret from the press and the public for the simple reason that the bigger fish, Scott, was still on the loose. As the police Chief remarked, "I'd rather we starve him of information so he could speculate than help him plan the next strategy through the television."

At the station, Detective Valerie and her team had descended on Rodney with a light interrogation. "We're asking for your cooperation. I'd appreciate you come clean with us because it'll make things easy for you and for everybody. But you've been uncooperative," Valerie said persuasively. She resorted to use a softer, calmer but professional voice. "Rodney, we understand Scott is your very good friend and we already know his full identity. All we need from you is to tell us where he's now. He needs to be off the street tonight before he does more harm to innocent people. Can you tell me? I know you know his whereabouts."

Valerie's strategy didn't work. The chief decided to pull a different strategy drawn from his previous interrogatory experience. He stepped out to the lobby with Valerie for a brief conference. They returned about five minutes later to Rodney. They'd been careful not to come across as interrogating him at that time because it could be counter-productive. Chief William started the second round of request this time.

"My friend, here's the deal. We'll work out a plea deal with you if you decide to pursue that route with your lawyer. I'm aware you need your lawyer before you make any statement. Let me be clear; you aren't under interrogation now. The immediate plan is to find Scott and we need your cooperation. There's no telling what an anxious fugitive might do next. Think about it this way; God forbid. He could kidnap your relation to get around the police or even indulge in unwarranted harmful behavior that endangers the lives of other people. The police would like to nip these speculations in the bud than to regret. I wish you would understand our worries," Chief William said.

Rodney appeared interested in the offer and the Chief noticed it. The latter cashed in on it to push a final strategy. "Take a few minutes to think about the offer." The Chief left the room again with the detective.

"It was a good offer," the suspect thought. But he'd never trusted the police. "What if it was a booby trap?" he wondered. He needed an assurance that the police would be trusted to honor their promise before he divulged any information.

The chief returned into the chatroom. "I'm sure you're ready to talk to us now?" he asked Rodney.

"There's no guarantee you would uphold your promise. I'll stick to my rights to remain silent."

Valerie interrupted and said sternly, "I'm a bit offended you said that. As trained officers, we conduct ourselves with integrity, which includes standing by our words within reasons." "This guy needs to get off the street sooner than later. The Chief had been clear about this and had offered to work with you. I believe you don't want your friend or any officer hurt. That's why we want him in custody peacefully."

The police chief was a bit frustrated. "You insist on having an attorney present. The court will appoint one for you when you face the judge soon. You could provide your private attorney, if you have one. No more time to waste on this issue. These are your choices."

The change in his tone was noticeable. Rodney knew they meant business and decided to soften his stance. "I didn't mean to be difficult. Here's where I suspect Scott would be."

"Where's that?" asked Valerie.

Let Me Die

"Look him up at Guest Home Motel."

"Where's that?"

"The motel is at a blind alley on Gutera drive."

"What's the room number?"

"Room number thirteen."

"When was the last time you talked to Scott?" Chief William cut in.

"Yesterday," he lied.

"He's still there right?" Valerie asked subtly.

"I don't know." He retorted.

Valerie looked at Chief Williams for an instruction. She calculated Scott would be gone if they wasted more time.

"Sergeant, I want you to dispatch officers to Guest Home Motel now," the Chief instructed.

Sandra had been silent all the while.

"What's your role in the burglary and robbery?" Valerie chipped in.

"I'd indicated I would not answer personal questions without an attorney present," he insisted.

"Who else played a role here? Don't lie to me," Valerie followed up.

"Ask Scott and his girlfriend that question later," he volunteered.

"You said 'his girlfriend; who's that?" she pretended like she'd never met Hannah before.

Rodney was hesitant to mention Hannah. He'd realized he'd slipped his tongue and decided against answering more questions. "Hannah would definitely give me up." It occurred rather late to him. It was too late to retract his words. Also, he'd not known his neighbor in the cell room across was Hannah.

They'd gotten the immediate information they required for their next operation. That preliminary chat was halted by the Chief. Interrogation experts would follow up at the appropriate time.

Officers Ross and Terence had led a squad of four other officers on 'Operation Capture Scott' and had raided the Guest Home Motel. The squad turned in a negative report to the chief. They'd surrounded the motel around 9.45 p.m.

Ross, Terence and two of the officers went inside the motel. While Ross and Terence waited at the reception, the other two officers stood guard by the door of room thirteen. Their service pistols were drawn as they waited for orders to barge into the room.

The motel staff were terrified. They informed the police that it was a near miss. Scott had been gone since 9.20 p.m. But the police matched their description with what they had on record.

Notwithstanding, the officers searched room thirteen for evidence. They collected Scott's fingerprints and continued the search at surrounding lodging areas, gas stations and public places. Scott wasn't at the 'Dancers Night Club' and his Grand Am wasn't seen either.

Two officers waited around the motel all night for this fugitive in case he decided to sneak in alter. The other two were joined by more officers to patrol the vicinity that night.

It was time to retire for the night, but the Chief wouldn't until his squad leaders came back. The next agendum was to hunt Scott down the next day. Police's other premise was that he'd left the motel environment. He'd carjacked someone probably to disguise and get away.

HPD spread their dragnet to other cities. The department was eager to hear from anyone who'd been carjacked and robbed within the next twelve hours. These precautions preceded the disappearance of Scott from the motel.

An offer for lesser sentence and community service was extended to Hannah to work with the police to trap Scott the next day. It was emotionally difficult at first, but she accepted. She'd been remorseful and cooperative with the police unlike Rodney.

Chapter Fifteen

The police was ready to go to the River City Shopping Mall. Unexpectedly, a young man called and reported he was attacked, robbed and carjacked. It happened at a gas station twenty minutes away from the Guest Home Motel. The assailant had snatched his wallet and ash color ford focus at a gunpoint. His description matched Scott's height. That robbery happened around 6 a.m. that morning.

The Patrol Officers who'd rushed to scene recovered a Grand Am car, which they towed to the station. The fingerprints from the car matched those at the motel and indeed they were Scott's.

Meanwhile, inside her solitary cell, Hannah had become frustrated that the cops had set her up for a dirty job against her boyfriend. Like the biblical Judas who betrayed Christ, that would hunt her indefinitely. But put differently, Scott had put her in that situation, she noted and loathed the thought of long jail term. For now, love comes last to her while the plea deal comes first because the cops had enough evidence to convict her. Jail term was inevitable if that happened. It would be a matter of time. She would have to face the judge and learn her fate.

As she worried about her future as an ex-convict, the time she would waste while in jail and the social ostracization, tears gushing down Hannah's cheeks like a flood. She blamed herself for not recusing from

that forgery mess. In a sudden jolt of anger, she banged on the wall in her cell and said, "Dammit. I should've insisted after I'd declined that shady job." Referring to Scott who'd persuaded her, she yelled, "You vagabond. Don't let me set my eyes on you because I'll eat you alive."

Corporal Pamela was attracted by the noise. She rushed to the scene. "What's going on Hannah; you alright?" she asked through the bars on the door.

"I'm alright. I had a hallucination. I apologize," she covered up.

It was 10 a.m. Detective Valerie and Sergeant Sandra were ready for the day's operation. They escorted Hannah from the cell and put her inside her jeep.

"Here's your key. You're driving and we're riding with you," Valerie told Hannah. She sat in the passenger's seat in the front by Hannah.

"No," Sandra said. "I'm driving." She took over from Hannah. "I'm sorry. Please sit at the back."

"I'm I missing something here?" asked Valerie. "That wasn't the plan. Help me understand." Valerie was confused because it'd been planned and agreed among the officers that Hannah would drive her car to the mall.

"I'll tell you later why I changed the arrangement. But Hannah will finish up when we get close to the mall." Sandra said.

"Let's talk for a second," Valerie requested. They stepped aside from the car but still kept close eyes on Hannah.

Sandra started, "Val, our safety comes first. I'm not prepared to entrust my live to a suspect. We'd just learned from Corporal Pamela she was frustrated this morning. What if she drives us into a ditch or an oncoming car? This person might be suicidal due to her situation. I'm not prepared to take that chance because of my kids at home. I want to go home to them at the end of the day," Sandra concluded.

Valerie agreed with her. "I see where you're coming from."

Sandra cuts in, "She'll finish up when we're closer," as I said before. "We would've lessened the danger. I didn't forget the plan at all."

"Is she going on handcuffs?' Valerie wondered.

"Poor thing. I don't think she poses any threat. She carries herself well if not she entangled herself in this quagmire," Sandra said.

Hannah was spared the handcuffs while behind the car. Sergeant Sandra got into the freeway 45. The drive would be 28 minutes to the mall.

Minutes away to the mall, Sergeant Sandra pulled up on the curb. She hopped out and said to Hannah, "Your turn to drive my dear." She sat behind while Hannah went behind the wheels.

When she approached the signpost to the mall, detective Valerie said, "Make a right turn at the intersection."

"Alright," she responded. She turned right at the intersection.

"Make another right into the main parking lot and park at the empty space on the far right by the light pole number five."

Hannah got to the spot and turned off the ignition and waited for the next instruction.

The police planted Hannah inside her jeep. She was positioned at an unoccupied area of the open parking space of the popular River City Shopping Mall. The safety of police officers, Hannah, shoppers and Scott drove the police to choose the area. The most paramount in that operation was to capture Scott alive without incidence or harm to anyone involved.

The mall was chosen because it was neutral. Scott could blend into the crowd easily and didn't have to bother with Hollywood Police Department. The mall was familiar and his favorite. But the cops didn't know that.

―⁕―

The cops had wired her car to be able to tap into ongoing communication with Scott. The police believed Scott was hiding somewhere around and hadn't left the state of Florida.

Hannah was handed a prepared script, which contained sequential instructions, to facilitate her communication. The tone was mostly a sweetheart kind of offers enough to tempt a fugitive who'd ran out of

resources. The instruction was neither to disagree with his requests nor argue with him until he fell into police dragnet.

Initially, Officer Bennett was planted at the back of the car to guide Hannah. The police rethought that idea and withdrew him for security reason. The fear was that Scott might become aggressive and hurt Hannah in the process if he spotted a cop with her. The police had to rehearse the script with her.

"Here," Valerie said. She gave Hannah back her cell phone they'd seized during her arrest. "Call Scott to start the process." She looked at her wristwatch. "It's just 10.32 a.m. If things go as planned, we'll be able to get out of here pretty soon with Scott."

"It might be a little wait game before until he arrives. It depends on how you've convinced him," Sandra added. "The ball is in your court."

"Any questions for us?" Valerie asked. "Once the conversation begins, you're totally in charge. No more noise on the background otherwise, he won't show up. This is delicate and requires utmost carefulness. We can't make mistakes at all." She peered into Hannah's eyes. "Are you ready for this?"

"I'm ready, but scared a little. I don't want to be hurt please," Hannah became panicky.

"You'll be okay. Just follow our instructions," Valerie said. She rubbed Hannah's back affectionately to show her human side.

"Please, don't to kill or harm Scott in this operation," she pleaded amidst some sobs.

The police officers empathized. However, they've got a business to take care of.

Sandra cuts in again. "This is what we do often to keep the community safe. The police are humans. Like everyone, officers love life and our families too. But when there's business to take care, it's no-brainer. No officer would fire his or her rifle unless it's critically necessary. We have your back from our hideout as well as eavesdropping your conversation. An important request from you. Please don't attempt to flee with this car when you're alone. It might spell serious doom for you. Undercover and uniformed officers are planted around the mall and watching as we

Let Me Die

speak. You can't go far at all, that's if you make it out of the mall. You've been so cooperative. We appreciate it sincerely," Sandra said.

The officers came out of the car "We plan to stick around until Scott responds," Valerie said. "We'll leave to take our positions once he indicates he'll come down to see you. Alright, please make the call."

Hannah called and he didn't answer. She repeated the call two minutes after. There wasn't any response still. She left him a call back message.

Scott saw her missed calls. A veteran criminal of his caliber wasn't in any hurry to make or answer calls carelessly in his circumstance. He knew the police sets booby traps sometimes. It was also possible that they were trailing his calls. He played safe and stayed off his phone.

They've been incommunicado from each other for six days. He wasn't aware she'd been nabbed but rather thought she'd heard the breaking news. His defense would be to maintain the out-of- town alibi if she confronted him. A little delay tactics before a response was sent would buttress his lies he thought. However, some risks were involved even to return the calls. He believed the police must have bugged his phone by now to tap into his conversations. "So cautioned would be the watch word," he advised himself.

Money would push Scott to take a risk since he'd completely ran out. His girlfriend would serve that purpose and still be his informant at this precarious time. "I'll be safer to ask her for money than to dive deeper into more crimes to survive," he thought. "More crimes meant more charges against me whenever I'm caught."

Scott chose the devil's alternative to contact Hannah. It'd been about fifty-eight minutes since her last call. That was enough time to drive three quarters of the distance he'd lied that he went using his apartment as the measure. Presumably, he was about 22 minutes away from town. That was exactly how Scott decided to reframe his lies, play his game and maintain his alibi.

His thought switched back and forth Rodney occasionally. He'd given up on him. Scott was worried that Rodney hadn't contacted him since he left the motel to see his mother. "Three scenarios were likely here," he opined. The cops took him in probably or he'd voluntarily

turned himself in or he'd chosen to remain silent and got off the phone like him. He knew Rodney wouldn't run and hide for long because his mom was a popular figure around the community. His wished Rodney would develop a thick skin than to become a fink or snitch for the police. Scott decided angrily and vowed, "If he blackmails, I would expose that son-of-a-bitch to his mom and the police. We'll go down to hell together." Scott blamed Rodney for his situation. "He owes me some ransom, now that I thought about it. He's to pay up to appease me or hell will let loose. I don't care where the hell he might be now," he cursed angrily, "I'll continue to call his damn phone until it busts. I'll hunt him down until he pays up."

In a twinkle of an eye, an evil grin flashed across his face. An idea, seemingly good, crept into his head. Rodney's rich mother would likely pay the ransom to protect her reputation. "Elsie would have to pull the strings for her son for once," he mocked.

All the while, Scott had camped inside the premise of a derelict small strip mall. He'd been sitting inside the car he'd snatched from the young man who'd reported it stolen to the HPD that morning. The car was backed into the fence deliberately to conceal the registration number. He rolled the tinted glasses of the dodge charger to the brim and reclined the seat to relax for an hour. It was safer not to drive around aimlessly in a stolen car much more while on the spotlight. A little nap would surely soothe his nerves from all the runs he'd done since the previous night. His cell phone alarm was set to wake him by 12.45 pm in case he fell asleep.

Scott had reflected on various risks he'd taken for Rodney for mere pittance or none in some cases for the sake of friendship. There's nothing to show for it. It seemed like a personal regret or repentance as he recounted his lifestyle. "I've lived most of my adult lives on the street, in and out of short or long jail sentences. Unfortunately, there isn't many choices or options out there for people like me who'd been tagged as ex-convicts. Some of us want to turn our lives around. Sometimes, the society drives us back into crime because we're denied opportunities to prove we could do better or turn our lives around. I've got to survive somehow, at least, to get the basic food and clothing. Snatching,

home invasion or armed robbery occupy the mind until the unforeseen happens. Do I like that lifestyle? Hell no," he screamed within him.

Hannah resurfaced in his thought. "She was a disciplined woman of integrity. I wish I'd shunned my ego and adhered to her admonishments? The crack head only aunt of mine couldn't do anything for me, not even an advice. I'd ignored Hannah two years ago when she asked me to learn a skill, my life would've been far better," he regretted.

"Nobody had guided or advised me during childhood because I barely knew my parents. Death had snatched them away very early from me." Tears welled up his eyes. I love freedom like everyone. If I'd acquired good education or good skills through apprenticeship, I would've lived a clean, decent and straightforward life than run from the law all my life. Now, a long jail time stares me in the face." He shook his head sadly. Scott lit his last cigarette and drew some smoke inside his lungs. As he puffed out the fume, he looked vaguely at shoppers who sauntered along the hallway of the strip mall.

He'd considered to give himself up to the police but rescinded that idea for a simple argument that the law would still apply equally whatever he did. He thought he'd better enjoyed the remaining freedom until it fizzled out than to play chicken with the police.

He'd planned to call Hannah by 12.45 p.m. after he'd woken up. It was 11.48 a.m. in the morning. This would be the genesis of losing normal sleep. Fatigue would set in every now and then, reciprocated with short naps here and there until fate catches up with him.

A call came in as he was about to dose. "Oh boy. It's Hannah again." He answered drowsily. "Hi honey."

"Dude where are you? You've kept me at bay for almost a week. I'm worried about you. Is everything alright?" she asked as informally as possible.

"I apologize. I'll tell you when we see. But everything is fine notwithstanding."

"Are you in town?"

"About twenty-two minutes away. I stopped to buy some gas."

"Are you going to your apartment?" she snuck in subtly.

"I'll get home first and then see you after," he lied. That was a prank to gauge what she knew about him as far as a fugitive.

That was an opportunity for her. "Don't return to your apartment honey. It's unsafe for you right now. That's my advice."

"Why not?" he pretended.

"It's not something I want to discuss over the phone. To give you a heads up, the police is looking for you. They might be hanging around your area to grab you."

"What," he screamed. "For what?"

"It's not a phone conversation. See me as soon as you could at the River City Shopping Mall, "she prodded him. "Nobody has talked to me about you so far. There's no it'll happen any time in course of their investigation. I'm purposely waiting at the mall to talk to you. Home is too precarious now. I'd be glad if you'll hurry up," she said.

"I'm heading that way right away. Can I borrow some money from you please, if you have? I'm a broke ass now," he said.

"I have some money for you. Please hurry up so I could leave this place quickly. I'm at the main parking lot. I'm alone at pole number five. You can't miss me," she said.

"Very good. Let's get off the phone now. In case you wonder, I'm driving a friend's silver color dodge charger with dark tinted glasses. My car parked up along the way. See you soon." He hung up.

It didn't take rehearsing up to a quarter of the whole script to convince him.

"Good job Hannah," detective Valerie said. "We've got to leave now before he arrives."

Ten minutes later, Scott pulled up beside Hannah. He looked around carefully before he rolled down the glass. "Hi dear," he said through the window.

"Hello sweetheart, long time?" she said excitedly. "Where you've been? Hop into my truck so we could talk."

"Scott looked around again. Every environment was suspicious so he had to tread cautiously. He left his car and sat with Hannah in the jeep.

The police had been watching attentively from their hideout. The end of wait time for them was whenever Scott left his car for Hannah's. That moment had just come. In a split second, four police patrol cars with two unmarked undercover cars surrounded the jeep and the dodge charger. The police rushed out, drew and pointed their rifles at the jeep from a safe but close distance.

"Come out of the car now," Officer Terrence yelled from behind the driver's side of his patrol car.

Scott realized he'd been set up. He pulled Hannah back into the car when she attempted to escape. His left arm went around her neck, while the right pointed a toy gun at her forehead.

"You aren't going anywhere bitch. You set me up?" he asked. "Be ready to die with me," he threatened.

Hannah melted with fear. "No. I didn't," she retorted. "Please don't hurt me."

The police had been used to the tactics used by fugitives to kidnap and use their victims as human shield. They softened their tone and approach when they noticed he had a gun and a hostage. Nobody could tell it was a toy gun. They approached the car with care to a point every movement was visible to them. The situation at hand was handled with caution for the safety of the hostage.

"Drop the gun now," the Officer yelled out an instruction. "Please follow police orders. We don't want anybody to get hurt." The Officer used a blend of instruction and persuasion.

Hannah reinforced the instruction. "Please drop the gun, honey. You don't want the police to shoot us. Please do it for my sake." Her fear was heightened. "Let's surrender now honey." She raised her arms up in the car.

Scott let go of Hannah following her plea and denial that she'd not set him up. He dropped the toy gun inside the car. His hands were visibly raised up in front of the jeep.

"Step out of the car," Terrence yelled, still pointing his gun.

With hands still up, Hannah alighted from the car. To clear doubts that he didn't have a gun, Scott remained in the car so the cops would open the door.

Two officers rushed to the driver and passenger's doors respectively, from behind, and forcefully overpowered him. They dragged him out and gently lowered him to the ground. He was handcuffed, frisked and taken to one of the patrol cars.

Hannah wasn't handcuffed because she wasn't viewed as a flight risk any longer. The cops put her behind a different police car.

Operation Catch Scott was led by Detective Valerie. "We got him," she told the police chief over the phone.

"Oh, that's a good news," the elated Chief responded. "I'm so happy. Any incidence?"

"None sir. Nobody was hurt. In fact, we're getting out of here in a minute."

"Alright, I'll be here. Good job." Chief William hung up.

The police refrained from answering questions from two unexpected reporters and a cameraman. Officers knew that "no comment" was the trick with journalists, whatever they asked and however the questions were framed.

The dodge and the jeep were searched. The toy gun was recovered from the jeep but nothing from the other car. Before they left as a convoy, the police called for two tow trucks and transported the aforesaid cars to the HPD station.

Chapter Sixteen

Elsie and her kids came to see Rodney at HPD with Ethel Manor, a criminal defense attorney. Rodney insisted on seeing his attorney before he would make a statement or cooperate with interrogators. Mistrust led him to reject a government appointed attorney.

Rodney was among the groupthink conspirator theorists who'd believed that government lawyers barely represented the citizens. Rather, they remained loyal to the government, their paymaster, whose ultimate intent was to arrest, prosecute, convict and jail. He didn't expect his case to be any different or an exception. Adamantly, he stuck to his gun to get a private lawyer, however long it took to get one. He exploited his mother's support in that regard.

Ethel, his attorney, had a tête-à-tête with Rodney about the case. Rodney had denied any direct involvement in the whole saga. "I'd been associated with Scott because we're close friends." He lied to the attorney. Ethel sat with Rodney throughout his interrogation that morning. She observed him take questions from two interrogators and also while Rodney penned down his statement.

The district prosecutor, Sophie Tyman, refused to discuss possibility of plea deal for Rodney with Ethel because she thought the suspect

didn't tell the truth in his statement. She insisted on taking the case before the judge based on police investigation.

Ethel was confused about who to believe, the police or her client. She sought another private audience with Rodney before his family. "I asked for another opportunity for an attorney-client privilege to discuss the concerns of the district attorney. It didn't smell good so far. The district attorney didn't took your statement with a grain of salt and didn't even want to hear about any plea deal."

"Really," Rodney exclaimed in surprise. "Last night, the police Chief promised me a plea deal if I told them Scott's whereabouts," Rodney said.

"Hmmm. Interesting. Did you tell them?" she asked curiously.

"Yes I did."

"Whoa. Bad idea. The police wouldn't exonerate you easily if you've told them that no matter how you profess your innocence. Always remember these are intelligent officers. I can bet you they'd already extracted lots of information from that response. To say you knew where Scott was implied you probably had a hand in it or aided him."

Elsie cut in. "So what's your next step from here?"

Ethel switched her gaze to her. "I'll know in a minute. It's important we come to an agreement with Rodney first. That would point to the next direction we'll follow."

"Alright," replied Elsie. "Do your thing."

Using a direct eye contact, Ethel asked Rodney to open up to the family what he knew about the forgery and armed robbery at attorney Buckman's office. She was blunt and serious. "I'm your attorney now, no matter how brief or temporary. I need to know all the truth from you in order to figure out how to defend you. This is a felony and not a joke. You're looking at a minimum of six years or more dangling around your neck if convicted." She'd concealed a privileged information which Sophie just shared with her until she'd heard from Rodney again.

Sophie had revealed what Hannah had said about Rodney.

Rodney looked morose at first as he stared into the thin air. He battled within what to disclose and the best way to present it. The atmosphere was charged by the presence of his family. They wanted to

hear it. He was concerned that he would disappoint his mom and Josh, who'd always stood strongly behind him. All the same, his attorney had demanded the truth and nothing less.

Apparently realizing his position, Josh called esoterically, "Rod," "Please say something if you knew about those incidence. It's better for you and everybody. We're your family. The more your lawyer knows, the better for you. She's your solicitor," he said appealingly.

Ethel looked at her wrist watch. She tossed a desperate prank aimed at hastening him. "I need to talk to Sophie before she leaves. District attorneys are usually busy. It's been about ten minutes since they allowed us to speak alone with you. I'm afraid the police might withdraw you any moment. As a strategy to keep him in check, Ethel disclosed her private discussion with Sophie. "To let you know, Rodney, the District Attorney and the police knew a lot about you from Hannah before you were interrogated. They knew what they'd considered the truth. But they wanted something from you to hinge the plea deal upon. They don't want to look stupid before the judge. From experience, suspects who're strongly convinced they're innocent, might shun plea deals based on principle. If that's your case, you could move on with the case as is. It's entirely up to you," she asserted sarcastically. She knew that wasn't an option for him.

Reluctantly, Rodney began, "Anyway, sometime ago, I'd overheard mom discussing her will with attorney Buchman over the phone. I told Scott about it. He'd asked if I was interested to know what was there for me. I said I wished but wasn't privy to it. A few days later, Scott told me he'd obtained the will." He lied with a straight face.

"What," Elsie yelled out spontaneously. The family members listened incredulously with mouth agape and arms wrapped around their chest.

"Please," Ethel pleaded with Elsie to calm down. She didn't want Rodney to be distracted as much as she wanted him to hurry up.

"Scott told me he'd attempted to alter the will in my favor. I'd thought that was one of those silly jokes he pulled occasionally. I didn't pay him any mind or got involved in any of those. He said he would take care of things but I have to pay him after. In the same vein, I agreed but never offered him a dime. I'd thought all was a joke, up till now,

until that breaking news. I swear to God, I didn't know anything about the robbery and other things he'd done or intend to do to accomplish his mission. Here I'm in police custody," he said with a gesture. Rodney shook his head. It'd dawned on him that he'd been busted. He'd disappointed his family, especially his mother. He couldn't even look them in the face.

Deep inside, Ethel didn't believe an iota of his mumbo jumbo. However, she would have to finish the business she'd been hired to do. "Alright, let me see what Sophie is up to this time," she said. "Elsie please come with me. Guys excuse us for a few minutes."

Sophie was cooperative this time. She requested for Rodney to amend his initial statement to reflect his recent change in story. As a condition for a plea deal, he'd signed an agreement to testify against Scott in court. "Mind you, this isn't a guarantee. To grant this request or not is the judge's discretion. It'll be his decision entirely," Sophie said. "On my part as the prosecutor, I'll not oppose a reduced sentence and community service for him if the defense pushes for it." She paused for a sip of water. "We'll see what happens in court next week. I'll suggest you don't count your eggs before they hatch. You can't be sure of your cake until you have it."

"I understand," said Ethel. Seizing the opportunity, Ethel asked, "How about a bail for him today?"

"I'm not going there. The judge will make that decision during the preliminary hearing on Tuesday," Sophie responded. In her personal opinion, she'd considered Rodney a flight risk regardless of his mom's credibility. "For Elsie's sake, I'll not argue against a bail if you ask the judge for it. I'll let it fly."

Ironically, Rodney and Hannah still didn't know they were cell mates, even closer than they would've imagined. Probably, they would in court. Their commonality was that each of them had been processed, interrogated and looked forward to reduced sentences. It remained to be seen whether the plea deal would apply equitably for both.

As it stood, Hannah was better positioned because she'd attracted some innate sympathy among the female police officers. In addition to her gender, which had curried affection, she'd been cooperative,

obedient, calm and intelligent. Throughout, Hannah had distinguished herself with class.

The police was puzzled how she got into that mess. They believed she didn't belong to such a quagmire, which had enveloped her two malevolent counterparts. Detective Valerie and Sergeant Sandra had been particularly kind to her much as they'd walked the fine line between professionalism and personal interest.

Corporal Pamela was more often in the office than in the field. She'd been underground in the entire picture, although she was more around Hannah than any of the field officers. Her goodwill towards Hannah couldn't be minimized. While on duty, she checked on Hannah often and provided her little needs, which the corporal could afford around the office.

Whatever their positions, the cops recognized Hannah's culpability in the case. None treated that with a wave of hand or condoned it, yet neither of them wanted her to go to jail, not after she'd been used as a booby trap for Scott. They reasoned she'd made a great sacrifice, which could've hurt or killed her if Scott had gone haywire with the cops. That reason united them to work with the prosecutor to make the plea deal happen.

The prosecutor hung unto Hannah as a principal witness against the other two guys. Her testimony would particularly damage Rodney by direct contradiction and reversal of the lies he'd told Ethel and also submitted in his statement.

During interrogation, Scott barred his mind about Rodney. At first, he'd been recalcitrant with the police.

The cops pulled the same stunt meted to Rodney-plea deal- to get Scott to talk. It'd played to police's advantage these two culprits didn't know each other's whereabouts. They police played it by the ear with each them.

Scott explored the plea deal opportunity to his advantage. He'd thought the cops would use him to take Rodney into custody.

The cops played his games with Scott. They gave him his cell phone to call Rodney as he'd requested. Officers didn't interrupt. The strategy was to let him exhaust and expose himself in the process. The imaginary

Rodney at the other end was the police who were also in possession Rodney's phone as well. As part of police prank, the officers told Scott not to reveal his location, but rather leave an exhaustive message for Rodney if he didn't answer.

Expectedly, Scott fell for the trap. He'd blabbed their business and had threatened Rodney by the messages he'd left. He'd recounted their discussions and processes that led to altering Elsie's will. By the end of that call, Scott had corroborated Hannah's testimony and had tied himself and Rodney together as symbiotic partners in crime.

From that phone call, the police had concluded that Rodney was the mastermind behind all the crimes, from home invasion to the robbery. All of those crimes revolved around successfully forging Elsie's will. The cops gathered that he'd hired Scott as a paid executioner of those criminal activities and that they'd planned all of those together. The exception was that Rodney invaded his mother's house by himself, otherwise, the rest were credited to his henchman. The cops also believed that Scott had used toy guns based on the one they'd recovered at the mall.

In all his statement and blab, Scott deliberately left Hannah out of those. That was his reciprocation of her nicety to him. It wasn't because he'd forgotten that the genesis of their crime was due to her advice as a professional secretary. Prior, neither he nor Rodney had thought outside the box to process that document.

What bothered Scott was whether she'd set him up for the police, or was unfortunate to be under surveillance set for him and incidentally caught up in the brouhaha for being nice to a fugitive. The court would clear his doubt in the days ahead.

Chapter Seventeen

Janet took Nancy out to visit some of Goodwill Home Healthcare, GHH, clients. That was her Tuesday weekly routine. She was flexible with prioritizing her time to accommodate clients who wanted to see her for particular reasons outside her schedule.

Since they'd worked closer together, Janet had liked Nancy a lot. She'd been quite pleasant and open to teach Nancy what it took to build and maintain a client base, manage the employees and comply with health and state laws and other regulatory bodies.

Nancy shadowed Janet to learn home healthcare business and supervision. She'd already in a nursing program at a community college. It'd been tough to combine full time studies, especially nursing, with work at a fast paced business of patient care. However, she and Josh had resigned their positions from their previous jobs after they'd discussed with Elsie.

Elsie had instructed Nancy to face her nursing school squarely and work part time at GHH for full pay. The consideration was that Nancy would take over Janet's job after the latter had moved on. Elsie had also planned to retire after her daughter and son were done with school. The school was to equip them with the required skills to run the business effectively.

They've just left the home of Janet's last client for the day for the

office. That client was Ms. Joice, a 67 year old female, who'd been with the company for twelve years. Due to exhaustion, the duo were mum about ten minutes of the drive until Janet broke the silence. "What a day," she said amidst yawning. "Can we grab a bite to eat somewhere, I'm starving?

"Sure. You read my mind," Nancy responded. "I'm hungry too."

Janet didn't mind somewhere they could relax, eat and discuss for few minutes. "What do you feel like dear," she asked Nancy.

"I don't mind a quasi-lunch anywhere. I'm looking at a Coney Island ahead. Do you like it?"

"I don't care right now, "said Janet. She pulled up at the restaurant. As the waitress readied their orders, Janet explained to Nancy the nitty-gritty and peculiarity of individual client whom they'd visited. "You'll handle the business next Tuesday and I'll stay on the sideline. That'll help you to get acclimated to the practice. It's fun when you know what to do and the right questions to ask clients. Remember, they'll look up to you as the professional."

"I'm already nervous," Nancy said with a smile.

"You'll be fine. No big deal. You'll get used to it with continuous practice. I'll be with you anyway."

Janet chose to eat-in because she had something important to tell Nancy about her Elsie. She waited until their food arrived. Janet had ordered an omelet cooked with spinach, ham, cheese, mushrooms and broccoli with hash brown on the side and ketchup.

Nancy ordered almost the same except that she substituted ham with beef and fries on the side with honey mustard. Halfway into the food, Janet switched the subject from their visit to Elsie. "Hey Nancy," she began, "You're aware your mom is planning to retire in about two or three years right?"

"Yes. She said so." She drank some Coca-Cola and waited to hear from the slim built, blue eye, beautiful woman, who'd been her mother's close confidant for ten years.

"Very good. I'm glad you guys are one happy family again. Paused a moment. "Do you know your mom's major ailment?"

"Mm. Not quite. What is it?"

"I'll tell you quickly, though I'm not supposed to because of privacy laws. However, it's secondary hypertension due to high anxiety. As you know, we've come a long way. She was rushed to the ER the last time because of that. Since then, I check her BP about three times every week." She scooped some omelet into her mouth and downed it with some water.

"Whoa. Thanks a lot. Mom never ceases to talk about you."

"Oh, that's nice to know. But it's not about me or about expecting a thank you. It's about personal concern for her health. Yesterday, her BP shot up from what it was the last time. It didn't drop after I rechecked for a couple of times. I figured your brother's arrest led to that. Anyway, it's nothing to worry about. She'll see her doctor this week. You know that right?"

"Yes, I do."

Janet chuckled. "How do you guys see her directive about not to be resuscitated?

"I don't even want to think about it. Josh too. The directive didn't take our emotion into consideration. It's hard to stand and stare while your mom dies slowly or struggles with life when there's medical help? She was right to say 'what'll be, will be.' I like to give my best shot to anything and see the outcome rather than become a defeatist from the outset," Nancy opined.

"Isn't that something?" Jane asked rhetorically. "Have you guys talked to her to drop that directive entirely for the reasons you'd stated above or streamline it into specifics of 'to do' and 'not to do' list. It's her right. However, it's hard to be compliant of that instruction verbatim.

"We've not spoken to her yet."

"The sooner the better," Janet suggested. "I don't mean to scare you. My love for your mom has now extended to the kids. I felt an obligation to discuss it with you. She'll be 73 next month with health issues. Recovery during old age is not as quick as during the younger days. You guys need to be on top of it now."

"Thanks for your concern. It's encouraging and a push to set the ball rolling than to foot drag. I objected to the idea when she mentioned it.

The time to work on her is now. I'll discuss this with Josh this evening. Thanks again."

"Always," responded Janet. "I'm all set here."

"Same here," Nancy responded. They left the restaurant for the office.

As the court date approached, Ethel met with attorney Buckman in his office to ask him to partner with the family to withdraw and settle the case against Rodney out of court. It was Ethel's idea. The family pounced on it because it didn't hurt to try. Ethel blended psychology when she espoused the impeccable relationship Buckman had had with Elsie.

In his remark, Buckman was thankful he didn't sustain any bodily harm from that horrible experience with Scott. He regretted that Elsie's son involvement had hamstrung him from prosecuting Scott to the full extent of the law. He'd already thought about it before Ethel' visit. He didn't object to her suggestion. He'd spoken to the police chief, the same day Rodney was arrested, in that regard.

Chief William didn't give definite response until he'd spoken to the District prosecutor, Sophie. He'd called Buckman back later with a negative feedback. Sophie had refused to withdraw the case. The lawsuit was between the state, the plaintiff, versus Rodney and Scott, the defendants. Sophie also noted that attorney Buckman was the victim in the robbery and also the principal witness in the forgery and armed robbery, therefore, would not recuse himself.

"Sophie had threatened to ask the presiding judge to subpoena me if I didn't show up in court," Buckman told Ethel. "My hands are tied. I wish there's other way around it to help Elsie. Worst still, Elsie might be required to testify in the court from what Chief William said. Elsie initial reported the invasion of her house. That was when her will was stolen as we seem to know now. The responding officer, Fredrick, will be in court as well," Buckman concluded.

It wasn't any surprise to Elsie that Buckman would be asked to

testify in the case. The most devastating was to learn that she would be asked to testify against her child in court. That didn't occur to her until Ethel said it.

Ethel gave Elsie a piece of her mind. "Candidly, Buckman was right. There isn't any way around this. It's a hydra-headed case and you're at the center of it all. There's no way you won't testify because the case revolves around your will, which is the genesis of it all. Remember you made the first call to the police. Worst still, Scott claimed that Rodney was the mastermind and paymaster. We'll see what happens."

Nancy posed a question. "Is there a way to make mom not to sit at the testimony box?"

"Good question. I was coming to that. There are two possibilities here; I could submit a plea to the court to excuse her by virtue of her health and emotional connection. Second, we could request the judge to grant her a deposition. It's at the judge's discretion to entertain or grant any of these applications. There's no guarantee."

"I hope the judge grants one of them," said Nancy. "I'll hate to see my mother put under stress and scrutiny by prosecutors."

"Wait till we get to court." said Ethel.

At the preliminary hearing in court, Scott and Rodney weren't physically present in the court. They were arraigned from a remote location. Hannah was present in court. She was escorted by Sergeant Sandra and Corporal Pamela.

Before their charges were read, the presiding judge, Anna Sunberry, asked the criminal defense attorneys to identify themselves.

Ethel stood up for Rodney, who was the only suspect that had a private representation. It was clear because his mom was the wealthy woman sitting at the front row inside the court, flanked by her son and daughter. Elsie did whatever was necessary to ensure her name was redeemed.

Attorney Buckman sat at the other end of the court with Sophie, the prosecutor.

The judge said to Scott and Hannah, "The court will appoint government attorneys for you, unless you indicate you could afford private representation. Any objections;

"Hannah?"

"No your honor."

"Scott?"

"No your honor."

The court clerk read their charges one after the other.

Judge Anna Sunberry entered 'not guilty' plea for all of them as they'd pleaded. The judge addressed them on their rights under the law and representation. The suspects affirmed they understood their rights under the law as read.

Judge Sunberry indicated that the case wouldn't linger in her courtroom. She was known for her patience, diligence, thoroughness and expedition of cases before her. She targeted to dispense with the case in three months at the most.

Ethel stood at this point. The judge recognized her to speak. She requested her honor to grant her client, Rodney, bail. Her request was based on personal recognition. She argued that Rodney wasn't a flight risk because the mom was well known in the community.

In denying the request, Judge Sunberry said, "Counsel, I'm not convinced your client wasn't a flight risk because of his mom. Also, I understood the mother, whom you've referenced and son, who's the suspect in this case, might be in opposite camps as far as this case goes. I hope I have that fact right?" She turned towards Sophie, the prosecutor, for clarification.

Sophie stood up. "Your honor, the mother of the suspect will be one of the principal witnesses for the prosecution. Your fact is right. As far as the bail is concerned, I'm neither here nor there. I'll leave that for your honor to decide." She sat down.

"Thank you for clarifying that," Judge Sunberry said to Sophie. She looked at Ethel and said, "Based on the circumstances surrounding this

case as clarified, I'll have to deny your request for bail. This applies to all the suspects," she dropped the gavel and made some notes. "Counsels, any other thing to address right now.

"No your honor," Ethel responded.

"No your honor," said Sophie.

"This court is adjourned." Judge Sunberry dropped the final gavel and left the court.

Outside the court, Josh and Nancy shielded Elsie from the journalists who'd approached her for interview. A couple of journalists from television and newspaper respectively, doggedly followed her to the car, sticking out their microphones up to her mouth.

TV journalist: "Mam, what do think about your son's involvement t in the case?"

Josh: "No comment."

Newspaper journalist: "You're known around town; has this case affected your reputation and business?"

Josh: "No comment."

They got to her black Cadillac Escalade SUV. Josh opened the passenger's door behind. Elsie stepped in. Nancy sat at the passenger's side in the front and Josh drove off.

Chapter Eighteen

The denial of bail to Rodney bothered Elsie. She was worried about how he'd coped these several weeks in jail, which was anomalous. The family reputation, which Rodney had dragged to the mud, was troubling to her as well. With these hovering worries, Elsie decided to have a quiet time at home with her children.

Nancy called and informed Janet about the development, though without the details.

From her experience over the years, Janet could tell when Elsie's mood changed. She suspected that Elsie's mood had derived from the outcome of the court that day. "Please wish her well for me," Janet told Nancy over the phone.

Nancy and Josh decided not to discuss her will her advanced directive particularly, until Elsie's mood improved. Rather, they chose those subjects that brightened her day and distracted her thought from Rodney. Their academic success, social lives and progress with their wedding arrangements were among the topics.

Success stories about Elise's children was no brainer to her. She'd already offered to foot the bill for their wedding. Laura, who'd organized the wedding, picked the same day for Nancy and Josh at her court

registry, the same registrar, the same venue for reception and a common guests.

Leon won a spot in Elsie's heart by his affection, gentleness and warmth towards Nancy. Such a handsome, caring and devoted young man was the type of guy Elsie wanted around her only daughter. She'd seen them together more often after the party.

Nancy agreed to seal it up quicker with Leon after her mom had sparked her interest through her insinuations. Her mom resorted to the use of idiomatic phrases to prod her. Her favorites were; "time and tides wait for no one; Make hares while the sun shines; and a stitch in time saves nine." Elsie was very old fashion. Those her idiomatic expressions conveyed a coded message to Nancy not to be too slow before another woman grabbed Leon. Another was that the biological clock of a woman ticks fast. Nancy was thirty four years and needed to speed it up.

As a septuagenarian, Elsie couldn't wait to have grandchildren from Nancy. To hasten the process, she'd stamped her finger in it. Her children meant the world to Elsie and she would stake anything for their comfort. At seventy-three, she'd lived very well and looked forward to the joint wedding in a few month.

It was 10 am the next day. Nobody had seen Elsie at the office. As usual, Janet called her house phone. It wasn't picked up. She repeated the call a few minutes later and got the same result. As her last resort, Janet called Elsie's cellphone and she still didn't pick it up. "That's anomalous," she suspected. It occurred to Jane that Nancy had said yesterday that her mom didn't feel good. She grabbed her stethoscope and her car keys and made towards the exit. "Kester," she called out, "Let me check on Elsie. She'd not picked up her phone."

"Alright," Kester yelled back from his computer room.

It snowed lightly that morning. Janet didn't notice any tire marks on Elsie's driveway. Janet knew Elsie's children went home yesterday because the driveway was free. She figured Elsie was probably home alone. Jane pressed the front door bell and listened for a response. It felt like Elsie was responding very faintly from her bedroom but couldn't come to the door. Janet opened her purse and drew the spare key Elsie

had given her a few days ago for this same reason. She opened the door and went searching for Elsie inside her house.

Inside her bedroom, she'd wrapped herself in a comforter and laid in her queen size bed. Elsie was wide awake but very weak to get up. Her house phone and the extension were in the living room and kitchen respectively so she couldn't get to any. The cellphone had been in her handbag since she'd left the court yesterday. It'd been ringing off the hook but she couldn't reach it.

Janet placed her right palm on Elsie's forehead. Her temperature was high. Janet pulled a chair closer to her bed and sat down. She wrapped blood pressure cuffs around Elsie's left bicep and took her BP. It was outrageous. The systolic was 197 and 109 for diastolic. She repeated on Elsie's right arm, it was about the same. She placed her first and second fingers on Elsie's left wrist and checked her pulse. It was a bit fast.

"Your checkup is due on Friday right?" Janet asked.

"Yes," responded Elsie.

"Your BP and heart rate are high. I'm afraid you need to see your doctor fast. You're also running a temp."

"But I'm not due till this Friday. How about I take a Tylenol in the meantime?"

Nancy was scared she might stroke out if she ignored this. But as a nurse, she comported herself professionally so she wouldn't scare her. "You need to see a doctor immediately. Who's your primary doctor?"

"Dr. Sukra," she responded.

"Can I call his office? It's not about when you're scheduled or not. This is serious and you definitely want to see Dr. Sukra soon," Janet insisted.

Elsie agreed. Janet called Dr. Sukra's office and spoke to him directly. The vital sign result triggered the doctor and he requested to see Elsie at his clinic as soon as possible.

Janet assisted her to dress up. While Janet drove her to the clinic, Elsie quietly reclined her seat and laid back. A thick furry fleece sweater provided some warmth for the drowsy and sleep deprived septuagenarian. Janet woke her up after she'd pulled up in front of the clinic.

Dr. Sukra examined Elsie as soon as her vitals were rechecked. An intravenous was administered with some medication. Her progress was monitored in a private room. The fever disappeared after a while, but the BP was still high. She wasn't stabilized satisfactory to go home safely. Dr. Sukra contacted Dr. Mahesh, a specialist, who'd treated her before, at the Hollywood Hospital. Elsie was promptly transferred in an ambulance to see Mahesh. The emergency technicians monitored her IV very closely while on the way.

Janet followed behind in her Buick. Thankfully, her boss was conscious this time unlike a few months ago. She'd never been that scared in her life like she was that day. It wasn't easy to keep pace with a fast moving ambulance, which blared a siren. Surely some concentration was needed. But Janet managed to reach out to Nancy and Kester respectively, with an update.

Nancy was surprised because they didn't see that coming. They'd left her house less than fourteen hours ago. Elsie had complained of minor weakness. If she knew it was that serious, Nancy wouldn't have left her by herself. Anyway, her fears were allayed this time since Janet had reported that her mom was conscious and at alert, except for weakness and the high BP. She regretted that they postponed talking to Elsie about scaling down her "Do Not Resuscitate" directive. Inside, she wondered about what would happen assuming her mom's situation escalated. But she refused to entertain negative thoughts so far.

A VIP room was readied for Elsie before she arrived the Hospital. Dr. Mahesh was her attending physician. He examined her on arrival. Her heart rate and BP were still high. Mahesh invited a cardiologist to take a look.

Dr. Gregory, the cardiologist, ordered an EKG on her immediately.

The attending nurse, Prisca, helped the EKG technician to stick the leads on Elsie and connect the cables to facilitate the test. The result was printed in hardcopy and also transmitted electronically to the physician.

While Dr. Gregory was still reading the EKG result to determine what medication to order, Elsie became unresponsive from the blues. Janet and Prisca had just walked into her room to check on her. Elsie's eyes were half opened but she wasn't breathing.

Janet shook Elsie and said at the same time, "You alright. There wasn't any response. The expression on Janet's face changed. She shook her arm gently and repeated the same question, "Elsie, are you alright?" She didn't respond again. "Please can someone get the doctor immediately," Janet yelled.

Like a flash of light, Prisca dashed out of the room and informed Dr. Gregory that Elsie had coded. The hospital code was activated right away. Prisca pulled a vital sign machine along with her, back into Elsie's room to take her BP and oxygen.

Doctors Mahesh and Gregory rushed into Elsie's room at the same time with Mr. Cosmos, the shift supervisor. As the first medical personnel on the venue, Mahesh took over the CPR from Janet who'd spared no time commencing that process earlier on, while Dr. Gregory logged into the EMR to search for Elsie's history of evaluation, diagnosis and medication.

The emergency medical team arrived within minutes after the code was called. These were varied Hollywood hospital medical personnel ranging from doctors who specialized in different fields, respiratory therapists, physician assistants, clinical nurse specialists, nurse anesthesiologists and so on. They were alert, ready two-four-seven and specifically trained to handle such situations. Everybody jumped into a role on arrival.

Dr. Abbey, the lead physician yelled, "Can someone hook up the oxygen please. I also need a set of vitals on her please." He'd played that role throughout that emergency process.

The in-house respiratory therapist knew he had to get to work immediately.

The supervisor played a coordinating role alongside the experts in the whole emergency resuscitation process. Mr., Cosmos referenced the list expected duties during emergency situation when a patient is coded. Cosmos ensured that medical equipment and supplies were readily available for the emergency team. He delegated duties to his regular staff such as, "Please get the crash cart, take her vital signs again" and so on. He stuck around to answer questions and clarify issues for the emergency team about the patient. Cosmos make notes of the

procedures performed on Elsie, the time and the medication, including the injection and IV administered.

The clinical nurse ensured that the required number and mix of personnel were available. Ms. Rossi barricaded the door and disallowed entrance of excess medical team in order to decongest Elsie's room for free flow of air.

The team alternated roles to perform CPR on Elsie.

"I need a picc-line please," Dr. Abbey yelled out. The tone of these requests was military-like.

The nurse had hardly raised Elsie's upper arm to insert the needle when her pulse was felt again and her breathing resumed.

Elsie opened her eyes to a big surprise and confusion. Unconsciously, she wrestled her arm from the picc-line nurse. Slowly, she turned her head around the room and saw some jubilant medical team who'd donned white coats and scrubs respectively, standing over and around her. She noticed a full IV bag on the pole and connected to her, a telemetry machine monitoring her heart beats and, a nasal cannula inside her nostrils. Her chest was exposed and breast visible because of the CPR and the EKG performed. Elsie was old fashioned and hated that exposure. It registered to her as the exact process her mom underwent and still didn't make it.

"Where's Janet?" she asked. Janet was standing directly in front of her. Elsie didn't recognize her.

"I'm here." Janet responded.

"Were are my children?"

"They're here as well," responded Janet.

Her children arrived about the time she'd opened her eyes. They were denied access to the room and were directed to the family room. They refused to leave the scene. Rather, they took two strides away from the door to monitor the activities. Josh and Nancy remained calm after someone had assured them that Elsie was alive.

"I'd requested not to be resuscitated to skip this nightmare my mom went through and still died. That was the whole reason I'd say to you in my directive to let me die in peace. Extra pain from sporadic needle

stick and all the other support are unnecessary. Somebody will still die if the Lord had ordained it to happen?" Elsie said indignantly.

Doctors Abbey, Gregory and Mahesh quick conferred privately.

"Elsie, I'm sorry we didn't know about your directives. As medical professionals, lives come first to us. Please let's worry about that when you're well. We need to get you to the ER to check your high BP quickly," Dr. Gregory said.

Her children walked in at this point. Nancy kissed her lips and said, "I love you mom," and Josh kissed her forehead and said, "I love you mother."

Elsie rejected the doctor's order. "I think I'm fine now."

"Mom, you need to be checked out," Josh said.

Elsie agreed with Josh although reluctantly. She was transferred to a stretcher with her IV and nasal cannula still connected. Prisca and some of the responding team pushed her through the connecting hallways to the ER, about a quarter of a mile from her room. A crew of Dr. Abbey, Dr. Gregory, a respiratory therapist, and Prisca, the nurse, accompanied Elsie to the ER. Janet and her children also joined the crew.

The ER discharged Elsie the following day back to the cardiology department to monitor her BP and pulse for a couple of days more before her final discharge.

In her final discharge note, Dr. Gregory had recommended about two months rest from daily business stress. Abstinence from alcohol and smoking was mentioned, although she didn't consume those. The doctor suggested she arrange for a nurse to stop by her house thrice a week to check her vitals and monitor her BP.

To ask Elsie who'd been vibrant, energetic and hardworking all her life, to stay at home was an uphill task for her. She would be bored definitely. But if she had to accomplish her goals, including, outlive her parents, enjoy her children and watch the grandchildren grow, she'd better heed the doctor's advice.

There wasn't a better time she needed her Goodwill Home Healthcare company than while she was at home. Elsie had achieved her goal to receive care in the comfort of her home. She'd wished that

for her parents but it didn't happen. However, she didn't have to deal with Katrina and her likes who'd brought bad names to nursing homes.

It was Janet and Ivory, who'd recruited and designated two nursing assistants from their staffing pool to work with Elsie for those two months. Her assistants fixed her meals, helped with grooming and other home chores as needed.

Chapter Nineteen

Three weeks later, Rodney, Scott and Hannah came back to court to face Judge Anna Sunberry.

Rodney had four count charges of home invasion, theft, forgery and conspiracy to commit felony.

Scott was charged for being an accessory for home invasion, burglary attempt, assault of a security operative, armed robbery, carjacking and conspiracy to commit felony.

Hannah was arraigned for providing services to facilitate forgery. Specifically, providing administrative support to tamper and mutilate official document, an offense punishable by three years in jail or more.

The judge addressed Hannah's charges first. Judge Sunberry treated her with leniency considering her penitence. "Mam, I'm going to give you a break in this case for two reasons. I believe your counsel that you became a victim of circumstance because you offered professional services, oblivious of the criminal intents between the duos when they hired you. Furthermore, neither Scott nor Rodney cited anywhere as a cohort in their respective statements. However, as a professional, I believe you should have smelt rat or seen a red flag when you were requested to alter an official document such as a will. You should've called the police. But you didn't.

Let Me Die

I took the circumstances surrounding your situation, including your penitence, into consideration. I'm ordering you to do one year community service under the supervision of a probation officer. This officer will work out a program for you and report to this court. It's so order." The judge brought down the gavel. You're excused by the court.

"Thank you, your honor," Hannah said with tears of joy gushing down her cheeks. She hugged her attorney who'd been standing beside her. Officers Sandra and Pamela escorted her out of the court.

Ethel presented the plea bargain agreement on behalf of Rodney to the Judge. The judge refused to grant it on the ground that Rodney had felony charges almost of equal magnitude as Scott's, against him. His case was aggravated by the statement made by Scott, including the phone call. The judge couldn't separate both men as unequal accomplices in all the crimes as charged, although, Rodney didn't physically participate in the attempted burglar and armed robbery. She considered the duo as flight risk and still refused to grant bail to any.

Days before that court sat, Ethel had informed Judge Anna Sunberry in writing that Elsie wouldn't be in court due to her medical condition and doctor's order. She'd copied Sophie, the district prosecutor. Technically, Elsie was supposed to be a principal witness for the prosecution.

As the principal victim in the case, the state needed Elsie to testify against her son.

That was difficult her because their biological connection was strong. Therefore, her personal interest would take precedence.

Sophie had threatened to push for contempt of court if Elsie didn't show up. She handed down the same measure to attorney Buckman.

Scott's case was non-negotiable. He'd never denied any involvement or actions. In his testimony, Scott tied Rodney inescapably around the crime from intent, planning and execution. His court appointed attorney barely asked the judge to enforce the quasi plea deal the cops had promised because he understood it was a decoy to fish for information.

The judge found Scott's testimony more credible than Rodney's because he was more forthcoming. She'd ruled to continue with the case that day.

Josh was in court. So was Terry, Rodney's dad. Terry had wanted to speak to his son if the bail had gone through, but it wasn't so. He left the court behind the judge. Prior court proceeding, he'd spoken to attorney Ethel and got her phone number for a follow up.

Josh talked to attorney Ethel after court. He was concerned about his mother's health in view of the outcome. Both of them agreed to brief his mom frugally due to her BP. Also, they wouldn't tell her that Rodney was remanded in jail indefinitely. Rather, they would say that the judge would consider that in the next hearing.

Dragging into lies wasn't what Ethel wanted as an attorney and her integrity. But Elsie's health condition was most paramount.

Ethel didn't disclose she had a plan to recuse herself from the case to Josh. She wanted to send a hardcopy, with her reasons, to Elsie. That might deal a lasting blow to Elsie regarding her BP. But Ethel had no choice than to put Elsie on notice early and give her enough time to scout for another attorney before the next hearing. Ethel would also have enough window to debrief the incoming attorney about the case.

The latter still needed some time to study the case file and acclimate with the client before court appearance.

Chapter Twenty

All was set for Josh and Nancy to wed their spouses, Rita and Leon, respectively, at the 76th District Court. It seemed like a joke, but during the botched reunion party, Elsie had given Laura a nod to organize the marriage. By then, the arrangement was for Josh and Rita. Eventually, Nancy and Leon were added.

Laura sealed the wedding date for Friday so that the invitees would attend and enjoy an uninterrupted weekend after work.

By the noon of that sunny day, the registrar joined a brother and his sister with their spouses.

The happiest moment, which Elsie had patiently waited for, was, "By the powers conferred on me as the registrar of the 76th District Court, I pronounce you husbands and wives." And, "You may kiss your bride."

The after wedding reception was held at the Elite club. Guests were treated to a nice mix of American and Middle Eastern buffet. The bar was open for endless trips for wine, liquor, beer and soft drinks. Some of the guests who knew about the ongoing case were surprised that attorney Buckman was there and wondered that Elsie sat at the table alone with him. They talked and laughed at the wedding.

Those two had demonstrated a firm friendship, which had started

as attorney-client relationship. The doubters didn't there wasn't any bad blood between them as a result of the case. Apparently, they separated temporarily to avoid conflict of interest because Scott robbed Buckman.

The event was super charged with fun. A life band performance brought the celebrants and some guests to dance nonstop on the floor. Some guests meandered around to exchange pleasantries.

There was an unexpected shocker for Elsie. That was Frank holding hands with Tracy as they made their way towards the buffet counter. Elsie had paused and stared at him. She was surprised and uncomfortable. "When did this happen?" she asked inadvertently. She maintained her looks at him until they sat down. She wondered who'd invited him.

"Hope you're alright?" Buckman asked.

She came back to herself quickly. "I'm alright. Thank you." she responded.

Frank, who was Elsie's erstwhile gigolo, hadn't gotten over her accusation of infidelity and sudden severing of their relationship. His primary mission to the after wedding party was to rub Tracy on her face. Frank exploited jealousy, which was Elsie's weakness, to torment her on her happiest moment. He'd become a member of the Elite club since they broke up and was entitled to the rights and privileges.

Elsie had exclusively booked and paid to use the Elite Club at that time. She was certain Frank wasn't invited to that wedding. He'd gate-crashed the reception.

Notwithstanding, the wedding was very successful. Elsie was called upon to propose a toast for her children before the ceremony came to an end.

A week after the wedding, Ethel met one-on-one with Elsie at her house and tendered her resignation from the case contrary to her initial plan to mail it. Trust was a huge issue for her. She didn't want to continue because she'd inferred from the proceeding that Rodney had hoarded a lot of information, which had left her handicapped and hampered her effort to prepare for his defense. Also, she was flabbergasted by Scott's

testimony, which had put all the blame on her client. The prosecution frequently took her aback because she didn't have all the relevant facts.

"It's an attorney-client privilege to know all the truth about a case. But that wasn't the case here," she said. "It's my legal responsibility, as his attorney, to keep his private information secret and confidential. I'm not sure whether that was his problem why he wasn't forthcoming with all the information." She paused. "Regrettably, I have to recuse myself from this case. I wish him success," Ethel concluded. She handed her resignation letter to Elsie. "I'm so sorry that I brought a bad news," she continued, "but I'll be available to debrief your new attorney and work him through the case file the much I know. I thank you for the opportunity to work with you, albeit, very short."

Elsie reached for her pair of reading glasses. She tore the envelope open and took a quick glance at the letter.

Luckily, Josh was present to uphold his mom. It wasn't any surprise to him that little things worried Elsie. Considering her medical history, Josh and Nancy had closely guard against those things that would shoot up her BP. "There's a solution to every problem," he said. He pushed back a bit in an effort to sway Ethel from her decision.

"Attorney Ethel, could you kindly take another shot with Rodney? He should be able to read the handwriting on the wall now that he'd known that judge Sunberry found Scott more credible," Josh requested.

"I doubt it. I've already told him I'll not be representing him at the next hearing.

For the first time, the dumbfounded Elsie broke her silence. "My dear, if money is the issue here, I'd be glad to work out something. I could stretch myself a little more. I don't mean that in a derogatory way. I need you to continue with this case because you already have a grip on it. Please" she pleaded.

"Oh, not at all. I would've told you if money was the issue. I had a case I've been on before I took your brief about Rodney. I'm afraid, it might be in the way. I hate to say that, "Ethel told a getaway lied. She barely looked at Elsie.

Josh jumped in. "Could you recommend a good attorney for us?"

177

"Hmmm," Ethel thought a little. "I'll check. I'm not sure at the moment." Ethel was noncommittal.

"We'll surely appreciate to have an attorney before the next hearing," Josh said.

"We'll see," Ethel said. She rose to depart. She leaned over and hugged Elsie. Ethel hung unto her for a moment and said, "I wish you good luck and speedy recovery."

"I hate to see you go. Thank you for helping us during our emergency," Elsie said. "Please keep us in mind about another attorney," she concluded. They walked Ethel to the exit.

A month and half later, Judge Anna Sunberry found Rodney guilty of all the charges. He was sentenced to six years in prison.

Likewise, Scott was found guilty of all the charges and was sentenced to ten years in prison.

It was a Saturday evening, two weeks after their wedding, Nancy and Leon moved into a house they'd rented next to Elsie's. That hurried relocation, three weeks ahead of schedule, was to keep an eye on Elsie due to her failing health recently. Also, Elsie had been adversely affected since Rodney had been in jail. Nancy was concerned that might trigger Elsie's blood pressure with associated heart attack if not monitored. She assisted with her mother's care as well as monitored the type of care, which her staff from her Goodwill Home Healthcare provided.

It wasn't in doubt that her education, as a nursing student, complemented with hands on experience from Janet, had guided Nancy to provide care for her mother. She kept records of care provided, types of meals and the medication she took, to assist her doctors whenever Elsie went to the clinic. She ensured that nurses visited her mom as scheduled. Her role, overall, helped to improve Elsie's health.

For once, Elsie felt fulfilled and confident that her children had her back. Their concern and closeness had allayed her initial worry about succession and last days. She'd enjoyed what she'd wished for her parents.

Regretted, that didn't happen in their life time. However, she thought she gave them all her best in the prevailing circumstance that time.

During their private dinner on a Friday evening, Elsie sprung up an unexpected question for Nancy. "My daughter, I'm so proud of you. You've been involved in my care. You too, Josh. But this is for Nancy," Elsie said. "You still owe me. Just one more thing."

Curiously, Nancy exclaimed, "Hmmm. What's that mom?"

"I need a grand baby from you," Elsie said with a grin on her face "I understand it's not by your power. I believe God will surely make it happen. That'll make me the happiest mother on earth until God calls me to glory," she said. She introduced a silly joke. "Tell Leon to press his legs against wall; that's how you score goals faster."

They couldn't stop laughing for the next two minutes. Elsie had always surprised her kids by the raw jokes she spilled out occasionally. Most astonishing was their disbelief she still joked vulgar at that age.

———

Eight months later, the family attended a graduation ceremony for Nancy. She'd finished her associate in science for nursing. In that succession, Nancy had a baby boy, her first child, six months after her graduation. She took a maternity leave to care for Joseph junior. The boy was named after his grandfather, Joseph Pelton, Elsie's dad.

The next graduation, seven months after Joseph junior was born, was Josh's. It was longer, expectedly, because he'd pursued a bachelors in health administration. Like his sister, his family attended his graduation ceremony, including Kester, Janet and even Ivory who hardly ever show up on social events.

Elsie's children were an example of success. She was happy to be alive to see them getting ready to take over her thriving business. She could finally retire to enjoy the rest of her life without stress. Perhaps, that would improve her health.

Her children hired a private psychologist to counsel her for stress and depression she'd suffered due to excessive thinking about Rodney.

Before she died at eighty-two years, Elsie walked back a few steps from her stringent "Do Not Resuscitate" directive. She'd granted all their request but life support. She couldn't emphasize enough on that. She became comatose for three days from a cardiac arrest. Elsie died peacefully at the hospital according to her wish.

Rodney was allowed only two hours to attend his mother's burial. The prison authorities allowed him to dress up in black suit, which Josh got for him, to pay his final respect to a woman who'd stood behind him as his heroes. Rodney was accompanied by heavily armed but amiable sheriffs.

His siblings and their spouses wore black suits and skirt suits respectively.

Attorney Buckman, now seventy- eight years, was accompanied to the funeral by his two sons, who'd taken over the management of his law chamber. They'd continued to advance the relationship, which their parents had begun, with Josh and Nancy.

A year after Elsie's death, Josh and Nancy took over the respective positions occupied by Kester and Janet who'd retired. The duo of Kester and Janet were member of board of trustees of Goodwill Home Healthcare as provided in the will.